BEYOND MODERNISM

Essays on Art from the '70s and '80s

KIM LEVIN

ICON EDITIONS

HARPER & ROW, PUBLISHERS, New York

Cambridge, Philadelphia, San Francisco, Washington, London

1817

Mexico City, São Paulo, Singapore, Sydney

In memory of my mother, Jean Lien Levin

BEYOND MODERNISM. Copyright © 1988 by Kim Levin. All rights reserved. Printed in the United States of America. No part of this book may be used or reproduced in any manner whatsoever without written permission except in the case of brief quotations embodied in critical articles and reviews. For information address Harper & Row, Publishers, Inc., 10 East 53rd Street, New York, N.Y. 10022. Published simultaneously in Canada by Fitzhenry & Whiteside Limited, Toronto.

Designer: Ruth Bornschlegel

Copy editor: Marjorie Horvitz

Library of Congress Cataloging-in-Publication Data

Levin, Kim.
 Beyond modernism.

 (Icon editions)
 1. Art, Modern—20th century. I. Title.
N6490.L455 1988 709'.04'7 87-45637
ISBN 0-06-430176-1 (pbk.)

89 90 91 92 HC 10 9 8 7 6 5 4 3 2

Contents

I FAREWELL TO MODERNISM

1. Farewell to Modernism

II ABSENCE: THE '70s

List of Illustrations

Acknowledgments

I want to thank the late Gregory Battcock for his encouragement in the early '70s; Richard Martin for giving me absolute freedom in what I wrote for *Arts Magazine;* Jan Hoffman and Jeff Weinstein, my editors at *The Village Voice,* for their sensitive and intelligent editing; Lanny Powers, John Pateman, Jon Block, Elaine Reichek, and Lucas Samaras for their suggestions and support of various sorts. And I especially want to thank Cass Canfield, Jr., for initiating and encouraging the project of putting together in a book a selection of my writings on art, and for his wise guidance through all its stages.

Introduction

Time changes the way we think and the way we see. Sensibility changes, and I don't mean personal taste but rather some vague shared desire for clutter or barenness, for brushstrokes or taped edges, for sensations or ideas. Styles can change, too, by adapting themselves—as an involuntary survival mechanism—to the mood of the time. Picasso's paintings of the 1960s can look like Pop Art of sorts, Pop Art in the '70s could mutate into an almost Minimalist version of itself. In the '80s, painting is sometimes a Conceptualist act, and Minimalist style is being reinvented as a kind of neo-Pop. The same work looks different at different times: we recognize what we are looking for. The art of the '60s carries different messages for the rematerialized '80s than it did for the dematerialized '70s, and the art of the '70s is just beginning to be reevaluated. And we can now reinterpret the radically conservative late de Chirico as an early simulator, the perversely philistine late Picabia as an old appropriator, and the blithely superficial Dufy as a newly appointed ancestor of pattern-and-decoration art. In a linear history of art, questions of déjà vu and overlap tend to be ignored, but hybrid, crossbred, renegade work is what interests me most. Given time, peripheral art that once ran countercurrent to a mainstream often becomes relevant and sometimes central. Hindsight can be as informative as insight.

Information, or lack of it, alters responses, too. In this age of supposedly instant global access to information and images, the history of recent art still varies from place to place. It depends on where you are as well as on what the political and social climate is. Writing about art's history, even the most recent, is like making a period movie: you can't help but reveal your own moment.

This selection of pieces is, like everything else, partly dependent

on the hazard of time and place. There are artists I wish I'd written about but haven't yet. Maybe their show didn't coincide with my deadline, maybe a colleague at the same magazine or newspaper got to it first. There are pieces I wrote that for one reason or another didn't make it into this book and others that were weeded out as I tried to balance what seems relevant now with what was significant then. Rather than trying to amend and append, I prefer to let the pieces stand as much as possible as they were. Except for the Picasso essay, which was rewritten to combine a gallery review, a catalogue essay, and a lecture, I've left the writing essentially intact, with the occasional addition of a note or the deletion of some extraneous installation detail.

I could claim that what unites these essays and articles is an underlying historical theme: the decline and fall of Modernism, or its death and rebirth. Written over a span of fifteen years, these pieces document what seemed at the end of the '70s to be the emergence of a new era, but now looks more like the waning of the old one. The perspective has shifted: the prefix of choice in the '70s was *post;* in the '80s it's been *neo.* In the '70s many artists were in the uneasy position of shifting from familiar Modernist grounds, which were slipping out from under them, onto uncharted territory. More recently, artists have drawn back from the brink, seeking footholds on familiar soil. From the earliest attempts to sabotage Formalism to the most recent sarcastically formal art, each successive wave has staked a claim at being postmodern. And each in its own way partly is: nothing neo can rightly be called modern. Art since 1968 has been undergoing what Thomas Kuhn, writing about the history of science, described as a "paradigm crisis": a moment in history when the accepted belief system becomes inadequate and the possibility of a new belief system is only vaguely perceived. Although he cautioned that his theory of scientific revolutions should not be applied to other fields, it applies very neatly to what's been happening in art. A sense of malfunction has led to different standards, different definitions, disagreement about what the problems are.

The pieces divide into two parts: those I wrote in the '70s about art in the '70s or art that was significant to the '70s, and those from the '80s. Duchamp heads the first group, because he was the undisputed ancestor for artists during those years. Picasso begins the second section, not because he was an influence on the '80s in the same

sense that Duchamp had been earlier, but because the resuscitation of his reputation and the reassessment of his last work coincided symbolically with the "return of painting" and with a sudden shift of taste.

I've called the first part "Absence," because artists in those years absented their art from the usual modes and materials; tried to remove it from the gallery system; rejected form, style, or materiality; and began to absent themselves from the role of inspired creator. Art disguised itself as photographs, objects, or actions in the world. It treated style as a masquerade and form as camouflage. It secreted itself in other disciplines and experimented with various vanishing acts. The most interesting art during most of the '70s was seldom where you'd expect to find it and was often barely recognizable as "art." Art didn't disappear during the years between 1968 and 1978, but it went into hiding, paradoxically, as it tried to become accessible and move into the world.

I've called the second section "Afterlife," because by the end of the '70s (just as Postmodernism in art was becoming a critical issue), the traditional art object returned like a ghost along with other discredited aspects of the past. Art came back, so to speak, from its experiments with life, but it had shed a number of the old Modernist beliefs. Accessibility, a major concern during the '70s, was radically redefined. Merging with the world had been one way of making art accessible; the pattern-and-decoration movement was another; and perhaps the departure of earnestness was a third. The emphasis now is on the arbitrary and spontaneous nature of images, on spurious forms and synthetic materials, and on the commodity status of an art object bereft of its "aura."

At the moment, sensitized to the issue of simulation, it's easy to pick this tendency out of the past. Ever since Johns cast twin beer cans and Rauschenberg duplicated a drip, artists have been toying with simulacra of various sorts. Malcolm Morley's mimetic work and Super-Realist sculpture, of course, can be viewed in terms of simulation. But so can Eleanor Antin's historical personas, Dennis Oppenheim's surrogate performers, and Bill Wegman's dog. In the '70s, sculptors simulated architecture, painters simulated decoration, video artists simulated TV, and performance artists simulated life. The new domesticated Formalism may be the unexpected progeny of this.

The role of the art critic also changes. Back in the 1940s, before American art had made a name and a support system for itself, critics could be—indeed had to be—the advocates of artists and styles. Today dealers, collectors, and curators have taken over that role, and the critic is left to choose between acting as master of ceremonies or theoretician—or finding other, more adversarial, ways of mediating between history and taste. Recent criticism parallels recent art. If the dominant critical methodology of the 1960s was Formalist, like the art, by the '70s criticism began to clothe itself in the methodologies of other fields: philosophy, psychology, political theory. I don't subscribe to any single methodology, unless being against methodology per se is, as philosopher of science Paul Feyerabend has proposed, a method in itself.

1 FAREWELL TO MODERNISM

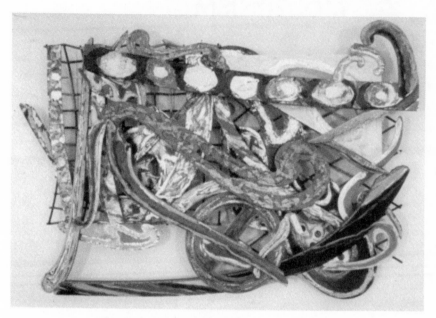

Frank Stella, *Harewa,* 1978. Private collection.

1 Farewell to Modernism

The '70s was a decade that felt as if it was waiting for something to happen. It was as if history were grinding to a halt. Its innovations were disguised as revivals. The question of imitation, the gestural look of Abstract Expressionism, and all the words that had been hurled as insults for as long as we could remember—illusionistic, theatrical, decorative, literary—were resurrected, as art became once again ornamental or moral, grandiose or miniaturized, anthropological, archaeological, ecological, autobiographical, or fictional. It was defying all the proscriptions of Modernist purity. The mainstream trickled on, minimalizing and conceptualizing itself into oblivion, but we were finally bored with all that arctic purity.

The fact is, it wasn't just another decade. Something did happen, something so momentous that it was ignored in disbelief: modernity had gone out of style.[1] It even seemed as if style itself had been used up, but then style—that invention of sets of forms—was a preoccupation of Modernism, as was originality. The Tradition of the New, Harold Rosenberg called it. At the start of the '70s there were dire predictions of the death of art by Modernist critics and artists. By now it is obvious that it was not art that was ending but an era.

We are witnessing the fact that in the past ten years modern art has become a period style, a historical entity. The Modernist period has drawn to a close and receded into the past before our astonished eyes. And because the present was dropping out from under us, the past was being ransacked for clues to the future. The styles of Modernism have now become a vocabulary of ornament, a grammar of avail-

Written in the early days of the modern/postmodern debate, this essay appeared in *Arts Magazine,* October 1979.

able forms, along with the rest of the past. Style has become a voluntary option, to be scavenged and recycled, to be quoted, paraphrased, parodied—to be used as a language. Modernist and pre-Modernist styles are being used as if they were decorative possibilities or different techniques—breeding eclectic hybrids and historicist mutations—by narrative artists and Pattern Painters, by post-Conceptualists and former Minimalists and unclassifiable mavericks.[2] For many artists, style has become problematic: it is no longer a necessity.

The art establishment is still uneasy with the idea.[3] It is more comfortable searching shortsightedly for the trends of the decade—as if it were just another decade—or calling it "pluralistic," or proclaiming, as Philip Leider did recently,[4] that pure abstraction is still the new paradigm.

Nevertheless, Postmodernism is fast becoming a new catchword, and it is full of unanswered questions and unacknowledged quandaries. What is it that has so irrevocably ended, and why, and when did the break occur? If we are going to talk about Postmodernism, we should start by defining Modernism, by questioning how we can recognize whether something is—or isn't—Modernist. For those who have stepped outside Modernism, the successive styles of the modern period, which seemed so radically different from each other at the time, are beginning to merge, with shared characteristics—characteristics that now seem quaintly naive.

Modern art was scientific. It was based on faith in the technological future, on belief in progress and objective truth. It was experimental: the creation of new forms was its task. Ever since Impressionism ventured into optics, art shared the method and logic of science. There were the Einsteinian relativities of Cubist geometry, the technological visions of Constructivism, Futurism, De Stijl, and Bauhaus, the Dadaists' diagrammatic machinery. Even Surrealist visualizations of Freudian dreamworlds and Abstract Expressionist enactments of psychoanalytical processes were attempts to tame the irrational with rational techniques. For the Modernist period believed in scientific objectivity, scientific invention: its art had the logic of structure, the logic of dreams, the logic of gesture or material. It longed for perfection and demanded purity, clarity, order. And it denied everything else, especially the past: idealistic, ideological, and optimistic, Modernism was predicated on the glorious future, the new and improved.

Like technology, it was based all along on the invention of man-made forms, or, as Meyer Schapiro has said, "a thing made rather than a scene represented."

By the 1960s, with Pop Art embracing the processes and products of mass production, and Minimalism espousing the materials and methods of industry, the ultimate decade of technology had arrived. By the time men were traveling to the moon, art was being assembled in factories from blueprints, Experiments in Art and Technology (E.A.T.) was showing the results of its collaborations at the Armory and the Brooklyn Museum, the Whitney had a light show, MOMA had a machine show, Los Angeles had a technology show, and at the ICA in London there was an exhibition of cybernetic art made by machines.[5] It seemed as if the glorious technological future the early Modernists dreamed of had arrived.

But at the height of this optimism, Modernism fell apart. The late '60s was also the time of Vietnam, Woodstock, peace marches, race riots, demonstrations, and violence. Nineteen sixty-eight may have been the crucial year, the year we stopped wanting to look at art as we knew it, when even the purest form began to seem superfluous, and we realized that technological innovation wasn't enough. The work of a great many artists underwent radical changes. Minimalism, the last of the Modernist styles, collapsed in heaps of rubble on gallery floors as scatter pieces proliferated; the Castelli Warehouse opened; the Whitney had its anti-form, anti-illusion exhibition; Earthworks went into the wilderness; Conceptualism came out of the closet; and art became documentation.[6] In a sense, it was the ultimate godlike act of Modernism: creating a work out of nothing. In another sense, it was obvious that something was over.

It may have been especially obvious to the surviving Surrealists, who had spent a lifetime interpreting the unconscious. In September 1969, on the third anniversary of André Breton's death, "a group of his followers announced that the historical period of Surrealism had ended but that it had eternal values."[7] At the time, it seemed a belated Surrealist joke. In retrospect it proves uncannily accurate: the Modernist era, within which Surrealism had existed somewhat unwillingly, had actually just ended.[8] It could be argued that the precise moment of its demise was signaled a few months earlier by the revelation of Duchamp's *Etant donnés*—with all its hybrid impurity, illu-

sionistic theatricality, narrative insinuations, and counterrevolution-
ary contradictions—opening a peephole into the magical natural
world as if predicting the concerns of postmodern art.

It has taken ten years to realize we had walked through the wall
that was blocking out nature. Modernism, toward the end of its reign,
came to be seen as reductive and austere. Its purity came to seem
puritanical. It was in the terminology—in a word, Formalism—which
implied not only the logical structures of Modernist invention but also
the strictures of rigid adherence to established forms. "There is no
other democracy than the respect for forms," one of the new French
philosophers, Bernard-Henri Lévy, has remarked. Like democracy,
Modernist art is now being reinterpreted in terms of its insistence on
forms and laws rather than in terms of liberty and freedom. The
Modernist vision may have had democratic aims—a progressive
emancipation of the individual from authority in an age of unlimited
possibilities, as Schapiro has noted, but in practice it was elitist: the
public never understood abstract art. It was as specialized as modern
science. And emphasis on structure rather than substance is what we
came to see in it. Like science, Modernist art has begun to seem
dogmatic and brutal.

Because it was competitive and individualistic, it saw everything
in terms of risk. Like capitalism, it was materialistic. From its collage
scraps and fur-lined teacup to its laden brushstrokes, I-beams, and
Campbell's soup cans, Modernist art insisted increasingly on being an
object in a world of objects. What started as radical physicality turned
into commodity; the desire for newness led to a voracious appetite for
novelty. Postmodernism began not just with a disillusionment in the
art object but with a distrust of the whole man-made world, the con-
sumer culture, and the scientific pretense of objectivity. It began with
a return to nature. The mood was no longer optimistic. Logic no
longer sufficed. Technology has undesirable side effects, and in a
world threatened by defoliated land, polluted air and water, and de-
pleted resources, by chemical additives, radioactive wastes, and space
debris, progress is no longer the issue. The future has become a ques-
tion of survival.

Only now can we begin to realize just how widespread this shift
of consciousness was. In 1967 the art magazines were full of sleek
cubic forms; by 1969 those steel and plastic objects had been replaced

by natural substances, ongoing processes, photographic images, language, and real-time systems. It wasn't simply the appearance of another new movement, as in the past. It was a crucial change, which affected artists of all persuasions. For a large cross-section of the art world it was a turning point.[9] And all the changes can be traced, by various circuitous routes, to a strong desire to make things real, to make real things. Those photographs from the moon of a marbleized little blue earth may have altered our perception. In diverse and unexpected ways, art was going back to nature. But having been absent for so long, nature was unrecognizable. In the beginning it looked like demolition. But the post-Minimal movements—statements against formal purity that were Modernist reductions as well—were not just an issue of withholding goods from the marketplace, an embargo on the object.[10] Returning materials to their natural state, subjecting them to natural forces, sending art back to the land or internalizing it within the body,[11] they were evidence that time and/or place were becoming crucial, clearing the way for the psychological and the narrational, for personal content, lifelike contexts, and subjective facts. The feeling against style and objectivity proved more subversive than the antipathy toward objects and form: Postmodernism arose out of Conceptualist premises—that art is information—while protesting its Modernist aridity.

Postmodernism is impure. It knows about shortages. It knows about inflation and devaluation. It is aware of the increased cost of objects. And so it quotes, scavenges, ransacks, recycles the past. Its method is synthesis rather than analysis. It is style-free and free-style. Playful and full of doubt, it denies nothing. Tolerant of ambiguity, contradiction, complexity, incoherence, it is eccentrically inclusive. It mimics life, accepts awkwardness and crudity, takes an amateur stance. Structured by time rather than form, concerned with context instead of style, it uses memory, research, confession, fiction—with irony, whimsy, and disbelief. Subjective and intimate, it blurs the boundaries between the world and the self. It is about identity and behavior. "That the artist is now ready to lay his life on the line over a silly pun begins to define the sensibility of the Seventies," commented *Esquire* magazine early in the decade.[12] The return to nature is not only an involvement with the natural world but an acceptance of the frailties of human nature. Which may have something to do with the fact that, if the artist as godlike Creator[13] was the leitmotif

of Modernism, the absent artwork—nonvisual, shrunken or expanded beyond visibility, hiding out in the world or within the artist—was a theme of the '70s.

But just what is Postmodernist? Separating Late Modernist works from postmodern ones is no easy task at this juncture of periods. As in late Roman and early Christian art, or late Gothic and early Renaissance, they coexist. And right now a great deal of what is passing as postmodern is really Late Modernist or else transitional—a confusing mixture of both. The '70s has been a hybrid decade in more ways than one.

Douglas Davis jokingly called Postmodernism the fast-food chain of art, a phenomenon of late capitalism. And, with its accessibility, its informality, its unpretentious self-service and self-deprecating banality, it is certainly more like a Big Mac or a Whopper than the formal feast of modern art. But fast food is all form and no content, preformed and packaged, reduced to a scientific formula, technological and sterile—exhibiting all the qualities of Late Modernism. And that is where the confusions lie. Because we thought the severity of Minimalist sculpture, of Ryman and Marden and Conceptualist art, signaled the ultimate reduction and the end of modern art, we have not been prepared to recognize that the appearance of decorativeness and ornamentation can be another manifestation of the late stage of a period—traditionally characterized by extremes and excesses, and veering from severity to overelaboration.[14] Playing with Modernist forms, elaborating on them, making them mannered and extreme, sacrificing structural honesty to appearance and decorative effects, is—in art and architecture and hamburgers—a Late Modernist trait. Where is the line to be drawn between Late Modernist excess and postmodern recycling?

The intricate mannered space and ambiguous spatial illusions of the '70s are even more perplexing, for in those distortions and compressions the elastic space of Postmodernism begins: an irrational, inclusive, and warping space has entered art during the past ten years, curving to encompass the totality of vision, and it can be seen either as a Late Modernist stylistic trait or as a postmodern perception of an insecure earth.[15] In the same way, mimicking the methods of science and technology or parodying their procedures, as some recent art has done,[16] may be another Late Modernist excess, but at the same time

the romanticization of science and technology into something personal and mystical—into a doubtful fiction—is postmodern. But then, I should also point out that the act of defining and analyzing and trying to categorize is probably Modernist. Old habits die hard. The Modernist era may be over, but Modernist art is still being made, sometimes by self-proclaimed Postmodernists, just as postmodern work is being done by artists who still think of themselves as Modernists. Almost everybody during the '70s has been transitional and hybrid.

If the grid is an emblem of Modernism, as Rosalind Krauss has proposed—formal, abstract, repetitive, flattening, ordering, literal—a symbol of the Modernist preoccupation with form and style, then perhaps the map should serve as a preliminary emblem of Postmodernism. Indicating territories beyond the surface of the artwork and surfaces outside of art. Implying that boundaries are arbitrary and flexible, and man-made systems such as grids are superimpositions on natural formations. Bringing art back to nature and into the world, assuming all the moral responsibilities of life. Perhaps the last of the Modernists will someday be separated from the first Postmodernists by whether their structure depended on gridding or mapping. But because the substructure of any terrain recreated on another scale depends on lines of longitude and latitude (the grid with which we have ordered the earth), maps are the secret and not-so-secret grids of reality, grids gone back to nature, hugging the earth, delineating content. The graph-paper diagrams of the '60s reduced the grid to its final stages: it became useful, a blueprint for making instead of a formal device. In our transitional time, the grid—when it is not elaborated into a decorative motif—has become a tool for making scale flexible, a device for mapping the features of an imagery, the memory of an experience, a place somewhere else, or a visionary plan.

And if psychoanalysis is the mode of self-discovery analogous to Modernism, perhaps we should look to the self-awareness movements that became popular during the '70s for a terminology appropriate to the new art:[17] based not on scientific reason and logic and the pretense of objectivity but on presence, subjective experience, behavior, on a weird kind of therapeutic revelation in which it is not necessary to believe or understand—it is enough if it works. Or should we say that these fast-food chains of enlightenment are Late Modernist too? And instead of structuralism, linguistics, semiotics, what shall we pro-

pose? For the gridlike mental structures of those fashionable systems of analysis are already a little outmoded. They, too, belong to the transition.

Ten years after the end of the Modernist age—but "end" sounds too final, "age" too grand—ten years after, the last Modernists are still clinging to power and the postmodern forces are still a ragged band lurking in the underbrush, to put it in purple art prose. They don't always even recognize themselves, or each other, for mostly they are caught in the middle, with sympathies on both sides of this metamorphosis that is taking place. Postmodernism has barely begun. It is too early to predict whether it will open a new era in art's history or merely provide a final perverse coda to Modernism.

NOTES

1. And it wasn't just art. In fashion, the decade that marched in on space-age platform shoes is ending up in classic clothes and a series of revivals of past styles. In music, too, the past is being scavenged for alternative sounds.

2. Artists as apparently unlike as Frank Stella and Lucas Samaras, Charles Simonds and Scott Burton, Dotty Attie and Eleanor Antin, Peter Saari and Roland Reiss, Jennifer Bartlett and Alexis Smith, for example, are joined by this attitude toward style.

3. The architectural world, however, has openly welcomed Postmodernism, perhaps because of the sterility of modern architecture or the writings of Robert Venturi and Charles Jencks. Or perhaps during the '70s—with sculpture largely a matter of natural structures, habitations, observatories, miniaturized villages, rearranged landscapes, or imaginary civilizations, and painting often moving directly onto the wall to deal with the support structure—architecture has become the dominant art. Nevertheless, the genealogy of postmodern architecture is at variance with that of art. For example, Venturi traces the origins of Postmodernist architecture to Pop Art. Hilton Kramer erroneously follows that cue for art, claiming that Pop Art was anti-Modernist while dismissing Postmodernism as "revisionism from within." On the contrary, Pop Art was thoroughly within the Modernist tradition in its acceptance of technology, and its formal use of contemporary objects from everyday life as abstract signs was not essentially unlike that of the Cubists.

4. In his catalogue essay on Frank Stella's work of the '70s.

5. And at Wise on Fifty-seventh Street, there was always a show of electronic or kinetic art. Rauschenberg's Soundings at MOMA and Bob Whitman's Pond at the Jewish Museum were two of the more memorable works using sound and light.

6. The language shows at Dwan focused attention on words, and in January 1969 Seth Siegelaub opened and closed his hit-and-run gallery with a show of things that

weren't there. Douglas Heubler's statement in the catalogue ("The world is full of objects, more or less interesting; I do not wish to add any more. I prefer, simply, to state the existence of things in terms of time and/or place") defined the new mood.

7. According to Nicholas Calas.

8. The position of Surrealism within Modernist art is complex. The Surrealists had contempt for Cubism, they scorned Art Deco, their space was borrowed from the Renaissance, and though they were revolutionaries, they didn't quite share the Modernist faith in progress and objectivity. But their use of the unconscious derived from scientific technique. And as Motherwell noted in 1944, "plastic automatism . . . is actually very little a question of the unconscious. It is much more a plastic weapon with which to invent new forms. As such it is one of the twentieth century's greatest formal inventions." And now, as we move beyond Modernism, the question of Surrealism is cropping up. Frank Stella's most recent reliefs have Surrealist traits; so do Robert Morris's irrational mirrors. Roy Lichtenstein has been using Surrealist motifs. Lucas Samaras, whose art has often anticipated postmodern concerns, has always been accused of being a Surrealist. And there are Surrealist overtones in the work of the Poiriers, the Harrisons, John Baldessari, Vito Acconci, Dennis Oppenheim, Jonathan Borofsky, Jared Bark, and many other recent artists. It may be significant that the big Surrealist exhibition at MOMA took place in 1968.

9. A glance at almost anyone's chronology reveals this shift. It isn't only the long list of artists whose careers start at that time, or the many artists who gave up painting or sculpture for process work, documentation, or performance, who shifted to natural substances and gave in to gravity. To name just a few, Baldessari burned his paintings and began painting lettered statements; Bob Irwin started using light instead of paint; Eva Hesse's work became snarled and visceral; Newton Harrison switched from technology to ecology; Samaras gave up the box form and began his chair transformations. Others gave up art entirely. Super-Realist objects and images began to emerge. Renegade artists like Joseph Beuys and Hans Haacke, like Bruce Nauman, Malcolm Morley, and Les Levine, and eccentrics like Joseph Cornell and H.C. Westermann, began receiving attention. Saul Steinberg's cartoons began to be accepted as art. And long-established artists like Philip Guston, Al Held, and Jack Tworkov gave up Abstract Expressionism for idiosyncratic illusions or ominous personal imagery.

10. Nor was the new randomness and informality simply a formal move. Barbara Rose's recent theory of the influence of the 1967 Pollock exhibition on scatter works is somewhat misleading. In 1969 Robert Morris wisely warned against identifying the new art with Pollock's fields on the grounds that this would be a formalistic misunderstanding. Robert Pincus-Witten's collection of essays on post-Minimalism locates the shift in sensibility in the late '60s, but places it within the Modernist tradition, and indeed most of the artists he chose to write about were still primarily involved in reductive Modernist logic—in the analysis of pure form. His own style of writing since 1976, however, has been diaristic and narrative, more postmodern than the art it discusses.

11. The photographic documentation of this work, along with the snapshot imagery of Photo-Realism, led to photography's becoming the new medium for art by the early '70s. Susan Sontag, viewing the popularity of photography as a result of the destruction of Modernism, has said, "I wasn't writing about photography so much as I was writing

about modernity." The same could be said of art's sudden enthusiasm for the photograph: it was another sign of the demise of Modernism and the acceptance of nature.

12. The comment referred to a piece by Chris Burden, whose body works at the time were literalizing the Modernist idea of risk.

13. The Matisse chapel at Vence, the Rothko chapel in Houston, the Citicorp Nevelson chapel, are not anachronisms, and recent *Artforum* articles comparing abstract art and religious icons are not irrelevant: the Modernist condition alternated between puritanical denial and endless desire. Each style had its catechism of sins, its pantheon of saints. It is just that, religion having withered away, what was being worshiped was the spirit of invention.

14. The Late Minimalist proliferation of forms seen in the work of artists like Sol LeWitt and Jackie Ferrera belongs to this final stage of Late Modernism, but so do the Pattern Painters' multiplication of Minimal forms into ornamental designs, the decorativeness of recent work by Mel Bochner and Dorothea Rockburne, who started out with the severest of notions, and the wild profusion of elements in Stella's metal reliefs and in Samaras's aptly titled fabric "reconstructions." "Structural excess," Arthur Drexler called it in recent architecture, and in fact, much so-called postmodern architecture would seem to be Late Modernist, for a facade that tilts wildly or a reflective shiny surface may negate Modernist functionalism with its excesses, but basically it is nothing other than an elaboration of Modernist forms.

15. This space can be found in Chuck Close's heads and in Al Held's geometry, in the three-dimensionalization of painting by Ralph Humphrey and Stella and in Lichtenstein's two-dimensionalized sculpture, in the spatial distortions of Samaras's Polaroids and the undulating space of Morris's recent mirror works and Kenneth Snelson's photographs, and in Malcolm Morley's "plastic drift." There is even something of it in the bloated mannerism of Philip Pearlstein, Al Leslie, and Jack Beal, in the awkward foreshortenings of Alex Katz and Alice Neel, in the violent perspectives of Richard Estes and Robert Cottingham.

16. For example, work by Les Levine, Arakawa, the Harrisons, Chris Burden.

17. Along with their counterparts, the self-effacing mystical religious cults of the '70s, these searches for fulfillment and meaning in life parallel art's new concerns with human potential. "This self-absorption defines the moral climate of contemporary society," writes Christopher Lasch in *The Culture of Narcissism* (New York: W. W. Norton, 1979), viewing it as a desperate concern for personal survival, a symptom of the late twentieth century. Even in science, the trend is away from objectivity. A noted astronomer recently remarked that perhaps it was time to stop seeking the origins of the universe in logical systems and turn instead to mysticism for explanations.

II ABSENCE: THE '70s

Marcel Duchamp, *Etant donnés: 1e La Chute d'eau, 2e Le Gaz d'éclairage*, exterior, 1946–66. Philadelphia Museum of Art.

1 Duchamp in New York: The Magnum Opus

*Despite the fact that Duchamp was everybody's ances-
tor during the 1960s and '70s, his work never lent itself to
formalist criticism. After decades of enigmatic denials of
meaning and disguises of nonsensicality on his part, and after
years of official blindness to signs of his wayward "literary"
content and outlaw symbols, the early '70s found a number of
Duchamp scholars hot on the trail of an elaborately concealed
iconography. The clues Duchamp planted or didn't plant were
sniffed out, dug up, pawed over, and subjected to detailed fo-
rensic analysis, as "iconography" reentered the critical vocabu-
lary with a vengeance. Posthumously, Duchamp remains the
secret saboteur: his iconography wreaks the same havoc on art
criticism that his ideas worked on the history of twentieth-
century art.*

In 1912 Paris, Cubists in the Salon des Indépendants rejected *Nude
Descending a Staircase* on the grounds that it was not authentically
Cubist. They were too involved in a new cuisine of painting, and in
new doctrines, to see its most radical implications, but they realized
it was inedible.

A year later *Nude Descending* became the scandalous star of the
Armory show, that landmark in American art history. *Les Demoiselles
d'Avignon* may have opened France's eyes to a new way of seeing;
Nude Descending opened our minds to a new way of thinking. And

Written in 1973, this essay was originally published in French translation in *Opus
International* in March 1974. It was revised in 1976 and appeared in the *LAICA* (Los
Angeles Institute of Contemporary Art) *Journal,* July/August 1977.

while France followed the tantalizing gyrations of the omnivorous Spaniard spewing forth new forms and styles, Duchamp toyed with America, with infinite patience.

While the Cubists pursued their analysis of plasticity in a rational climate, Duchamp was betting against the odds, finding alternatives to logic in the chance processes of selectivity. While they dissected three-dimensionality, he played with ideas of a fourth dimension. While they created paintings at the extreme limits of the visual, he envisioned an art that interacted with the elements; negating the artist's role as creator, making notations of imaginary devices, he acted as an inventor, bringing art full circle from Leonardo's notebooks. He had already renounced painting, before the Armory show, and started his speculations on the nature of art, started his experiments with chance and choice, space and time, perspectives, dimensions, and secrets. He had already become the alchemist, transmuting art from one plane to another, rarefying it, shifting it from the visual to the mental, coaxing it along the perilous process from matter to energy, but nobody knew it.

In 1915 he arrived in New York, an unexpected celebrity, to turn himself into a work of art, to invent the future of American art. Duchamp, almost single-handedly, slowly made New York the capital of the art world. Ironically, in doing it he also masterminded the downfall of Paris.

Of course, to say that is to oversimplify; it is incomplete, it falsifies, but it is also true. Cézanne, Redon, Braque, Matisse, Picasso were in the Armory show too, but it was Duchamp who caused the ripples and became the catalyst. America, with no preconceptions of modern art and little past in art, sprouting with new technology, was the right place for his mechanical allegories, his robotic images of speed, precision, and sex, his mechanistic nudes and erotic machines. Hartley and Dove, Sloan and Bellows, Joseph Stella and Stuart Davis, all were affected by his use of mechanical forms and techniques.

But while American painting absorbed the idea of the machine— the apparatus of his ideas—he was turning mass-produced utilitarian objects into art. He was making art a matter of choice, selecting readymades, hanging them from the ceiling or nailing them to the floor, or assisting them with additions or subtractions. He was inventing aliases and disguises and puns, and playing games with illusions, shadows, optics. He was working on the *Large Glass*—making a trans-

parent painting like a diagram, with foil, wire, and dust. He even resorted to painting with paint, depicting the projected shadows of his readymades on a wall and offering color swatches and reminders that measurement is flexible on a canvas torn apart with illusions and patched with real safety pins. When he took a trip to Paris, he brought back to New York a goateed *Mona Lisa* and a vial of Paris air, as if defacing tradition in order to breathe. Was it pure chance that his first work in New York was a snow shovel and his last the blacked-out window or the caged sugar cubes? He had shown American artists the way through painting, but they were still clinging to the dense surface. He couldn't dig them out. In 1923 he vanished back to Paris, where he was unknown, leaving his *Chocolate Grinder*—made in 1913, before he had ever left France—to become the inspiration for Demuth and Sheeler, and the Precisionist movement. His deeper clues to a new art remained dormant.

When Dada paralleled his insistence on the gratuitous gesture, he said he was not an artist or antiartist but an engineer, and he constructed machines that ran the illusions of optics into the ground with precision optics and real motors. When the Surrealists held exhibitions of paintings, he became a designer of real space, hanging twelve hundred coal sacks from the ceiling or threading a mile of inflammable string through the gallery. His obliging assistance concealed a generous helping of critical sabotage.

He was back in New York in 1942, along with the Surrealists in exile and the immigrant abstract artists. He is usually credited with providing alternatives to Abstract Expressionism in the 1950s. But in the '40s, if it hadn't been for the atmosphere of his ideas, de Kooning and Pollock might have become provincial Surrealists. Matta, who had been an architect working for Le Corbusier and seen what Duchamp had done, became a painter and an agent in the transition from Surrealism to Abstract Expressionism. No one likes to give Duchamp any credit in its appearance; its physical involvement in the material, the dense paint substance, seems the antithesis of his aims, but Abstract Expressionism was also a literal limited understanding of his idea that art was a series of gestures, choices, chances in space. For the Abstract Expressionists, he originated the idea that it was necessary to make a new picture: it was no longer a question of painting apples or nudes or dreams; the picture itself was the question. Their purely physical solution, their reliance on inspired crea-

tion, and their inability to read that it was actually painting itself that was in question, led to the crisis within the style. "The same reason Duchamp doesn't paint is the same reason all these other fools keep painting," said one disillusioned Abstract Expressionist in the early '60s.

By the 1960s, because of his relevance to Johns and Rauschenberg, by way of John Cage, Duchamp became an open secret among artists: permutations of Duchampian ideas permeate the succeeding styles of the American '60s, from the messiest Happenings to the tidiest Conceptualism. Coincidental similarities or deliberate allusions, accidental parallels or conscious reactions and homages, multiplied as art came down off pedestal and wall and blended into life. Attitudes toward readymade imagery and techniques and the desire to be a machine, to be indifferent, to eliminate traces of the artist's hand, can be traced to him. So can experiments with perception and the phenomena of vision, plays with words and meanings, with the erotic force of objects, with use of the self as an object. Knowingly or unknowingly, fragments of his ideas have been taken on, extended, magnified or telescoped to fit other mentalities, other visions. His motifs cropped up continually, altered to alien purposes—color scales, units of measurement, diagrams, molds—and more and more extraneous materials were forceably inserted into the realm of art.

Almost all artists in the '60s acknowledged Duchamp in one way or another at some point in their work, wanting to trace their lineage from him, which is not to say that they were necessarily derivative. He was a starting point. The '60s was, it could be said, his creature. He set it in motion. And he sat pretending to play chess while it acted out his paradoxes in unpredictable, unrecognizable, impure ways, acting on what was useful or similar, reflecting its own preoccupations. Just when we might have seemed finally to be making the new rarefied art he proposed, to be finally getting rid of style, he planted *Etant donnés* in Philadelphia like a delayed time bomb to force revisions, to offer alternatives, to hint that we are still, nevertheless, making art—dealing in illusions. Just in time to coincide with our own new impulses toward trompe l'oeil.

No one has ever liked to acknowledge debts greater than they can repay: the artists loved him, but for years the New York art establishment officially dismissed his importance. California could mount a comprehensive museum show in 1963, London in 1966, because they

do not owe him what we do. New York showed him in bits and pieces; it was more comfortable that way. Only at the end of 1973 did we finally see a major show of his work, but by then innumerable pilgrimages had already been made to Philadelphia, where, since 1954, the Arensberg Collection had quietly been on public view. When a gallery show of his work opened in New York on Valentine's Day 1967, he was seated in a solitary armchair in another room, full of Picabias. He was very erect, very transparent, very beautiful, very old. He gave an impression of neatness, correctness: the impeccable genius, wearing large furry embroidered slippers on his feet. In stealth and silence he moved too fast, leaving the rest of art behind. We have not caught up with him yet. But Duchamp, master of incongruity, American citizen, gave us a head start on Europe.

Because he made the question of style obsolete, nobody ever mentions that there is a certain evidence of style in his readymades or that they share his iconography. It has become apparent now that the shock of their intrusion into art has evaporated. There is an elegance, a wiry linearity, a precision to these objects; they have a lunar chill and the cleanliness of plumbing and bridges. They tend to have an arching circularity and spindly extensions—spokes, hooks, prongs, teeth. They are objects of pristine delicacy and neatness. The comb or the urinal, the hat rack, coat rack, bottle rack, or perfume bottle, even the box in a valise, are objects of personal grooming and civility—objects of the gentleman—decorous, fastidious, and on the move, traveling light. They are traps for the attire of outward appearance, receptacles for discarding physical luggage, for shedding coverings or guises or habits, stripping off illusions, facilitating transitions. Or they are sites of transitions: windows or doors. The malic molds ("cemetery for uniforms and liveries") supposedly contained the hollow shapes of uniformed figures (soldier, policeman, priest, etc.), filled with gas. Much later the readymade waistcoat and the pair of aprons materialized, along with the three erotic female objects. The discarded clothing is another aspect of the stripping bare. With inscriptions, mementos, replicas, miniatures, Duchamp retains only the memorabilia of his ideas, as if emptying out his desk drawers—to reveal the contents of a mind hermetically sealed with secret knowledge.

The more he insisted his choices were made for amusement, without sense, without meaning or significance, the more it became neces-

sary to explain him. The more he has been explained, the more inexplicable he becomes. Perhaps his work was not just addressed to artists. In spite of recent protestations, we are still concerned with making art in a way Duchamp no longer was. We repeat ourselves, we remain recognizable from one work to the next, our most formless abandonments of style do not escape being art. But Duchamp might have been—literally—an alchemist, and his art a code for other alchemists to decipher, a treatise or dialogue or manual.

Robert Lebel discreetly suggested it in 1959. "Given a man who surrounds himself with secrecy, who obviously follows a rule, who sets himself exhausting tasks which he makes certain shall bring him neither glory nor profit and which he suddenly abandons for no apparent reason, would we not be justified in looking for some connection with alchemy? Signs are not lacking, from the incontestably initiatory character of his thought and works, based on the consistent use of a secret language, a symbolism of forms and a system of numbers." When Lebel asked him, Duchamp evasively replied: "If I have practiced alchemy, it was in the only way it can be done now, that is to say without knowing it."

More recently, other Duchamp scholars have begun to look for this connection and to uncover hints of alchemical knowledge in Duchamp's work, buried between the lines of art history: a compositional analogy between a sketch of *The Bride Stripped Bare* and an illustration in an old alchemical treatise; formal similarities between the Bachelor apparatus and alchemical mills, furnaces, and distilling apparatus; symbolism such as the hermaphrodite and the union of opposites (known to alchemists as "chymical nuptials").

But the question of alchemy becomes more intriguing if we look beyond the motifs presently under consideration, the esoteric symbolism and mechanical apparatus. There is another aspect to alchemy—the alchemists' actual chemical process, their laboratory procedure. This procedure, supposedly last performed in the seventeenth century, was apparently a homemade method of releasing nuclear energy. The technique was a closely guarded secret. However, shortly after Lebel raised the question of alchemy in regard to Duchamp, Pauwels and Bergier, the latter a French nuclear physicist, happened to publish a partial description of the alchemists' patient procedure. This account went unnoticed in relation to Duchamp's "amusing phys-

ics," but alchemy as the ancestor of nuclear physics may well provide the key.

In the process described, the alchemist first prepares a mixture of an ore with a metal, such as iron, lead, silver, or mercury, and an organic acid, which he must grind and mix for months. The mixture is then heated, treated with acid and polarized light. An oxidizing agent is added. It is repeatedly dissolved and reheated, "stripped bare" over and over until a sign of readiness "blossoms" on its surface—crystals shaped like stars, or an oxide formation that resembles the Milky Way. The *Large Glass*—using silver foil, lead wire, and dust (some impurity is thought to be necessary in the alchemical process), silvered with mercury and meant to be etched with acid—may well be more than an enigmatic lovemaking machine. With its accompanying diagrams and notes, its Bachelor apparatus and chocolate grinder for mixing and grinding, and its Bride, described by Duchamp as "blossoming" into the Milky Way, it could easily be hiding the functional secrets of alchemy in the workings of its puzzling mechanics.

After a period of "ripening," the alchemist's substance is placed in a hermetically sealed transparent receptacle and reheated, its temperature precisely controlled. Eventually it becomes a fluorescent blue-black fluid or essence that is really a liquid gas (known to science as electronic gas and made up of the free electrons of the metal). After more heating and cooling, the alchemist opens the receptacle, in the dark. The liquid gas solidifies on contact with air; its dregs are washed and rewashed in triple-distilled water, at constant temperature, in darkness. The water then becomes a universal solvent, a radioactive elixir, which the alchemist drinks. Then the secrets of energy and matter are supposedly revealed to him, his body is rejuvenated, and his mind is "illuminated": he is transformed.

Couldn't the fluorescent liquid gas and the water with magical power be Duchamp's Illuminating Gas and Waterfall? Like the alchemical gas, his Illuminating Gas in the Bachelor apparatus solidifies during its passage from the sealed molds to the open sieves, becoming "spangles," according to Duchamp's notes. In his notes there is also a warning that "Given, in the dark, 1st the Waterfall/2nd the Illuminating Gas, in the dark, we shall determine the conditions for the extra rapid exposition (= allegorical appearance) of several collisions." Given the activated water and the solidified dregs of liquid

gas, the alchemist can then proceed with further complex manipulations, which involve finally grinding up specially treated glass to obtain a powder, the "philosopher's stone," which can transform base metals into gold (the King), silver (the Queen), or platinum.

This could explain not only the *Large Glass* and *Etant donnés*, but the sealed vial of air, the darkened windowpanes, the thermometer in the cage of heavy cubes, the bottle of precious water with the transformed photograph on its label, the *View* cover that resembles the Milky Way: they could signify stages of the process. The coal sacks on the ceiling could have meant fuel for the alchemist's furnace. Even Duchamp's first readymade, the *Bicycle Wheel,* may have been an announcement: the alchemist's work was often called The Wheel.

Other correspondences may be waiting to be deciphered. Further knowledge of the alchemical processes might explain elements of his iconography that have remained elusive, and might decode his cryptic notes, clarifying what he meant by "a reality which would be possible by slightly distending the laws of physics and chemistry." If not just the symbols and apparatus but also the procedures of the "chymical nuptials" prove to be fully mirrored in the workings of *The Large Glass* or in the sequence of the readymades, a verdict on Duchampian alchemy could be pronounced. His art may well have been a vehicle for transmitting secret techniques. But Duchamp the young librarian, whether he actually practiced alchemy or not, could easily have become familiar with rare alchemical treatises, adopting their mode of working as his life-style and adapting a personal poetic interpretation of their secrets to his imagery; he could have accommodated the alchemist's means to the ends of art. Posterity has just begun to uncover in his work what he once called the "art coefficient"—a confrontation "between the unexpressed but intended and the unintentionally expressed."

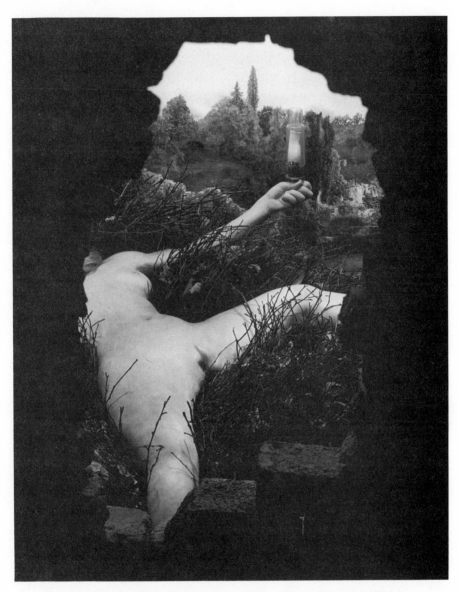

Marcel Duchamp, *Etant donnés: 1ᵉ La Chute d'eau, 2ᵉ Le Gaz d'éclairage,*
1946–66. Philadelphia Museum of Art.

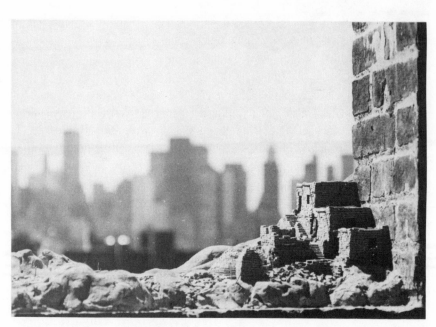

Charles Simonds, *Dwelling*, 1976.

2 The State of the Art

Robert Smithson's Earthwork in Great Salt Lake—the *Spiral Jetty*—is submerged under five feet of water like some relic of the prehistoric past, Photo-Realism looks passé, Minimalism is the establishment, Conceptualism the old order, and Conceptualist Douglas Heubler's statement about the world being full of objects—"I do not wish to add any more"—has the ring of history.

And nobody seems to know what's happening. The '70s came and went, and most of the art world pretended it never existed at all, grumbling that there was no new art, no superstars, no new movements, no isms that lasted longer than fifteen minutes. And while the majority of critics, curators, and dealers thought all through the '70s that it was still the '60s, hailing Ryman and Marden and Martin and whatever was most Minimal, most Conceptual, most reductive—most familiar—as new, Barbara Rose proclaimed in a show she organized in 1979 that the '80s would be a replay of the '50s and brought forth a bunch of messy neo–Abstract Expressionist paintings out of walk-up studios by artists who had done them in the '70s. Since she decreed that the '70s didn't exist, except for artists in their seventies like de Kooning and Dubuffet, she had to relegate them to the future in order to return art to its glorious past.

But confronted with upheaval, could art really return to the triumphant days of Abstract Expressionism, miraculously restored to a petrified semblance of its vanished youth? Nobody in the art world took Rose's talk of the "old-time religion" and the "ethical superiority" of painting too seriously. She was obviously attempting a last-ditch

Art Journal, Fall/Winter 1980.

effort to uphold Modernism while on all sides there were signs of its demise. As the '70s ended in confusion and recrimination, "postmodern" was the word. Modern art was looking as safe as the Renaissance, Pollock and Picasso were in the same pantheon as Rembrandt, and even Hilton Kramer, in the Sunday *Times*, was talking of Postmodernism as if he hoped it would be a return to the good old days of the Victorian salon. "Pluralism" was the other word bandied about, mostly by Modernist critics who couldn't quite accept the end of their era and preferred to think of coexistence and confusion rather than come to terms with all those scattered new voices, which might really be talking about something else entirely.

What scattered new voices? The public barely knew they existed. "A realistic assessment of the situation suggests that schizophrenia is the only intelligent approach," wrote Charles Jencks in 1977. He was speaking of architecture, but it might as well have been of art, which seemed to have splintered into a million individual pieces, with private mythologies and eccentricities apparent on all sides. The work went to extremes. Some exposed the processes of its own making or else disguised itself as anthropology, archaeology, natural history, or ecology. Other was pure artifice or simple ritual, or was involved in basic mechanics or elaborate shams. There was postliterate story art and mute Pattern Painting. Gigantic land projects and miniaturized villages. Aggressive feminist art and passive political art. Coldblooded virtuosity and intractable ineptness. Painstaking simulations appeared, and so did awkward images. There was art you could hear instead of see and art that was nothing but light.

Then there were all the revivals. Not just the painterly Abstract Expressionist one but all kinds of private revivals. Galleries showed work that looked like Islamic tiles or Pompeian wall fragments, primitive Byzantine chapels made of candy-wrapper foil, or sophisticated Japanese prints of geishas licking ice cream cones or faded sepia photographs recreating the life of Nurse Nightingale, and each was the work of a contemporary artist. From one angle the '70s could be seen as the decade of the Neo; from another it appeared archaistic. It *was* a decade of coexistence: between the old Minimalist art masquerading as the new—avant-garde and academic all at once—and the new art, informally disguising itself as other things, including the

past. A vague word like "pluralism" became the easy way out.

At the last moment, just as the '70s was ending, another word came to the Modernists' rescue: retrenchment. Everyone seemed to be dealing with problems of painting again. The decade started with an escape from the traditional end product of art—the art object. It would end with what looked like objects hanging on walls. Pattern Painting won out over Neo–Abstract Expressionism, partly because it least disturbed the status quo. Everyone said how radical it was to dare to be decorative and conveniently forgot to trace the development of pattern straight out of Frank Stella's protractors or Sol LeWitt's wall drawings. No one noticed that Jasper Johns's new work dealt with pattern, or remembered how decorative Pollock's swirls or Mondrian's plaids or even Warhol's soup cans could look, not to mention his cow wallpaper. Pattern Painting strayed not too far from the Modernist camp. It could be called revolutionary, hedonistic, impure, but patterns are, after all, the most logical of forms. And logic was the keystone of modern art. It seemed for a moment that the decade would end with postmodern art prematurely stillborn and the coup d'état of Neo-Modernism. But as the '70s ended, a number of artists were going beyond pattern to irrational ornamental excesses, and some of the most surprising new work was by established artists, like Frank Stella and Lucas Samaras, who undercut logic and patterned their hybrid, eclectic, and uncategorizable wall works with references to all the used-up styles of modern art, turning Modernism into yet another personal myth.

The truth was that Modernism *had* become a myth. Artists dealt with their loss of faith in different ways: escaping into fantasies of the past, inventing visionary private worlds, involving art in social issues, or starting anew. But whether synthesizing modern styles or mimicking past styles, whether turning style into decoration or discarding style entirely, artists in the '70s were not only signaling the end of modern stylization. They were digging out from the debris of the collapsing era, grabbing hold of pieces of the past for security in an uncharted future. In their apparent disregard of style, artists were turning to content, seeking substance instead of form. We may be in need of some simple definitions, a glossary of redefined terms to carry us into the present.

MINIMALISM: Dominant after Pop Art until the late '60s, Minimalism was an art without internal relationships, a reductive art of isolated cubic objects, static and implacable monolithic forms, serial structures, and sleek technological materials. It was also a turning point: since Minimalism, no style has had the power to lay down the laws, to channel art into a single direction, to dam up countercurrents with its scorn. Minimalism was the last of the totally exclusive styles, the end of the Modernist mainstream.

FORMALISM: The art critics' answer to Minimalist art, Formalism described not only the art but also a style of writing about art that excluded any biographical or iconographical information and pretended to pure objectivity. "Until late in the sixties, solemn formalism was assumed to be the only way one talked about art," a formerly formalistic critic said not long ago.

POST-MINIMALISM: Any or all of a torrent of reactions to Minimalism that occurred in the late '60s, including Process Art, scatter works, Earthworks, Conceptualism, and Body Art, each a logical extension of the reductive Minimalist ethic and a protest against its formalism, rejecting an art of objects. Post-Minimalism turned to the temporal, the ephemeral, the natural. In a way, it was a back-to-nature movement, but primarily it was a critique of form.

PROCESS ART subjected Minimalist forms to structural, material, or logical failure—and to natural processes and forces like gravity. It emphasized materials and procedure, and sabotaged Formalism by de-forming its objects.

SCATTER WORKS, an extreme type of early Process Art, reduced art to a random scatter of raw materials on the gallery floor. It emphasized the physical properties of substance and opposed Formalism with formlessness.

EARTHWORKS, an extension of Process Art that used the earth's surfaces as its materials, eliminated the art object by making art out of the land; it left the gallery and returned only as documentation. It emphasized nature as well as site and imposed form on natural formations.

CONCEPTUALISM, also known briefly as Idea Art, dematerialized art entirely and reduced it to the initial stage of the process: the artist's idea. It was as literal and objective as Minimalism but substituted documentations, proposals, and facts for objects. By offering an alternative to the art object—the idea that art could be information—it

became the most influential of the post-Minimalist movements. It introduced linguistics and interpreted form as information.

BODY ART, sometimes known as Conceptual Performance, combined elements of both Process Art and Conceptualism. It internalized art within the artist's body, which was used as a material for formal procedures, usually a series of simple repeated actions. The puritanical Minimalist orientation also led to masochistic violations of the artist's body that appeared to be making literal the old Abstract Expressionist idea of "risk." It emphasized behavior and replaced geometric forms with the human form.

PHOTO-REALISM: A style of painting, also called Super-Realism or Sharp-Focus Realism, that developed in the late '60s and depicted photographs with exact mimicry. The paintings presented naturalistic imagery and illusionistic space on Minimalist terms by disguising them as something actually flat, like the surface of the canvas: a snapshot or color slide. The sculpture related to this style was a pure literal simulation of objects, including the human body. Although Photo-Realism was seen in the early '70s as an aberration and a throwback to premodern realism, it was really another kind of post-Minimalist art and should probably have been called Minimal Realism. It emphasized imitation, questioned the art object by simulating real objects, and denied Formalism by turning to snapshot informality and reproductive formulas. It also hinted at narrative subject matter. However, it also was the most obedient child of Minimalism: its stance was as objective and object oriented as that of Minimalism itself.

After the early '70s, words fail us, the glossary dissolves. The lines of influence and threads of history get so tangled together that there are no more terms that really work.

You could say that Minimalism, after spawning all the post-Minimal movements, moved into mysticism in works like Robert Irwin's conceptualized white spaces. Or that it split into its own opposites: the severity of bare paintings like Ryman's and Marden's and the repetitive elaborations of artists like LeWitt, which, carried one step further, turned into decorative, maximal, and excessive PATTERN PAINTING.

But ideas run rampant. Conceptualism mates with other kinds of post-Minimalist art and fathers a strange array of wayward brats.

There's NARRATIVE ART, for instance, visible readable story art which combines words and images, turning Conceptualist facts into post-Conceptual fictions, confessions, or even propaganda. Other works, often narrative, use photography not to document facts but as a new medium, making the photograph itself into an object. The pictures of these artists, who might be called "Photo-Conceptualists," often expose the delusions of perception.

And what about trompe l'oeil and ABSTRACT ILLUSIONISM, those bastard children of Photo-Realism, which, aware of the artificiality of paint on canvas, flaunted their deceptions of brushstrokes with shadows or crumpled envelopes you could swear were stuck on? Or the ménage à trois of Body Art, Conceptualism, and Process Art, which produced video art and NARRATIVE PERFORMANCES, as well as work like Vito Acconci's scenarios with sound or Dennis Oppenheim's surrogate puppet performers?

Or the union of Earthworks, Conceptualism, Process Art, and Narrative, which gave birth to grandiose schemes known as LAND PROJECTS, to work like Will Insley's visionary *Onecity*, Helen and Newton Harrison's ecological *Lagoon Cycle*, Charles Simonds's tiny urban ruins of an imaginary civilization, and to immense outdoor constructions made for a specific site? This environmental sculpture returned to the galleries in the mid-'70s as makeshift architectural structures, rawboned habitations, strange models of bridges and towers, and visionary dwellings.

But these are categories—arbitrary labels rather than styles. Narrative paintings can be patterned. Pattern Painting can merge with Abstract Expressionist brushstrokes. Personal revivals can sit anywhere. And even the landscape projects have narrational elements. If the sculpture of the '70s often looks like architecture, and occasionally like furniture, the painting is ornamental. And it isn't just the Pattern Paintings or the decorative improvisations of neo–Abstract Expressionists, or even the artists playing with an array of modern forms or reinventing the distant past. Artists from Minimalist to Narrative began to ornament their paintings with patterned surface textures built up with anything from paint-soaked cotton balls to cardboard rosettes, shattered dishes, fabric, or sparkles. Others went to the opposite extreme, painting on the gallery walls. If sculpture was turning to construction, painting was trying to escape its own superfluity. You could say, as Gail Sheehy did in a totally different context, that

"the current ideology seems a mixture of survivalism, revivalism, and cynicism."

No wonder the critics threw up their hands and called it Pluralism. In the '70s, personal identity was at issue and art's history looked like another fiction.

Convenient as they are, decades never quite work. They are always beginning or ending too soon, overlapping, shifting direction in the middle. For example, the '70s began in 1968, while the '60s didn't end until at least 1974. To understand the recent past, you have to think in larger time spans, and history is a useful fiction. The twentieth century, until very recently, was characterized by a belief in the new, the improved, the modern. The confusion of the '70s was a matter of expectations: people were holding on to a suddenly inoperative idea of what art should be. Critics were looking for analyzable forms, recognizable styles, but what has united recent art is not an attitude about form but an involvement with content, not style but substance. If "pluralism" is too easy, "postmodern" also has its problems, but it does indicate the dilemma.

Modern art had promised a rosy future, an endless succession of stylistic advancements. But around 1968—in the midst of napalm and dropouts and widespread disruptions—the optimistic approach of modern art, asserting faith in technology and scientific belief in purity, logic, and formal procedure, became untenable. Instead of unlimited progress and expansion, there were shortages and outages, inflation and devaluation. Instead of evolution ever onward to a utopian future, we began realizing our own shortcomings. Style no longer sufficed. Art for art's sake—the self-referential art object—was not enough. And it began to seem that the British art critic J. P. Hodin had been right when he wrote soon after World War II: "We can go so far as to say that abstraction is nothing less than an escape from life, just as Freud spoke of an escape into neurosis." The invention of man-made forms no longer held all the answers in a world that was beginning to suffer the side effects of technology. Purity was not possible in an impure world. Modernity had lied.

The schizophrenia of the recent art world resulted from a double bind: modern art, on which contemporary artists had been weaned—the only art they really knew—no longer had anything to do with reality. Whatever it said to them of form and style was meaningless

once it had been revealed that style was only an empty shell. The future they had been led to expect did not exist. All transitional moments of history must have suffered a similar disorientation.

Because the Modernists insisted on objectivity in their "nonobjective" art, they ended up with nothing but an object in a world of objects—to be demolished by post-Minimalists, banished by Conceptualists. If objects were to exist again, they would have to enter on other terms: as containers of information, metaphors, symbols, meaningful images. So art turned from the manifestos and ideologies of Modernist abstraction to more pragmatic problems of time and place, from abstract ideas and abstract art works to the natural world and human nature.

Ironically, the return to the world can also be seen as an escape. Artists may be merging their work with the discourses of life—making it natural, social, architectural, narrational, theatrical, or ornamental—but they're doing it by turning to fantasy and fiction, to imaginary worlds and private revivals. The disillusionment of the late '60s was transformed into the illusions of the '70s. The art object itself had become a fiction in a world that, littered with technological debris, became obsessed with identity, behavior, appearance, with physical and psychic survival. The mystical cults, group therapies, private mantras, fitness rituals, and disco-punk polarities of the '70s had their counterparts in an informal behavioral art that abandoned form to reveal privacies, enact rituals, expose obsessions, depict illusions, or retreat to revivalism. They were all attempts to start over and efforts to create images. The one element that unites all the scattered voices— from Pattern painters to Narrative artists and visionary constructionists—is an awareness that art is fantasy. If abstraction was neurosis, the present schizophrenia may be a more advanced state of psychosis, but it is also, literally, a survival maneuver. In a culture defined as narcissistic, it may be "the only intelligent approach."

On the other hand, the preoccupation with Postmodernism may be premature. Schizophrenia may be just another way of describing what art historians have always called the late period of a style—the simultaneous split into opposites of severity and overelaboration, the teetering between extremes that tends to follow after classic balance. It could be argued that Postmodernism is just another name for Late Modernism, and sometimes that's true. Most of the dialogue within recent art is still with the modern past, but the art tends to be hybrid

and transitional. And while revivalists, survivalists, and neo-modern cynics may all be seeking security from the past, a different sensibility is seeping in. It's the difference between analysis and synthesis, between discarding and recycling, between specialization and breaking down boundaries. It may in the end depend on technique: what's new is an amateur stance.

The '70s belongs to the handcrafted and homemade. Artists were scavenging leftovers from the industrial era and scraps from the landscape to build clumsy fantastic constructions or were embellishing their work with domestic remnants like cheap cloth and glitter—as if trying artlessly to fashion practical devices for unknown purposes or to resurrect ritual objects of a forgotten faith. Artists were becoming narrational, telling picture stories as if to keep alive the modern myths of a linear, literate, and rational world. And—constructing, ornamenting, communicating, envisioning—they were involved with contexts and social concerns. There may be a variety of personal styles instead of one style, but they were all talking about the same thing: a desire for content, a search for meaning. If we begin to realize that the unity is iconographic rather than stylistic, the confusions dissolve.

While critics who never came to terms with the '70s were predicting the '80s—unaware that the '70s wasn't a decade but the start of a major transition—we've been witnessing the death throes of Modernism and the birth pangs of a postformal, nonrational, inclusive art speaking the vernacular and brimming with allusions to life. It's pragmatic and visionary and—in transit from one reality to another—slightly crazed.

Willem de Kooning, *Untitled Painting*, 1948. The Museum of Modern Art.

3 Fifties Fallout:
The Hydrogen Jukebox

Weeell be-bop-a-lula she's my baby bebopalula ah don't mean maybe bebopalula she-e-is mababydoll mababydoll mababydoll, wails the radio insistently. "WCBS-reliving-the-best-part-of-our-lives. Life is just a dream."

There have been other recent intimations of a '50s revival. The move of the galleries to SoHo at the start of the '70s coincided with the beginnings of it. Back to the tin ceilings, rough wood, metal columns, and makeshift spaces of the Abstract Expressionists, but sleeked up and professional: the show space of the '70s was imitating the work space of the '50s. It might have been unintentional, but a newly messy abstraction also sprang up at the start of the '70s— paintings with blotted, faded, runny, stained color, with intestinal intricacies, with Hofmannesque rectangles. It was heralded as "lyrical abstraction" or as a return to Abstract Expressionism. If it was a revival, it was an intentionally vacuous one. It was a paraphrase of a '50s style—falsely calm, blank, drained of emotion. It had little to do with lyricism or with feeling. It had more to do with becoming the machine Warhol wished to be, but while his fantasies were back in the tacky glamorous '30s, the "lyrical" abstractionists (along with the singing robots Gilbert and George) had leaped into the dismal '50s, the age of apathy. Back in 1971, Nixon could seem to equal Eisenhower, Vietnam could equal Korea. But in the interim we had become detached, cold-blooded, freaked out, heartless. We had learned how to turn ourselves on or off. The programmed automaton had replaced the kindly grandfather, and an agonized Pollock on the wall at Marl-

Arts Magazine, April 1974.

borough had come to look like a vapid textile pattern. Emotionalism had become obsolete.

Except in the field of pop music, the revival was premature. The '50s is still dangerous ground—a minefield full of painful yearnings and mixed memories buried in deliberate oblivion. It hasn't spewed forth its antiques yet; its despised detritus has not yet acquired value. It is not quite far enough away to have lost its taint.

We may be ready for '50s-style boredom, apathy, and restlessness; we may be ready for the nostalgia of jukeboxes, hot rods, soda fountains, drive-ins, sock hops, and *Mad* comics. But suffering is no longer fashionable. The '50s may not have wanted to think about anything, but it did want to feel, to experience, to be absorbed by immediacy. Apathy cloaked a passionate desperation. And the crying, dancing, soul-bearing emotionalism, along with the belief in inspiration and passion and spontaneity, is as alien today as the equally desperate '50s desire for normalcy and propriety. The silent generation, the beat generation, the last drinking generation, whether probing the depths of their souls or retreating into uptight, mindless conformity, into the security of teen marriage, jobs, and babies, into alcohol, were desperately trying to shut out the world. They almost succeeded. But along with the red-blooded, clean-cut, all-American boy and the hefty, blond cheerleader appeared the drifter, the mystic, the wandering madman, and it began to seep in. The suicidal apocalyptic romanticism of Kerouac's *On the Road* or Ginsberg's *Howl*, "listening to the crack of doom on the hydrogen jukebox," made it clear: the '50s was waiting for the end of the world.

The incomprehensible idea of the Bomb had sunk into people's souls. Hiroshima and Nagasaki had become public knowledge; bigger and better bombs—made from the invisible atom, from vaporous hydrogen—were being tested. The trauma permeated the decade. Behind the good times and happy days loomed the indelible newsreel image of an incredible growing mushrooming phallic cloud over the water at Bikini, irrational and horrifying. Or the image of a flower disintegrating, shriveling into oblivion. Or the human shadow burnt onto the wall. The crumbling wall. Searing light, blinding heat, total annihilation. Nothingness was possible.

No wonder the '50s was schizophrenic. It went to extremes. Extremes of apathy and emotionalism, of seriousness and absurdity. It preached togetherness and produced alienation. Invisible unknown

dangers and new words entered the consciousness: fallout, contamination, radioactivity, megatons, mutants. Guilt and horror and fear of retribution must have had something to do with the antiseptic, sterile cleanliness of the '50s, and with the cold war terror. The stain on rationality and projected anxieties must have contributed to the McCarthy inquisition's confusing privacy with un-Americanism and equating Reds with devils. It must have inspired the straitjacket fashions. The button-down collars and back-buckled chinos, the short-back-and-sides or the slicked-down DA, the stovepipe pants and gray flannel suits—too narrow, too baggy, and too short, as if men had outgrown their clothes or grown uncomfortable in them. The baby-doll-innocent ponytails, Peter Pan collars, and white bobby socks worn by girls, or the padded bras, hobble skirts, and stiletto heels that confined women. It was fear of the chaos, meaninglessness, and absurdity that Kerouac and Ginsberg, Beckett and Ionesco, and all the coffeehouse poets were expressing that was being held in so tightly by the repressed '50s.

Don't let the stars get in your eyes, don't let the moon break your heart. It was a decade terrified of loneliness. The need to be like everyone else, to be needed and wanted, to be encompassed, protected, and absorbed, and to forget the world was expressed in the embracing space of Abstract Expressionism as well as in Cinerama, sling chairs, and enfolding convertibles with tail fins. In the midst of blacklists, loyalty oaths, and civil defense bulletins, vocal groups wailed and harmonized about love, about regrets, absence, loneliness. The words were inane, but they were stretched and compressed, stuttered, falsettoed, baby-talked, distorted into agonized and sometimes explosive sounds of torment.

In the midst of insistent normalcy the '50s quietly built deluxe bomb shelters equipped with oxygen and armed with machine guns to keep the neighbors out. *Life could be a dream sh-boom sh-boom if I could take you up in paradise up above.* Or turned corners of basements into womblike shelter areas stocked with two weeks' supply of canned food and bottled water. *Hello hello hello again sh-boom and hope we meet again.* Or made schoolchildren crouch in fetal positions under their desks during monthly atom bomb drills. *You shake my nerves and you rattle my brain, too much-a-love drives a man insane. Come on baby drive me crazy goodness gracious great balls of fire.*

There were constant reminders of what to do in case of an attack.

Turn your dial to the special frequency. Wait for instructions. The bomb could not be kept out. Its terror burst into the lobotomized inanities of the '50s like the polite drawing room recitation in Ionesco's *Bald Soprano:*

> The polypoids were burning in the wood.
> A stone caught fire
> The castle caught fire
> The forest caught fire
> The men caught fire
> The women caught fire
> The birds caught fire
> The fish caught fire
> The water caught fire
> The sky caught fire
> The ashes caught fire
> The smoke caught fire
> The fire caught fire
> Everything caught fire
> Caught fire, caught fire.

The bomb spawned the humor of the '50s, the sick jokes, the Little Willie rhymes, the moron jokes. It crept into the slang: teenagers trying to shut out the world only succeeded in "bombing around" in crowded Chevys. Abstract Expressionists shut out the world to paint the insides of their minds, but the images came out explosive, splayed and splattered over the canvas with the violence of an irrational force. They talked about "the private myth" while they tried to transform matter into energy. They admired risk and failure and despised easy solutions. The style contained large amounts of self-destructiveness and denial: the canvas had to suffer violent transformations—wiping out, covering over, continually destroying in order to go beyond. Each painting had to be a game of Russian roulette, a confrontation with the unknown, grappling with immediacy, accident, and chaos. Only now is a connection becoming visible between the mushroom cloud and de Kooning's disintegrating "Women," Pollock's tangles of debris, Still's creviced darkness, Rothko's spreading reddish glow, Gottlieb's cold orbs, or Reinhardt's absolute negation.

By the time the '50s was over, the trauma was out in the open, exteriorized and almost over. It had become a public myth. The end of the decade had come to grips with the reality of chain reactions and cyclotrons, fallout, transience and impermanence. It was accepting

the idea that only the present moment, the immediate experience, was real. The risk, violence, and destructiveness inherent in the Abstract Expressionist painting process could become actual in Happenings, in Tinguely's self-destroying machinery, in Arman's sliced objects. Art could make use of actual impermanence—it could use discarded materials, junk, rusty metal, old cardboard—and it could be disposable. *Dr. Strangelove* and *Fail Safe* could appear, and even Japan's Godzilla, Ghidra, and Rodan movies, with their obligatory scenes of crumbling buildings and panicked citizens, powerless military and worried scientists, could be seen as therapeutic allegories of atomic power. And the last of the old-style vocal groups could sing *who put the bomp in the bomp-ba-bomp-ba-bomp, who put the ram in the ram-a-lam-a-ding dong.*

Robert Smithson, *Spiral Jetty with Sun,* 1970. Collection Nancy Holt.

4 Reflections on the *Spiral Jetty*

Robert Smithson wasn't the first artist to make Earth-
works, absenting his art from the gallery space and sending it
into the wilderness, using the earth's crust as his canvas. Nor
was he the first to bring evidence of that faraway work back
into the gallery in the form of documentation. But his Spiral
Jetty *in the Great Salt Lake captured the popular imagination*
in a way that no other Earthwork did. And his documentations
were never simply documentary evidence of the artist's ideas
but were always very visibly works of art in their own right.

He called them Sites and Non-Sites. But even if the Non-Sites
were supposedly simply cross-sections of nature and samples of
sites—microcosms of forsaken spots on the earth like Bayonne,
New Jersey, and other postindustrial wastelands, quarries, slag
heaps, and dumps—they were always something more than
that. The secret: in spite of Smithson's continual insistence on
things that were elsewhere or couldn't be seen, his bins of rocks
and sections of maps were always visually seductive.

The climate of the '80s isn't conducive to documentations
of invisible, distant, and sometimes no longer existent outdoor
works. With the return of thick Neo-Expressionist paint, con-
ventional materials, and traditional techniques in the early
'80s, we began to crave tangible art objects again. The 1982
retrospective of Smithson's work made us notice its coloristic
aspects and quasi-Minimalist forms. But the passage of time
creates distortions. The bins of rocks that look so elegant and
formal now—and so Minimalist—had a very different effect

Arts Magazine, May 1978.

when they first appeared: they intruded with the impact of raw nature. And when the work of an artist like Smithson is reduced to the material objects that were only part of it, half the meaning vanishes. For the function of those objects was to expand the boundaries of art, to move beyond the diminishing returns of Minimalism by focusing art back onto the natural world.

The *Spiral Jetty* is submerged now, truly invisible; the Great Salt Lake has been rising inexplicably. When the jetty comes out of the water, and it may be some years from now, it will be white, heavily encrusted with salt crystals. Robert Smithson's work entered into natural process, taking its chances with the elements; he would have appreciated the changes wrought by time.

"I am convinced that the future is lost somewhere in the dumps of the non-historical past; it is in yesterday's newspapers, in the *jejune* advertisements of science-fiction movies, in the false mirror of our rejected dreams. Time turns metaphors into things," wrote Smithson in 1967.

Art to be seen from airplanes, to be discovered by explorers, art as part of nature: it surfaced in 1968, during a season of technology and plastics that saw the MOMA machine show, the Brooklyn Museum E.A.T. show, Whitman's *Pond*, Rauschenberg's *Soundings*. Along with Conceptualism, Earthworks absented themselves ambivalently from the marketplace, leaving behind a mixture of documentation and negation. But they insisted on the physical mass that Conceptual art avoided.

I remember one of the first pieces of Smithson's that I saw, in a Whitney Annual in the middle of that Minimal winter: a metal crate of caged rocks. It wasn't the first or the most radical sign of the new earth activity, but it was more immediate than De Maria's earthroom, Heizer's trenches, or Oppenheim's circles in the snow; it brought home the beginnings of the end for Minimalism and technology. Nature had intruded: hard, rough, intractable chunks of it, gradated by size. Carl Andre's outdoor piece in Hartford must owe something to it. Its stony silence demolished the cold man-made geometry of Minimalism. Natural form had been injected into art, as severe and immobile as a cube but nevertheless an elemental denial, straining against the confines of a metal structure. This and his other Non-Sites were

cross-sections in microcosm of the earth, with maps, photos, documentation—containers of rock, samples of sites. Yet even at the time, they looked very elegant, very much like art.[1]

Earlier, in the mid-'60s, his work had appeared Minimal, serial, geometric. But those early pieces of his—tiered, stepped, faceted, with crystalline proliferations of diminishing cubes or geometric shapes fanning out in insistent expansion—now look more like Late Minimalism before its time. They suggest affinities with Sol LeWitt's honeycombing cubes or with Jackie Ferrera's stacked pyramids. They also suggest Smithson's own future direction: geometry, in his early work, resembles geology. References to minerals, to terraced hills and plate tectonics, are latent in the stepped metal cubes and stacked steps, and in the sheets of mirror and glass tiered like geological rock strata. Often they curve and slip, straining into arcs under pressure; the desire to circle and spin is implicit in them. Into a systemic art he introduced the concept of entropy. It now seems inevitable that the forms of his earlier sculpture would become bins for rocks and gravel—rocks that would later spiral into the landscape.

Those rocks were rich in content; they could be easily mined for historical ore. They were the basic raw material of sculpture itself, and part of the earth's crust. They could recall the Late Cubist vein of Abstract Expressionism—the forms that existed in de Kooning's *Excavation.* Or the stony substance crusting over those fossilized images of Magritte. Or Giulio Romano's rocky paintings on the walls of the Palazzo del Te, mixing giants and boulders. At the ends of the pure classical style of Minimalism, a Mannerist art was appearing, inflicting destructive forces upon those balanced forms.[2] Judd's entasis could not last. Smithson's rocks, like Serra's lead, brought forth the heaviness, the inertness, the natural processes of the earth's surfaces. Art was no longer the sleek, clean, industrialized object, divorced from relationships, free of content and context—pure form. Process entered, site entered, time entered, recreating the existential conditions of art. Contexts and relationships increased the complications, like meddling relatives.

In the spring of 1970 Smithson built his *Spiral Jetty,* fifteen hundred feet long, fifteen feet wide, curling into the Great Salt Lake of Utah. It is made of mud, black rocks, white salt crystals, red water.[3] Because hardly anyone had actually seen it, it functioned as legend, bouncing off our imaginations, planted in our memories by photo-

graphs, with the magic of faraway places untouched by reality. Inaccessible, it reverberated to the ends of the art world. It was the masterpiece of earth art.

It was exhibited at Dwan that November in the form of a film. A romantic documentary, the film gives the *Spiral Jetty* a rich, allusive iconography, equating dinosaur bones and prehistoric monsters with earth-moving machinery and huge rolling rocks, alluding to vast time spans, geographic changes, species extinction, and the ponderous moving of the earth to make the spiral in the lake. Smithson saw relations and connections, cosmic and mysterious, between seemingly unrelated things; he recognized the absurd significance of stray details, weaving coincidences into patterns. He was something of a symbolist.

He became interested in salt lakes in 1968,[4] when he read descriptions of their redness. But his initial interest was not purely coloristic; it must have been colored by the science fiction strangeness. He opens an account of the making of the jetty with a quote from G. K. Chesterton about the color red: "It is the place where the walls of this world of ours wear the thinnest and something beyond burns through." The "wine-red" water was rich in metaphor for him—it was fire, blood, primordial seas.

"A mood of thermal extinction prevails. Light bulbs appear to be dying suns. Over all the remains a crimson sense of radiation," he noted for a scene in the movie, describing the Hall of Late Dinosaurs in the American Museum of Natural History in New York. The sound effects: a clock ticking, a metronome, a Geiger counter.

Smithson rejected the idea of evolution and progress; processes of disintegration and deterioration were his alternative. The landscape that he loved was one of slag heaps and strip mines, polluted rivers and dead seas, swamps and quarries and gravel pits—sites that allowed him "the romantic notion of going beyond, of the infinite." The industrial wastelands of New Jersey were in his blood. He chose to work with tar and gravel, sulfur and asphalt, stone, sand, and salt. His tools: dump trucks, front-end loaders.

The Great Salt Lake was the perfect place. "The mere sight of the trapped fragments of junk and waste transported one into a world of modern prehistory. The products of a Devonian industry, the remains of a Silurian technology, all the machines of the Upper Carboniferous Period were lost in those expansive deposits of sand and mud," he

wrote about the site he chose, near Rozel Point. "A great pleasure arose from seeing all those incoherent structures. This site gave evidence of a succession of man-made systems mired in abandoned hopes." He described the desolate desert site, with its shattered appearance, its deposits of black basalt and networks of mud cracks, as "an immobile cyclone," "a rotary that inclosed itself in an immense roundness," a "gyrating space."

If the jetty's spiral form was suggested to him by the site itself, the spiral was a metaphor that echoed everywhere. There were legends of a huge whirlpool somewhere in the lake, connecting it to the Pacific. The film begins with an irresistible vortex image: the road ahead being gobbled up by a moving vehicle, the road behind being spewed out with dust. It ends with circling helicopter shots of the *Spiral Jetty*— sun reflecting in the camera lens, voice reflecting on the spiral construction of the sun, of galaxies and nebulae, of salt crystals. "And each cubic salt crystal echoes the Spiral Jetty in terms of the crystal's molecular lattice. Growth in a crystal advances around a dislocation point in the manner of a screw," Smithson explained in his writing. "For my film (a film is a spiral made up of frames) I would have myself filmed from a helicopter (from the Greek *helix, helikos,* meaning spiral) directly overhead," he wrote. "The water functioned as a vast thermal mirror. From that position the flaming reflection suggested the ion source of a cyclotron that extended into a spiral of collapsed matter." It reminds me of what Charles Fort, Dada scientist, collector of inexplicable facts, and another disbeliever in Darwin, called (in his *Book of the Damned* in 1919) his "sanatorium of overworked coincidences."

Smithson didn't mention DNA and the double helix, but then, he aligned his art with geology, not biology. James D. Watson's *Double Helix,* published in 1969, was absent from his extensive library. Nevertheless, those recently discovered spiral building blocks of genetics were receiving a great deal of attention at the end of the '60s, and the ideas in the air must have reinforced his own inclinations toward the infinitely coiling form. His designs for spiral paths, hills, bogs, and ramps proliferate from 1970 on. As for the Zeitgeist, the defoliation of Vietnam, with its changing of the terrain, and the back-to-nature movement of counterculture communes in remote places both received media attention in the late '60s and could well relate to the development of Earthworks.

If the *Spiral Jetty* (crusted with salt, its water silvery and mirror-like from the air) echoes the materials of his Mirror/Salt pieces shown the previous year at Cornell, it also reflects the forms of the instant monuments Smithson made in Passaic in 1967 with an Instamatic. The same fascination with water, circularity, and extension along the water's surface can be seen in the rotating bridge that became *The Monument of Dislocated Direction* or in the pumping derrick that he christened *Monument with Pontoons*. "As I walked north along what was left of River Drive, I saw a monument in the middle of the river—it was a pumping derrick with a long pipe attached to it. The pipe was supported in part by a set of pontoons, while the rest of it extended about three blocks along the river bank till it disappeared into the earth." About that visit to Passaic, he also noted: "Since it was Saturday, many machines were not working, and this caused them to resemble prehistoric creatures—mechanical dinosaurs stripped of their skin." Elsewhere he described "grim tractors that have the clumsiness of armored dinosaurs." Another of his Passaic monuments was a sandbox. It suggested to him "the sullen dissolution of entire continents, the drying up of oceans."

At the same time that Smithson was making his *Spiral Jetty*, Newton Harrison was doing his brine shrimp farm. The two artists met at the Spring Street Bar. Harrison tells an apocryphal story: "I told him 'hey look the water turns red doesn't it?' And he said 'yes, it does.' I told him 'hey then it turns clearer doesn't it?' He said 'yes it does.' I said 'it's the algae dunalliela,' I said 'look maybe it's because the brine shrimp have just eaten it.' I proposed that I live off his jetty and harvest brine shrimp. He got very offended. It delineated our opposition to each other. He apparently wasn't willing to let the purity of his work be compromised."[5]

A basic misunderstanding. "The earth to me isn't nature, but a museum. My idea is not anthropomorphic," Smithson has said. He said he was interested in matter, not nature. And what may look like purity now seemed impurity then. "Ambiguities are admitted rather than rejected, contradictions are increased rather than decreased—the *alogos* undermines the *logos*. Purity is put in jeopardy," Smithson wrote about the jetty.

Endings and beginnings: Smithson's *Spiral Jetty* is pivotal. Looking back, one can see it as the culmination of a decade in which art was a powerful object in the world. Relocating tons of rock, reshaping

the earth's crust as sculpture, using Bucyrus-Erie as a chisel, it had the sheer nerve of the '60s. Morality was not yet an aesthetic issue, and it cost only nine or ten thousand dollars. It also spun into the future, opening a very different decade. Its bizarre and flexible scale (which, he noted, "tends to fluctuate depending on where the viewer happens to be"), its insistence on the element of time, and its extreme fantasy are aligned with what has been happening in the '70s as art has been mimicking nature's processes and forms, informality and formlessness. It is interesting that in the early '70s, during a time of "naturalistic" painting, Earthworks evolved into a visionary sculpture that disguised itself as architectural collaborations with the landscape—and is now being called land projects. It is also interesting that its beginnings were literal and anti-illusionistic.

In the spring of 1968 there was a perfectly timed exhibition of eighteenth-century French visionary architectural drawings at the Met. With their eccentric geometry and sense of the infinite, Ledoux's saltworks, Boullée's spiral towers, and other bizarre structures with sulfurous fumes and flowing waters must have struck a sympathetic chord with the emerging earth artists, and may well have had a liberating effect on their work.

In its awareness of temporality and duration, Smithson's work also anticipated the new narrative sensibility. His writings are narrative adjuncts to his projects; in fact, they sometimes *are* the projects. With a sense of ruin, decay, fatigue, and ironic humor, he described journeys through Dantesque landscapes, Kafkaesque dreamworlds. He read widely, from *Mad* magazine to Jung's treatise on alchemy, referred to scientific texts, science fiction, and the daily newspaper, quoted Samuel Beckett, Nabokov, Poe. He spoke of rubble and sediment, and cited Pollock's pebbles, Yves Klein's cinders, Dubuffet's ashes, as geological artifices. "Oxidation, hydration, carbonization, and solution (the major processes of rock and mineral disintegration) are four methods that could be turned toward the making of art," he wrote. He shifted art history into another time scale and came up against natural history. In his own words, "the gardens of history are being replaced by sites of time."

NOTES

1. It was appropriate that *Non-Site #1* consisted of containers of sand from the runways of an airfield in New Jersey: the idea of his Sites and Non-Sites developed out of the earth mounds and structures that he proposed as artist consultant for an airport in Dallas in 1966. One of those proposals was a square asphalt spiral.

2. In Smithson's drawings for projects there is a recurrence of oozing, pouring, overflowing substances and collapsing forms. His concern with the mutability of form, the tension of his arrested processes, and the inherent contradictions that were part of his "dialectic" are all elements that can be traced in Mannerist art. The incomplete circle, like the cascade of asphalt in Italy or the partially buried woodshed at Kent State, its cubic structure overwhelmed to the point of collapse by a mound of earth, is a Mannerist conceit. So is his convoluted prose.

3. It's time to give Smithson his due as a colorist. His pencil drawing of a barge filled with sulfur gives no clue to the brilliant lime color of that substance, but in photographs of pieces he made, we can see the vivid orange of the glue he poured down a hillside or the indigo of asphalt spilling over a pinkish cliff. The white-on-white coloration of *A Non-Site, Franklin, New Jersey* seems proof of Smithson's attention to color: its white rocks contain minerals, calcite and willemite, that glow red and green under fluorescent light.

4. Other earth artists were drawn to desert salt lake sites around the same time. Heizer and De Maria had both done early works on dry lake sites in the western desert. Oppenheim's 1969 *Salt Flat* involved a shallow rectangular excavation in Salt Lake Desert and a matching rectangle of salt on the asphalt of Sixth Avenue in New York.

5. Later their work converged once again. In 1972 Smithson went to the Salton Sea, another dead salty lake in the West. He must have liked its entropic origins: a man-made accident of nature, it was formed early in this century as a result of flooding from a mammoth irrigation accident. He wanted to make a work there, a ramp, but was thwarted by lack of funds. It was the site, a couple of years later, of Newton and Helen Harrison's Fourth and Fifth Lagoon, works that exist in proposal form.

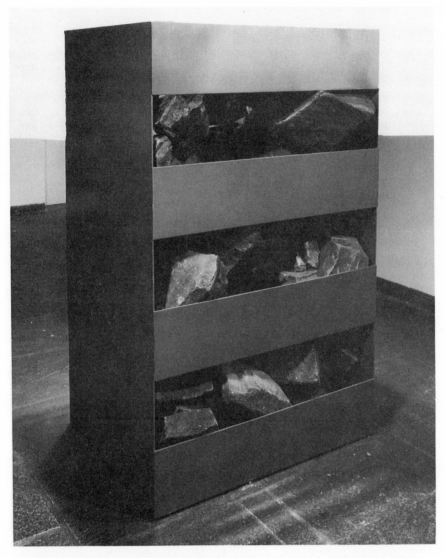

Robert Smithson, *Non-Site (Palisades, Edgewater, N.J.)*, 1968. Collection Whitney Museum of American Art.

Lucas Samaras, *Floor Piece (in 16 parts)*, 1961.

5 Eros, Samaras, and a Decade of Purity

> It is well for society that we do not know all the phanta-
> sies which accompany, consciously or half consciously,
> or unconsciously, every erotic indulgence.
>
> Wilhelm Steckel, *Autoeroticism*

> To put it simply, I make things to seduce myself. To put
> it differently, art is a dialogue between artists.
>
> Lucas Samaras, April 1964

*In the 1960s, when Lucas Samaras was exploring in-
timacies and outrages, his art was accused of being obses-
sional, eccentric, narcissistic. It was necessary, in the early '70s,
when this piece was written, to point out the intellectual basis
of his revelations of privacies, to insist on his dialogue with
Minimalism and on his deliberate use of psychological content.
Later in the '70s, when identity and survival—physical and
psychic—began to be popular issues and his art became an
unavoidable influence, Samaras, always contrary, started to
photograph other people's bodies instead of his own and to
make big fabric patchwork "Reconstructions" that were sleek
and abstract, conforming to the large scale, rectangular for-
mat, and flat picture plane of conventional modern painting.
They were sumptuous mockeries of the grand ideologies of
abstract art.*

In 1959, as part of his senior honors project at Rutgers, Lucas Samaras
presented a poem consisting of a centered square made of the word
"fuck" printed over and over hundreds of times. The poem ended with
a solitary "you" protruding from the corner of the square. This frontal
attack against the purity of Albers's squares as well as against propri-
ety marked the beginning of Samaras's ventures into forbidden ter-
ritories.[1]

A procession of intimate messages to the world threads through

Arts Magazine, December/January 1973.

his work. Repeated tiny "I love you"s dot an early announcement, echoing the square format of the poem. An ambivalent love-hate message swirls across a 1961 drawing as a page of writing is rendered frustratingly illegible by the word "love" scrawled repeatedly over it. "Lucas loves," "Lucas is dead," "love me," reads rainbow spaghetti lettering on drawings made in 1962. His work always demands a strong intimate relationship with the spectator; it draws the viewer in, by seduction or threats. It makes him a participant, an accomplice, an intruder, a victim. Samaras's boxes open and close, hiding and revealing their contents, asking to be touched, threatening to hurt. In 1964 Samaras lured the spectator into his tiny cluttered bedroom, re-created at the Green Gallery, and in 1966 trapped him in the dream-like endless space of the Mirror Room. In his recent Autopolaroids he plunges the viewer into his most intimate fantasies, actions, and bodily processes.

Everyone has noticed the pervasive sexuality, the menacing eroticism of his work, its "obsessive-compulsive" repetitions, and its obvious Surrealist antecedents. But in the process of its threats and seductions, its dialogue with contemporary artists has gone unremarked.

One of the strangest fantasies that some of Samaras's recent work contains is its mimicry of Minimal, its dream of geometry. Like Minimalist objects beset by nightmares, encrusted with desires, yearning for ecstasy, his boxes or chairs often seem to parody other artists. But these mocking references are clues: they point to his own past as well as to art history. The formal mainstream concerns of the '60s were always a strong undercurrent in Samaras's work. The fact of its squareness was basic to that early poem. Samaras, along with Judd and Morris, showed at Green in the early '60s. Though his affinities with the Expressionism of Kaprow, Segal, Oldenburg, and Whitman may be more obvious, his rejections of the past coincided as often with those of the budding Minimalists. From the beginning, he shared a Formalist concern with basic geometric structure and a literal attitude toward his materials.

His rectangular liquid aluminum and Sculpmetal wall pieces of 1961, mute, gray, and barely noticed at the time, were nonverbal attacks on the square. And by the square: a long straight pin sticks out of the center of one of them at eye level, another assault on the spectator's inviolability. In others, the rectangle itself was deformed by being curved out from the wall, or it was disoriented—elongated

and set diagonally, with vertical striping emphasizing the deliberate shift, and a razor blade as a sinister center axis. Samaras also took the rectangle off the wall and laid it down flat on the floor, making a large square "rug" in sixteen parts, vulnerable to being stepped on yet protected by its prickly Sculpmetal surface.[2]

In these pieces, the wriggled stripings of the liquid aluminum, squeezed directly from the tube like toothpaste, and the rough dabbed impasto surface of the Sculpmetal exploit the gesture inherent in the substance: each is the most direct and simple way of applying the particular material. Whatever substances he has used are used literally, without violating their natural properties. Only by repetition do pins, yarns, or mirrors accumulate into a fantastic surface covering.

Carrying on an oblique dialogue with Minimalism,[3] Samaras diverged in placing Formalist structure and literalism at the service of dreams, fears, and desires—at the service of psychology.[4] And in the mainstream tradition since Abstract Expressionism, psychology had been inadmissible. Yet in doing this, he made his work important to post-Minimal art,[5] with its psychological, organic, and bodily references.

Only on closer look did the square of that early poem separate into a repeated readable obscenity. Samaras's art more than most reminds us that like other manifestations of human culture, art has its origins in sexuality sublimated, in love redirected and hostility rechanneled. It also reminds us that sexuality, as well as being a source of creativity, can be part of the iconography, or of the formal vocabulary.

Psychosexual iconography in the traditional form of metaphor, exploited by the Surrealists' explorations of the unconscious through a Freudian dream symbolism of phallic shapes and female receptacles, went out of favor with the entrance of Minimal literalism.[6] "The narcissism typical of the Rivers-Rauschenberg generation"[7] led to the direct use of the body, with the exception of Oldenburg, who carried the metaphor a step further: in his work it is not only shape that determines sexuality, it is phallic mechanics—having to do with possibilities of action or position, and transformations between the hard and the limp.

The literal use of specific body parts in the form of casts, impressions, imprints, photographs, and actual bodies traces back to Duchamp's "erotic trilogy"[8] of 1951, to his much earlier photographs as woman and satyr, and also to Pollock's handprints. The tradition is

Formalist: most recent use of the artist's body has been matter-of-fact, abstract, and antierotic. From Johns's plaster casts of body parts and his skin-print drawings and Morris's early negative impressions in lead to Nauman's wax casts of body sections and measurements, the body has been treated as an abstract object—sectioned, depersonalized, devoid of any function other than to serve as a tool, template, or mold. Morris's *I-Box*, with its frontal-nude photograph grinning behind its little door, is as straightforward and impersonal as Duchamp's clothed and composed female self, or Nauman's *Portrait of the Artist as a Fountain*, or even Acconci's "concentration" on a part of his own live body by means of a simple repeated activity. Or Kaltenbach's cold-blooded use of the ashes of his amputated toe to glaze a small pot.

Samaras early let his live body be used as a medium by other artists, participating in the Happenings of Kaprow, Whitman, and Oldenburg,[9] and acting as model for several of Segal's early figures. He also used it himself: tinfoil molds of his hands and face, cast epoxy fingers, outlined hands and profiles, photos and x-rays of his head, recur in his work. In his recent series of Autopolaroids, his body is again the medium, but to see his use of it in these Polaroids as ultimately physical literal "self-portraits"—explorations, like Nauman's, of his facial expressions, his nipple, his navel, his penis—is to miss half the point. He is exposing bodily secrets less than he is unearthing erotic fantasies left over from childhood.

There is a basic difference between his work and that of the Minimal-oriented artists who are using their own bodies: even when their iconography is explicitly sexual, it is still fundamentally antierotic. When Morris did a naked dance with Yvonne Rainer, their bodies were pressed together, but the overtones were of concealment rather than eroticism. Nauman, who had done a videotape of himself in the activity of walking and bouncing rubber balls, made a film in 1970 called *Bouncing Balls*, " . . . only this time it's testicles instead of rubber balls. Another one is called *Black Balls*. It's putting black makeup on testicles,"[10] he said. These activities were eccentric but no more erotic than bouncing a rubber ball. Acconci in his 1971 film *Conversions* tugs at his breasts, burns hair from his chest, and hides his penis in a literal translation of Duchamp's female transformation.[11] But even as the work of Nauman and Acconci becomes more specifically sexual and psychological in nature, it remains based on

the Minimal ethic and aesthetic, retaining a puritan revulsion for the body which leads to masochistic violations. The paucity of the visual in their work is a denial of pleasure: it is sometimes hard to distinguish between prudery and emancipation. Samaras's 1969 film, *Self*, [12] while never exposing private parts, transferred erotic pleasure to the objects touched by the body, shamelessly recapturing the childhood eroticism of looking and touching.

Characterizing infantile sexuality, Freud wrote, "We have hitherto emphasized the fact that it is essentially autoerotic (he finds his pleasure in his own body)."[13] In Samaras's Autopolaroids and in Acconci's *Seedbed,* masturbation is part of the content. Both works have some shock value, for autoerotic acts have not yet become socially acceptable to the layman, in spite of Kinsey's statistics or Steckel's findings that "non-masturbators are exceptional. I have encountered a few cases of this type. They were extreme neurotics."[14]

Acconci, invisible, secreted under the ramp floor while unseeing spectators trampled overhead, spent time in "a private sexual activity," as he worded it with Victorian circumlocution. Loudspeakers exposed his secret shameful act. Point 4 of his plan stated: "My aids are the visitors to the gallery—in my seclusion, I can have private images of them, talk to myself about them: my fantasies about them can excite me, enthuse me to sustain . . . ," making it sound as if his "private sexual activity" were punishment or martyrdom.

For Samaras, the same activity is not shameful but, like eating and excreting, a normal body function. In his Polaroids he hides neither his body nor his fantasies, which, bizarre as they may look, are the basic ones of psychoanalytic literature, the most widely recurring of infantile fantasies: fantasies of parental copulation, known to analysts as "primal scene" fantasies, fantasies or fears of castration, and fantasies of returning to the womb. Samaras's content, like his use of materials, delves down to the most rudimentary level.[15]

"The primal scene schema is characterized by an identification, which can be either simultaneous or alternating, with both principals in a sadomasochistically conceived sexual act," according to psychoanalyst Henry Edelheit,[16] who has traced the origins of the Oedipus complex and many myths and rituals (including the Crucifixion and the bullfight) back to the primal scene fantasy. "The regressive effect of the nursing impulse is also responsible, I believe, for the frequent occurrence in primal scene fantasies of androgynous, hybrid and

composite forms, representing fusions of man and woman, mouth and breast, mother and child."[17]

Samaras's work has always contained an imagery of fusing and doubling, from his early twin plaster-and-rag dolls to his recurring use of mirror, or the two Autointerviews in his *Album* of Polaroids. Boxes and books are single forms that split open, doubling and halving themselves in the process. Besides his obvious use of primal scene imagery in double-exposure Polaroids of himself embracing, seducing, and copulating with himself, other Polaroids depict transformations of parts of his body into the shapes of female parts, of his face into female faces, of hand into foot, torso into penis, or penis into tongue, as well as fusions of face with buttocks or other parts.

Along with multiple exposures, "androgynous, hybrid and composite" body parts, crucifixions, pietàs, and angelic dreamers, are Polaroids suggesting Samaras banqueting on his own body. Oral gratification fuses with the threat of castration just as in his early work razor blades and splinters of glass often substituted for food. His nude torso at table, with knife and fork, is equated to a face—nipples for eyes, navel for nose, and penis-tongue—about to feast on itself. Or it is juxtaposed with a threatening shiny knife, a melon with a missing wedge, or an oozing wedge of tomato. Or a candle threatens the phallus or substitutes for it; its flame can be the threat or the sperm. "The aggression which is mixed with the sexual instinct is, according to some authors, a remnant of cannibalistic lust," noted Freud.[18] Edelheit has recently proposed that "banquet fantasies form a special class among oral transformations of the primal scene."[19]

Other Polaroids of his embryonic nude body, curled up and contorted in elaborate contrapposto, paraphrase the Sistine sibyls while enacting the return to the womb, bathed in a fluid red and green glow. There are the several stages of the fetus; there are foreshortened views down from the head, shrinking away to tiny feet, and views up from the feet that turn the body into a rubbery tadpole by means of perspective distortions. Boxes and rooms relate to womb fantasies. Part of the aura of the forbidden about entering Samaras's Rooms may lie in the fact that rooms, as well as being Expressionistic cubes, are Freudian receptacles: besides being embryonic, the whole body, inserted into a room or corridor, becomes phallic.

While Samaras uses traditional psychosexual metaphors and literal body parts, the eroticism of his work resides more in purely

abstract surfaces and textures—not commonly understood as sexual at all. But the eye is an erogenous zone, an organ of sensory satisfaction. Looking equals touching: the surface of a work can be read as a substitute for skin. The quasi-erotic quality of surface-as-skin passed from the Abstract Expressionist agitated physical skin of paint, particularly Pollock's, to Johns's touchy skins of gray and the denial of Morris's blank gray surface (which Samaras refers to as "boudoir grey"). Rauschenberg's *Bed* equated the paint skin with the skin covering of the bedclothes, and in hanging paint-spattered bedclothes on the public wall, exposed a resemblance between Pollock's skeining and sperm as well as exposing the privacy of the artist's bed. Samaras emphasized the sensation of touch by exaggerating the surface excitations. His prickly gray Sculpmetal surface, his encrustations of pins or jewels, his stripings of soft yarn, his felt-pen dottings on some of the Polaroids, are scratches, pinches, caresses.

If surface equals skin, and texture equals surface friction or excitation, it is equally possible for repetition within a work to relate to the repetitive motions of the sexual act. If repetitive thumbsucking, rocking, swinging, even the motion of a railroad train, are sexually exciting to the child, as Freud and company claim, repetitive surface forms may well serve the same function in art. The pervasive role of repetition in the art of the '60s, in addition to serving as a formal device, may be seen as an element of psychosexual content. In Nauman's bouncing balls or Acconci's attentions to himself, the erotic aspect may well be in the repetitive form of the work rather than in the bodily content. What has been referred to as pleasure-inducing craftswork in the work of Samaras—striping, cutting, any mechanical action repeated mindlessly—finds a precursor in the repetitive formal concerns of the '60s, but, oddly enough, when Stella or Noland used repeated striping, when Warhol covered a canvas with Coke bottles, when Judd made rows of cubes or LeWitt covered a surface with countlessly repeated lines, no one called it obsessive. In that early poem, the word "fuck" was repeated over and over, line after line, its insistence demanding recognition of its formal repetition as well as its expressionistic content.

NOTES

1. It also marked the end of Allan Kaprow's career at Rutgers. Samaras's professor, he left the school amid a furor caused by display of the poem. Shortly afterward, he began doing Happenings.

2. Judd reviewed Samaras's 1961 show for *Arts Magazine*, concluding, "Samaras' work is messy and improbable, as well as exceptional, and should present a general threat to much current cleanly dullness." He didn't mention the floor piece then, but he remembered it ten years later while talking about sculpture without a base (John Coplans, "An Interview with Don Judd," *Artforum*, June 1971).

3. For example, his Mirror Room, built of square panels of mirror, or the illusion within it, has affinities with LeWitt's open modular structures, Judd's wall of deep cubic compartments (shown at Castelli in 1968), Smithson's speculations on the cross-section and the infinite. Besides his rectangular pieces and his early use of the cubic form of the box, Samaras had made, in 1964, numerous small cubes of translucent plastic and silver Mylar. These split apart in systems of blocks and diagonals, or were pared down to open cubic frameworks; corners, steps, tiers, pyramids resulted as cubes were quartered, sliced, or bisected in different ways.

4. If Samaras's art resembles self-analysis, this relates more to the artistic heritage of Surrealism and Abstract Expressionism than to therapy. His use of psychology is less case study than treatise; he is well acquainted with psychoanalytic theory and has read widely in the literature. He often discusses the latest developments with his friend Henry Edelheit, a psychoanalyst.

5. Some of Eva Hesse's work done shortly after seeing Samaras's *Box #3* at the Whitney in 1966 shows the influence of that piece. The Mirror Room was an acknowledged influence on Kaltenbach's designs for rooms, and the perceptual confusions of Samaras's mirrored corridors may be significant to the development of Nauman's corridors.

6. As Ortega y Gasset has written, "The metaphor disposes of an object by having it masquerade as something else. Such a procedure would make no sense if we did not discern beneath it an instinctive avoidance of certain realities." Metaphorical sexuality, transmitted through Matta and Gorky, was absorbed from Surrealism into Abstract Expressionism, but in the transition it was immersed in the search for identity. It was apparent more in the machismo of the artists' life-style than in their paintings, though there lurks more than a tinge of sublimated sex in their painting process and thrusting brushstrokes, and in Hofmann's professorial push-and-pull theory. More direct manifestations of sexual iconography began to surface in the late 1950s: the aggressive reappearance of the nude in de Kooning's "Women" (the figure as a sadistic encounter), in Larry Rivers's mother-in-law (a hostile gesture that presaged his later female nudes with coldly labeled anatomical parts), Rauschenberg's *Bed*. The commercial sex symbols of Pop Art took the form of bodies as well as metaphors. Though metaphor generally went out of favor in the '60s, the direct use of the body avoided other realities. And of course, body parts can also function as metaphor; in Samaras's work they often do.

7. Nicholas Calas, "Wit and Pedantry of Robert Morris," *Arts Magazine*, March 1970.

8. Apparently cast from the female groin but in reality modeled by hand.

9. Samaras never did a Happening of his own; it is possible, however, to read the stories that he wrote at the time—"Shitman," "Killman," "Dickman"—as scenarios for imaginary Happenings, going to extremes not possible in an actual production.

10. Willoughby Sharp, "Nauman Interview," *Arts Magazine,* March 1970.

11. Samaras's 1965 *Box #38* (the Hermaphrodite Box) dealt with the same transformation, recalling Freud's statement: "a certain degree of anatomical hermaphroditism really belongs to the normal. In no normally formed male or female are traces of the apparatus of the other sex lacking. These either continue functionless as rudimentary organs, or they are transformed for the purpose of assuming other functions."

12. Photographed and edited by this author.

13. In his *Three Contributions to the Theory of Sex.*

14. Wilhelm Steckel, *Auto-Eroticism: A Psychiatric Study of Onanism and Neurosis* (New York: Grove Press, 1950).

15. His early stories, which provide the sources for much of his visual imagery (including that of his early pastels and his recent Polaroids), dealt with the basic body processes of eating, excreting, and ejaculating, and the basic infantile fantasies. In "Pythia" he explored womb fantasies; "Shitman" deals with anal fantasies; "Killman" is a compendium of cannibalistic oral fantasies; and "Dickman," of phallic fantasies.

16. Henry Edelheit, "Mythopoesis and the Primal Scene," *The Psychoanalytic Study of Society,* vol. V (New York: International Universities Press, 1972).

17. Ibid.

18. Freud, *Three Contributions.*

19. Henry Edelheit, "The Groaning Board: Banquet Fantasies and Their Relation to the Primal Scene," unpublished, 1972.

Eva Hesse, *Accession III*, 1968. Museum Ludwig, Cologne.

6 Eva Hesse: Notes on New Beginnings

This essay was published before the work of Joseph Beuys had become known in New York. Since Eva Hesse had lived in Germany at the time of Beuys's Fluxus performances, she must have been familiar with his work. In retrospect, it's clear it was an influence on the development of her work.

The Guggenheim Museum is an ideal environment for Eva Hesse's sliding monochromes of gray, her circular windings of string, her lucid glistening warped trays and receptacles, straggling ropes, dripping icicles, and gossamer webs. Her work triumphs over the architecture's antagonism to painting and sculpture—perhaps because of its hybrid character but more likely because the modular, serial absurdity of the exhibition space is matched in her work, as is the pale, monochromatic light. Or because the sloping, spiraling ramp and the unraveling course of her art both refuse to submit to the strictures of right-angle logic.

Eva Hesse studied with Albers at Yale in the late '50s and also absorbed the Abstract Expressionist aesthetic predominant at the time. She lived for a while in Germany, and on her return to New York in 1965 became intimately involved with the developments of the late '60s. Though her career was cut short by death in 1970, when she was thirty-four, she managed in five years to produce some work important not only in itself but for its influence: for showing that the way out of Minimalism could lead not only to further reductions—to Conceptual and Process art and theory—but also into unexplored private areas of feeling.

Art News, February 1973.

Her work has a delicately organic quality, hinting abstractly at tenuous marine life—nets, barnacles, jellyfish, eels, Sargasso seaweed; wistful and comic, it also evokes the excremental and the edible. And there is even something gruesome about it: it often suggests flesh and guts, surgical remnants, bombs with fuses, primeval traps. The wormy extrusions, waxy tubes and trays, rubbery molds and wafers, are like anthropological displays of excavated artifacts, wet and sticky, fossilized, purpose unknown.

It is not just that the traumas of Eve Hesse's life and the tragedy of her death have layered her work with morbidity, as have certain critical writings which exploit this pathos; her work itself has the power to inspire unease, wonder, even disgust. For she was piecing together a new kind of Expressionism, abstract and Minimalist in form.

She was attracted to extremes: "It was always more interesting than making something average, normal, right size." Her work relates oddly to the wall, the floor, the ceiling. It is hung too high or too low, dangling, propped, or jutting out. It is also expandable, enlargeable. She thought of her pieces as exceeding their own limits, as being unreasonable and, in the existential sense, absurd.

If the failure of logic is intrinsic to their plan, structural failure is inherent in their materials: papier-mâché, rubber tubing, twine, wood shavings, rubberized cheesecloth, latex, and fiberglass. These curious substances are layered, wrapped, covered by each other—cord is bound by string, wire is wrapped in cloth, wood shavings coated with paint, rope iced by fiberglass. All kinds of imperfections remain within their transparencies.

The forms of Minimal art are rational, literal, reductive, and formal; Eva Hesse's work starts out tightly bound and coiled, and unravels to become the antithesis of Minimalism. The allusive, the informal, and the unformed win out, insisting on everything Minimalism denied.

Much of post-Minimal sculpture is about the collapse of the upright rectangle under the force of gravity—an intellectual battle between form and formlessness. But Eva Hesse was not really exploring formal questions; rather she was using them to express something else. In her work the rectangle is involved in a visceral struggle with inchoate forces from within. Her geometry, never strict, is always subject to fatigue. It is warped, squeezed, stretched, and twisted under

the stress of the substance being formed. It is threatened and finally overcome by natural forces, primordial chaos—antimathematical, unmeasured, irrational—by the tangling, skeining webs that hang alone. Standing halfway between her unstable Minimalist geometry and her later dissolution of it, a piece like *Laocoön* is a cubic ladder (like a renegade, crusted fragment of one of LeWitt's structures), rendered helpless by looping, heavy rope—thick enough to moor a ship—snaking around it, threatening to annihilate the structure in its embrace.

This memorial exhibition spans the years from 1965 to 1970, beginning at the height of Minimalism's ascendance and the beginning of Eva Hesse's dialogue with that dominant style. The seriality, modularity, and grid structure in her work clearly derive from Minimalist principles; but less obvious precedents were a more important background.

It should be emphasized that the group shows in which her work was first seen, "Abstract Inflationism and Stuffed Expressionism" (1966, Graham Gallery) and "Eccentric Abstraction" (1967, Fischbach Gallery), were not so much reactions to Minimalism as a simultaneous countercurrent—a parallel, subsidiary development. This perversely expressionistic, impure line of development—initiated by Kaprow, among others—shared certain characteristics with Minimal art without ever totally disinheriting itself from its Surrealist and Abstract Expressionist ancestry. Some of the stylistic characteristics of what is now being called post-Minimal are a continuation of that Expressionist element from the early '60s that was suppressed in both Pop and Minimal art. When Eva Hesse's work absorbed Minimalist principles, it was to adapt them to this other vision. And when Abstract Expressionist qualities are found in her late work, it should be remembered that she, and many of the other artists in whose work these resemblances have surfaced, were students during the late 1950s, trained under the dictates of Abstract Expressionism. Albers was not her only teacher.

There are obvious influences from Jasper Johns in her early work. In addition, her biomorphism can be traced to Oldenburg and her psychological intensity to Samaras; her skeining line refers back to Pollock. All of this has been commented on elsewhere. But there were also Duchamp's web, Kusama's accretions, Paul Thek's meat.

It is not so much originality of form that animates her work as it

is her psychological manipulation of the type of abstract forms that were previously strictly objective and Formalist. Her originality lies in the way she imbued simple Minimal shapes with emotional power. Comparing her 1967 *Accession* boxes—perforated cubes, laced with flexible plastic tubing cropped short on the inside—to the cubes of Minimalism demonstrates her sensory expressiveness. But a comparison with Samaras's expressionistic *Box #3*, 1963 (which she saw in 1966; her strong reaction to it has been quoted) reveals much about the nature of her own kind of Expressionism. While the Samaras box bristles and prickles with an external covering of pins, Hesse's concentrates its tactile sensations on the shaggy inside surface. Samaras's surface is dry, brittle, sharp; Hesse's is pliable, flexible, wavery. His is reflective, sparkling, casting external light back in sharp points. Hers, translucent, absorbs the light, diffusing it in a soft internal glow.

Robert Morris's gray objects of 1963–64, some with hanging ropes, would seem to have provided clues to her too, as would his nine plexiglass units of 1967. But in contrast to their cubic regularity, Hesse's nineteen plexiglass cylinders of 1968 and her *Tori* of 1969 are vulnerable and random—more like Oldenburg's giant french fries and giant fag ends. Oldenburg's shapes, however, are full, stuffed, closed, while hers are empty, hollow, open. Her work looks pliable, but it is not often actually soft or limp.

The work of both Oldenburg and Samaras has qualities sometimes considered feminine; however, comparison brings out the more fundamentally female nature of Hesse's work. All three artists have in common a use of substances—tactile surface coverings—that suggests skin. The abstract associations of these surfaces with the human body might be thought of as a nonrepresentational equivalent of Body Art. Hesse's work also has affinities with primitive art, which often is embellished with tactile coverings, or fragile organic strands of raffia, hair, string, hanging from a solid form.

While Hesse's work often seems to absorb nourishment directly from specific pieces by other artists, as if by osmosis, to sustain its own emotional demands, the result is totally personal. The coherent development of her work and the consistency of its growth are striking.

When the eccentric forms of her earlier work met Minimalism, in 1965, a basic repeatable unit, with three parts, evolved: it consisted of

the grid, the circle within the grid, and the center point of the circle. More than a motif, it is pervasive and fundamental to her work. If this form is extended into space, the circle may become a hemispherical mound or a cylinder, the grid a series of traylike partitions, and the point a dangling thread, string, or rope. Any of the three elements may be omitted altogether, or may project itself to become a complete work in the absence of the others. Her pieces are all variations on these elements; their development is, simply, an expansion and extension of their possibilities and alternatives, carried to extremes.

The narrow *Ishtar,* 1965, can serve as prototype, with its progression of accumulating stringy rubber tubes hanging from the centers of two rows of hemispherical mounds, descending in increasing thickness and darkness to be cut off all together. By the next year, in *Ennead,* the mounds have increased in number and diminished in size; the rectangle has spread to classic proportions, and the orderly progression of the hanging strands gradually runs wild, ending as an uncut tangled skein dangling to the floor and then looping across a corner to fasten onto another wall.

By 1967 a single row of large mounds drops evenly spaced lengths of cords to the floor—or, in *Constant,* the mounds have vanished and many short lengths of tubing emerge from the thick, square slab, evenly cut and knotted at both ends. The *Accession* boxes can be seen as a closed three-dimensional elaboration of the shaggy *Constant.* The nineteen hollow cylindrical containers derive from the circle, while the greenish ice-tray cubicles of the *Sans* pieces explore the grid; the rolled square sheets of *Tori* strangely combine the two, making a sagging heap of bulbous split-open discards.

Or, retaining its flatness, the rectangular grid unit—as a curling, draping thin orange skin—can be nailed flat to the wall. It can be stacked; it can be joined end to end to snake out across the floor or, held up by ribs, can curtain across a wall. By 1969 and *Contingent,* it hangs in a row of taut, irregular sheets like glutinous drying skins.

After that, the viscous sinews of fiberglass dangling in space or stretching from the ceiling and accumulating on the floor can be seen as versions of the central string, detached from its support, attenuated in space. *Right After,* the delicate complex web of looping transparent threads caught by fishhooks, looks back to the tangle of *Ennead;* a later, dark and heavy rope version is even more irregular and snarled,

a menacing giant net that reaches to the floor. And in her seven L-shaped poles, the dangling element, gauzy yet rigid, stands erect by itself.

Compellingly allusive yet insistently abstract, Eva Hesse's work searched for a new way to express wordless emotions. It created, from the futility of logical structuring, a fragile beauty and wry humor out of inchoate uncertainty and dumb anguish. Bypassing meaning, it found a visceral response to meaninglessness.

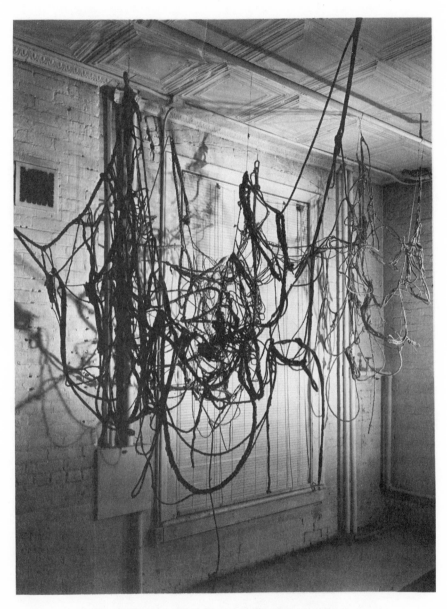

Eva Hesse, *Untitled (Rope)*, 1970. Private collection.

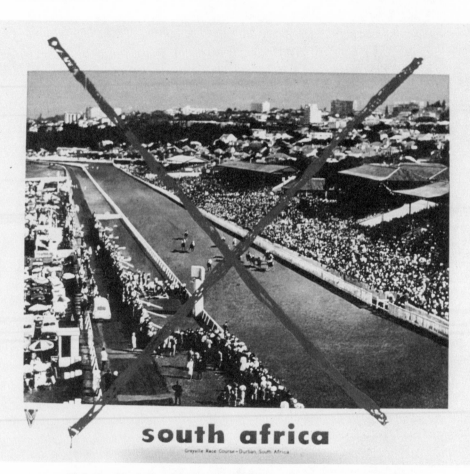

Malcolm Morley, *Race Track*, 1969/70. Museum Ludwig, Cologne.

7 Malcolm Morley: Post-Style Illusionism

According to the ancient but recently relevant story, Zeuxis may have painted grapes so lifelike that birds pecked at them, but the curtain that Parrhasius painted across his picture deceived even Zeuxis: to the eternal embarrassment of art history, he asked to have the curtain lifted.

Vermeer pulled back the curtain and exposed, behind a transparent picture plane, a box space that could contain even the artist, but he left the viewer a voyeur on the other side.

"All two-dimensional surfaces are pornographic. You are controlled because you can't penetrate them," says Malcolm Morley, who began his recent painting of Raphael's *School of Athens* as a public performance;[1] costumed as Pythagoras, with phony artistic gestures and Scriabin music playing in the background, he painted one row of the gridded canvas, and a strip of the Raphael emerged upside down.

Duchamp's *Etant donnés,* instead of shutting the door once and for all on art, opened peepholes to long-forgotten puzzles. If the beautiful old man in carpet slippers fathered the art of the '60s, he also bequeathed a private joke to haunt the '70s: the old ghost of illusionism. To be or not to be is no longer the question. The question is: are we witnessing a rebirth of the idea of art as imitation? As Morley's favorite philosopher, Merleau-Ponty, predicted, "The inquiries we believed closed have been reopened."[2]

The story of real birds pecking painted grapes had long been obsolete: art as a counterfeit of life went out with Meissonier. However, the question of imitation began creeping back before the '60s, unrecognized, of course. Rauschenberg erased a de Kooning and the

Arts Magazine, February 1973.

industrial revolution began; the handcrafted gesture gave way under pressure. It started as a rude test of the uniqueness of the personal brushstrokes of Abstract Expressionism: Rauschenberg's pair of identical paintings, Johns's flat flags, subjected it to the idea of repeatability. In the ensuing confrontation, the look of mechanical precision and mass production took over: repetition is the one element that unites the art of the '60s.

The Abstract Expressionist doctrine of art as a way of life, by shutting the material things of the world out of the studio, created the gap that led to a confusion between art and life. Art moved, literally, physically, into the domain of life—onto its own flat surface or into real space. It became another object in the world. "Illusionism" was a bad word in the '60s, but it was practiced by the very people who hurled it as an epithet.[3] No one at the time would have claimed to want art to become more "lifelike," but the desire for the absolutely real led not only to making things literal but to making things realistic—to, in fact, a new illusionism. The formal repetitions of the past decade contained the seeds of the present fascination with imitation—not only the act of duplicating and repeating but also inquiries into the imitation, the reproduction, the replica. Lichtenstein's diagram of Madame Cézanne was a beginning. Malcolm Morley's paintings during the second half of the decade showed the way to the present.

As a child in London during World War II, Morley used to make balsa wood models of ships, exact and precise, according to detailed plans. H.M.S. *Nelson*, almost completed, was left on a window shelf overnight, sanded and ready to be painted. But in the middle of the night a flying bomb destroyed the model ship and the house, and Morley, unharmed, became a refugee. He never made another model ship, and he says this blocked memory surfaced only recently, under analysis.

In the early '60s, his studio was an eighth-floor walk-up in lower Manhattan with a panoramic view of the harbor, and his paintings were abstract. They had horizontal bands of different kinds of markings, which questioned the validity of handwriting. They seemed to offer a variety of ways of painting the same thing, as if to expose a basic unreality, a fraudulence about painting. They also had something to do with landscape, testing nature against art by offering alternative means of representation, somehow trying to test how the making of art corresponded to the look of the world, probing for the

inconsistencies, for the edge between one and the other. The horizontal bands were horizons. And spontaneity was predictable.

"I was still yearning for that original image that had been lost forever. All art had possessed every image. What I wanted was to find an iconography that was untarnished by art." Morley, working as a waiter at Longchamps, exchanged a few words with a customer who had just come back from London: it was Barnett Newman. "I said, you're the reason why I'm here. Then old Barney Newman really became my teacher."

The last of Morley's abstract paintings had four strips of a photograph hanging from its bottom edge: a reproduction of a ship, cut into separate bands. Artschwager, who was using a grid for his paintings at the time, saw it and told Morley to forget the painting but keep the ship. "I'd been wanting to make an entry into objects. Actually I went down with a canvas to paint a ship from life. Then I got a postcard of a ship. The postcard was the object." In retrospect he says that every time he drives up the West Side Highway, the superstructures of the ships, with their bands of railings, portholes, lifeboats, look like his abstract paintings. "I feel that Barney Newman emptied space and I'm filling it up again."

The first ship painting, done meticulously on a grid in 1965 in stunningly realistic sharp-focus full-color Liquitex, without a trace of handwriting, was the *Leonardo da Vinci*. His new illusionism was literal and basically honest. Unexpectedly, it shared underlying premises as well as its grid structure with Minimal art. It gave itself up as false before it began: the most faithful reproduction of nature—the Kodacolor replica—was the most deceptive, as art. The game was up. No one would ever mistake a Morley for a *plein air* painting: it had all the delusions of a color print.

With his wide white painted borders Morley sealed in the illusion, bracketed it, bringing the eye back always to the surface, never letting it get lost in the illusion of space. With the white border[4] as a delaying action, space was proclaimed as fakery and was neutralized: the blank white edge is a no-man's-land canceling out the insistent space. It is also part of the illusion—the fact is that it is there in the original. So art was a grandiose copy of a cheap imitation of nature—on a flat surface. "It was like making art that couldn't be reproduced, because it goes back to the source it came from." The invisible painting, it reverts to being a photograph, a reproduction. The reality, twice

removed, was a surface realism that had to do with the snapshot, the reproduction, the two-dimensional image of reality. The third dimension exists as a conscious deceit on a flat surface; it is never mistaken for the real space. The reality is the surface—smooth, transparent, invisible. "I accept the subject matter as a by-product of surface," he said in 1967.[5]

Therefore, in order to be painted, the world had to be disguised as something literally flat. The shallow space and real scale of early American trompe l'oeil paintings of postcards, stamps, and souvenirs held on the surface by letter racks could be dispensed with if the vacation postcard, the posed snapshot, the travel poster became the whole painting. A photo can be reproduced any size—scale becomes elastic. Haberle, when photography was still a novelty, had to turn the world into a package to enlarge it—a landscape painting seen through wrappings torn in the mail. Morley makes it a blown-up replica of a reproduction, complete with hand-painted copyright or trademark. The source is banal and public, with its own built-in falsifications.

The subterfuge of painting landscape as an object would seem to carry with it the idea of place as a souvenir. New York is a postcard, stamped, addressed, and mailed. Rotterdam can be city, ship, or travel poster; the city and the ship are equal echoing forms, taking up adjacent wedges of the surface. Such echoes recur throughout Morley's paintings: conical turrets of a castle repeat as triangular sails of boats, a château on an island substitutes for a ship, a coronation equals a beach scene, because of a similarity of shapes or colors. If a place equals a thing, the location of forms in space equals the location of paint on a surface. Like an uncomprehending tourist in the material world, Morley confuses the categories, deliberately. Seeing only surfaces, he invalidates the distinction between figurative and abstract. When the likeness is preordained and the means becomes imitation, abstract considerations can take over; his organization is formal, abstract—and accidental. But then, the accidental has supposedly been an accepted tool of art since Surrealism. If Surrealism set the illusion of dreams against reality, Morley "chooses the simulated experience of reality, the counterfeit, and subverts it from within with an abstract eye; his attitude is closer to the Dada than to the realist tradition."[6] His double-edged illusionism relates to Dali's desire to make hand-painted photographs or Duchamp's defaced *Mona Lisa*.

To paint a ship named *Leonardo da Vinci* (or one called the *United*

States) implies a demythifying process by which an identity is usurped and defused, and a withdrawal of meaning takes place in the guise of homage. To paint a postcard of that ship suggests a ready-made version of Jasper Johns's notation: "Take an object. Do something to it. Do something else to it." Pop Art may have been cynical in the way it made use of debased commercial images. Morley's work rather suggests detachment, combined with ironic longing for the impossible: the idealized vacation propaganda of vacant content-ment—the scenic wonder or the smiling family—comprises the superficial symbols of experience, of escape, of how things never were. It is the opposite of nostalgia. The flat surface of painting is "porno-graphic" because it leads you on to unfulfillable desires: no matter how exactly it reproduces the world, you cannot enter its space, possess its images, or eat its grapes.

By the time Duchamp's posthumous work publicly posed the question of illusionism in 1969, Morley had all but finished perfecting his answer. Was it coincidence that while the "verist" sculptors produced the offspring of Duchamp's Bride, a whole school of Photo-Realist Technicolor painters sprouted up, each with a specialty, sleek and deadpan—the new salon painting, with shiny transparent surfaces and sometimes even white borders; and repetition, the formal device of the '60s, became life-style. Comments Morley: "The Cubist painters are much better than Picasso—it's always harder making the proto-type."

Now, while the anonymous salon art of the '70s, domesticated and docile, strays not too far away, Morley, working in an old building on Long Island Sound with clerestory windows and a portico of flat wooden slats that simulate classical columns, rejects the invisible painting and sinks the ship.

The red X in the South African racetrack picture had less to do with political protest than with crossing out a conception of realism. It was truly the most illusionistic painting he had made. The X was not part of the gridded design: it was added, affixed instantaneously; painted on plastic, reversed, and pressed against the surface, it was printed over the painting like a monotype. Coincidentally, it paral-leled in its shape the crisscross letter rack device of American trompe l'oeil, but it was simply a fatal flaw across the transparent surface, expressionlessly demanding visibility. Following that, the surface began to get rough, the paint to become more and more visible.

With *Los Angeles Yellow Pages,* the imperfection becomes integral. The gesture of crossing out the finished perfection of the racetrack painting is replaced by the preliminary tearing of the original phone book cover and including the rip in the grid, relegating the ripped surfaces back to the surface plane, and referring to the central rip held together by safety pins in Duchamp's last painting, *Tu'M.* [7] The phone book cover is not only ripped; as if used as a paint rag, it carries residues of paint wiped onto it. It also bears the scar of a palette knife stuck to it; a bit of its surface is torn away where the tool was removed, deforming the edge between border and illustration and buckling the illusion further.

The *New York City* postcard was the first New York had seen of the new visible surface, with "an induced carelessness as if I were doing something other than painting, polishing shoes for instance." Up close, the paint detached itself from the things represented, to feel its way over the surface, to insist on its paintedness, on its own substance, much the way it had done in Cézanne's mountains or Johns's flags. The resemblance of the paint quality was inescapable, which is appropriate because Johns's images, as flat and unyielding as the picture plane, had become Morley's flat images that yielded an illusion of space. His *Regatta,* a painting of a cashed scenic check (in this case with a picture of a boat on it) bearing his signature, recalls, besides his own ships, Johns's white flag and Duchamp's *Tzanck Cheque.* [8] It was actually Johns's Buckminster Fuller map of the world that influenced Morley in his breaking down of the surface: the map of the world led to a postcard of New York.

It is a deluxe multiple postcard, with a series of New York landmarks strung across it, the tourist's proof of having been to Mecca. Morley made the postcard's flap as a separate shaped canvas, "the beginning of my moving away from Euclidian painting." The stamp, with a subtle resemblance to Madame Cézanne, and the airmail stickers were also separate surfaces, stuck on. The border, always an aspect of the actual object, had become in *Los Angeles Yellow Pages* an area for greater incident. In the postcard it is even more integral, edging neatly around each view, intruding across the wide canvas to divide it into rectangles, like an all but forgotten memory of his early banded abstractions or an overlay answering to the invisible grid underneath.

With the second postcard, the unfinished *New York City Foldout,*

now in his studio, the painting comes off the wall and occupies real space, standing on the floor like an enormous folding screen, thirty feet long and painted on both sides. The two-dimensional surface gives way to a series of angled planes that warp and curve like paper. Like the original postcard, which is meant to be held in the hand and turned over, the views of New York are upside down and sideways, right side up, reversible; right and left are interchangeable. Close up, the images dissolve into a mass of thick rough paint, solid Winsor & Newton oils knifed on straight from the tube. Bits of matter that look like paint scrapings from a palette—little messy made things, including a crumpled and unrecognizable page out of a pornographic magazine—are wounds on the paint surface, which is itself a prickly impasto of tactile peaks of paint. The increased roughness is an intensified contact with the solid surface; refusing to be invisible, it fights back as the choppy rough paint insists on its density. Says Morley, "It is only a close-up of the earlier work. I used to do it under a magnifying glass and I felt like a pygmy." Now he wants to approximate the feeling of the magnification. It may be a relaxed reaction to the earlier exactness, a Burroughs-like shorthand, but it is also raw vision, bare opticality scratching at the eyeballs. "Each bit represents this patch of sensation."

The prosaic replica gains phenomenological overtones in the change of scale and category. Its implications correspond to Merleau-Ponty's radical reduction: "By the reduction Merleau-Ponty does not understand a withdrawal from the world towards a pure consciousness. If he withdraws, if he 'distends the intentional ties that bind us to the world,' it is 'precisely in order the see the world.'"[9] From a distance the thick substance of the paint reverts to an approximation of the postcard images, the surface returns to transparency. The Empire State Building and the Statue of Liberty reassemble themselves in the intervening space and the painting seems an exact replica of the postcard. "Morley represents, that is *shows again*, the world as paint."[10]

Morley's paintings have been considered artless in their literal and reductive mimicry of the world, but they are about art as much as they are about the world. From the flatness of an oversize print exposing the deception of Vermeer's space, Morley has moved to a painterly paraphrase of Raphael's *School of Athens* and to a heavily impastoed copy of van Gogh's last painting, both of which, besides

being imitations, have another intent. "For me painting is a way of making the past clear."

In an ambitious, futile effort to encompass the wisdom of antiquity, Raphael made the structure of man's thought visible as a series of steps on which Euclid and Copernicus could stand next to each other. Raphael, in a masterpiece that has gone out of style, was painting history. Morley repaints the Raphael as histrionics—as a piece of theater—and the artist as a mime replaying history[11] leads to the theatrical tableau of his *The Last Painting of Vincent van Gogh,* a portrait of the absent artist. Placed on a historically correct mock easel, Morley's copy of van Gogh's *Cornfield with Crows* is displayed; on the ground beside it, an open paintbox contains the traditional painter's palette and, instead of a brush, a gun—a period replica, the gun he might have shot himself with. A historical tableau depicting van Gogh's suicide—sentimental, melodramatic? A visual equivalent for the human condition or a way of underlining Morley's departure from the obscenity of the painter's limitations?[12]

When illusion threatened to become reality, Duchamp shut the door. His secret tableau allowed only a glimpse at the raped Muse. Morley's construction openly announces a footnote—the self-inflicted death of inspiration, the end of the myth of the romantic artist. As illusionist space was relegated to the surface and figuration resulted from a grid, thick paint is detached from Expressionist torment and reduced to another substance, devoid of irony or nostalgia, and painting is history. Style is going out of art.

NOTES

Unless otherwise attributed, quotes are from a conversation with the artist in 1972.

1. Invited to give a lecture at New York State University in Potsdam, early in 1972, he did the performance instead.

2. Maurice Merleau-Ponty, "Eye and Mind," in *The Primacy of Perception,* ed. by James Edie (Evanston, Illinois: Northwestern University Press, 1964).

3. For example, the way a Flavin corner piece wiped out the corner or the high finish inside a Judd cube could deny its cubic shape.

4. The painted borders with which Seurat framed his pictures were a preparation for the optical sensations by which dots of color could assemble into a picture; Morley reversed the process, with admiration for Malevich's *White on White.* An unfinished

nineteenth-century painting of a harvest scene by Eastman Johnson is an unintentional ancestor, with a broad border of unpainted canvas onto which one figure strays.

5. In a statement for the "São Paulo 9" catalogue, 1967.

6. K[im] L[evin], "Reviews and Previews," *Art News*, April 1969.

7. The phone book cover also shows the penciled red outline of a protractor, a reference to Johns's "device" circles.

8. Duchamp's check, dated December 3, 1919, is for the sum of $115. Morley's, dated August 3, 1971, is by chance for a similar sum, $116.94.

9. Pierre Thevenaz, *What Is Phenomenology?* (Chicago: Quadrangle Books, 1962), p. 83.

10. Frances Morley, statement for "Documenta 5" exhibition catalogue, 1972.

11. By mistake, he started in the wrong square, and on close examination it is apparent that one strip of the painting, cutting across a row of heads, is shifted slightly sideways; Morley accepts this accidental shift with pleasure, as "evidence of my lobotomizing philosophy." He also likes the fact that Raphael's figure sitting on the cube was an exact copy from Michelangelo.

12. In *The Last Painting of Vincent van Gogh*, construction becomes reconstruction. It is appropriate that it contains multiple references to recent history—to Rauschenberg's Combines, Rivers's last Civil War veteran, Dine's palettes, Segal's portrait of Sidney Janis with a Mondrian—as well as to the image of the painter at his easel in the Vermeer, and to Morley's own recent rough paint. If Morley's earlier work suggested the mood of Antonioni, his most recent work suggests parallels with the films of Ken Russell.

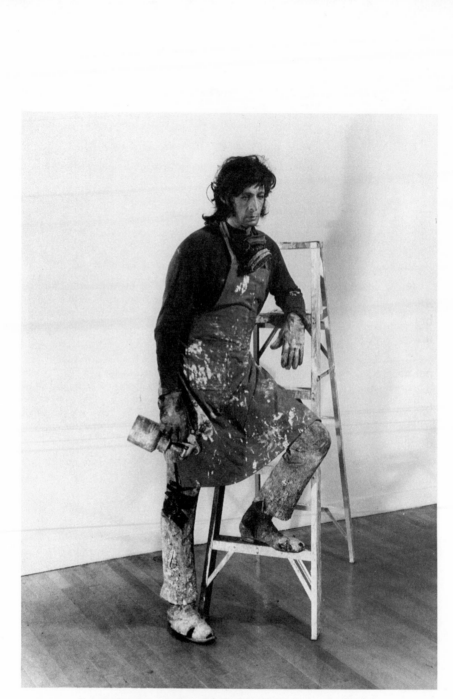

Duane Hanson, *Artist with Ladder,* 1972. Private collection.

8 The Ersatz Object

"One thing made of another. One thing used as another. *An arrogant object,*" noted Jasper Johns some time ago. His painted bronze beer cans were perplexing sentinels of literal realism and unreality for almost a decade.

In January 1969 the new Nixon was inaugurated. By July the posthumous Duchamp was revealed. A few weeks later men were walking on the moon. The moon's magic may have been extinguished by that first footstep, but it was beyond our wildest dreams to set foot in Duchamp's magically real landscape, just the other side of an old door.

When his magnificent illusion with sprawling pigskin nude and distant tinfoil waterfall was revealed, totally inaccessible, its role was symbolic. Appearing in the wake of the anti-form, anti-illusion seasons of scatter pieces, Earthworks, and Conceptual statements, it may have seemed cynically to signal the disappearance of art. By 1969 physical presence had been reduced to raw material or had given way to idea, but what also happened was that form had gone secretly back to nature. And while this may well have meant the disintegration of modern art, at the same time art was reemerging from the ashes in the protective guise of life. Extremes pass into their opposites; evolution is a tricky means of survival. Mimicry of the processes of nature was not as far removed as it looked from imitation of natural forms.

The moon men left the earth artists behind. What Earthwork could compete with a footprint on the lunar surface or a human shadow on a celestial boulder? Enacting a Conceptualist's dream, they took golf clubs to the moon, but in doing so they destroyed its mys-

Arts Magazine, February 1974.

tery, relegating it to a future tourist stop—a physical surface, a solid object. Recycling art, integrating it into nature, was no longer enough. Reality had to follow. Morris's ground covering of scraps, Smithson's rock samples, and Heizer's distant trenches had been unknowingly paving the way to realism. In 1968, when Alex Hay showed fiberglass replicas of wooden floorboards and giant brown paper bags, and when Nancy Graves showed life-size, lifelike camels covered with mangy fur, they appeared retrograde, anachronistic reversions to Pop Art. In 1974 they seem advanced, venturing prematurely into simulated reality.

Unknown, Duane Hanson and John DeAndrea must have been already at work when Duchamp, posthumous father after the fact, legitimized illusionism. Within months their figures appeared, and the tableaux of Segal and Kienholz looked suddenly insufficiently real. Totally accurate, totally inert, Hanson's and DeAndrea's bodies were more real than Madame Tussaud's, as natural as the animals in a museum of natural history or the stuffed people in *Planet of the Apes.* "I want them to breathe," said DeAndrea.[1] The fascination with imitations of life, duplicates of reality, was always lurking in the underbrush, but when the replica is no longer distinguishable from the original—like the robots in *Westworld*—sinister overtones are added. Stalin carried it to extremes: he had several identical rooms in different locations, and he traveled between them in a closed limousine.

Imitation can be repetition, reproduction, or replication, but it can also become pure mimicry. When it does, it is because style is no longer viable: art doesn't suffice. The desire for the absolutely real has unearthed long-buried deceptions and illusions, and has led art to define itself once again as imitation. Mimicking the world of appearances, art conceals and protects itself, forewarned of its own extinction, knowing itself to be a delusion. With artifice it assumes the disguise of artlessness, of nonart, of literal reality.

"The connoisseurs of the future may be more sensitive than we to the imaginative dimensions and overtones of the literal," wrote Clement Greenberg in 1954. He suggested that content could dissolve into form. But Formalism is now the past: what he called "old time illusionist art" has collided with the future by becoming, in its newest incarnation, as literal as Minimal form. Turning against its adherents

with a vengeance, "form" has redissolved into "content." Pygmalion is back in business.

The new illusionist sculpture is minimizing form deliberately. Its forms—its structures—are given, readymade. Actual size, real space, and accuracy to a model are its necessities. If it isn't cast from molds, it is reproduced by hand, copying exactly the shapes and surfaces of its models in life. In other words, structure has given way to skin.

But appearance is not reality: deception is involved.[2] Shedding form and taking on the ability to simulate actual forms of life and man-made artifacts, art became entwined not only in the illusionistic deception of imitating reality but also in the surface deceptions of materials. Along with the Photo-Realist insistence on snapshot style-lessness goes its mimicry of photographic surfaces: it disguises its paintedness with the look of photography. Mimetic sculpture, simulating solid things with counterfeit three-dimensional likenesses, is less limited in its choice of disguises. Polychrome plastics can pretend to be flesh and blood, clay can look like leather, cloth, or cardboard, wood can substitute for metal, or Styrofoam for wood. But while Photo-Realist painters have been proliferating, sculptors are still scarce. This may be because the idea of a surface streching over three dimensions is less accessible than flat photographic space.

Staking out the territory of the human body between them, Hanson and DeAndrea confront the human surface: the clothed and the nude are equally coverings, skins. What is under the actual clothes of Hanson's bodies is irrelevant as long as the visible terrain is convincing. Leather is also a skin, and Marilyn Levine's leather accessories made of clay, substituting metallic brittleness for soft crushability like the bronzed baby shoes buried in provincial childhoods, are foolproof to the eye. Her forms are covering for the body. Rauschenberg's are coverings for objects: with his clay replicas of cardboard cartons repeated in editions, he has stepped squarely into the same quicksand of the trompe l'oeil surface, but they are also extensions from his recent use of corrugated cardboard and his long concern with means of replication. Saul Steinberg, whose past work is full of riddles about nature and art imitating each other, is another trespasser on the grounds of literal realism.[3] Most of the hand-carved and painted wooden replicas of artist's tools on his *Tables* (drawing boards or actual drafting tables) were virtually indistinguishable from real

pens, pencils, or brushes, but other objects, obviously wooden, gave away the secret. Fumio Yoshimura, who first made six wooden bicycles in 1970, and Jud Nelson, who showed six Styrofoam chairs last fall, make no secret of their material deception, duplicating objects without the benefit of cosmetic coloring; their surfaces, their skins, are bare. They effect a subtle reversal of the trompe l'oeil confusion: instead of being amazed that it isn't the actual material, we are amazed that it is the unlikely substitute.

A disguise can make something appear to be what it is not, or it can make it appear not to be what it is—it can conceal the identity of a thing, or it can change its appearance. The peace marchers wore army surplus clothes. Hanson, DeAndrea, Levine, Rauschenberg, and sometimes Steinberg conceal the identity of their materials, arrogantly mimicking actuality. The deception becomes visible in the figures only because they don't breathe; in the objects it remains invisible—as with Duchamp's heavy sugar cubes made of marble, it is necessary to touch to be sure of the material discrepancies.

Instead of concealing identities, Yoshimura and Nelson change the appearance of their objects by obvious simulation, with substitute materials and neutral uncolored surfaces. While they deal literally with real objects, their attitudes toward realism are ambivalent: the illusionistic deception is exposed by their materials, which refuse to partake wholly in the illusion. The raw grainy wood of Yoshimura's intricate mechanical or natural objects, whether motorcycle, sewing machine, or tomato plant, and the white and weightless Styrofoam of Nelson's chairs, emphasize unreality. "We never had realism as an idea in Japan. I'm not intending to make any realism," Yoshimura says, pointing out that in the classic No plays, eighty percent of the characters are ghosts. "I'm not really reproducing the thing. I'm producing a ghost." Nelson, building an image as if it were made of air, is also involved with removal from the original. But where Yoshimura is less concerned with accuracy of scale and detail than with improvising a believable approximation, Nelson uses fanatic accuracy in his duplications. His chairs had six different but identical wooden folding chairs as models; each has its own almost imperceptible imperfections, individualities, birthmarks. Of his Styrofoam sunglasses he says: "These are mere copies, slavish imitations, everything is replicated to a sixty-fourth of an inch. I'm just pushing the extreme of exactness." But by taking such care, his work implies that each object

has a spirit, which he preserves with an Indian-like respect. Oldenburg's ghost objects took liberties, but tactility was insinuated into seeing when he replaced structure with skin. His soft skins, undisguised substitutes for other surfaces, opened the way for other substitutions, modifications, or reversals of hard and soft or heavy and light.

When illusionism became the issue, materials assumed new importance as the carriers of deceptions. And when one material substitutes for another, openly or in secret, structural elements that are no longer functional tend to be retained as decorative vestiges on the surface—hinges that don't bend, wheels that don't turn, stitchmarks in stoneware shoes, corrugations in clay boards, pores in plastic skin. Conforming to an alien appearance while keeping their own identity, the materials used by Nelson and Yoshimura openly emphasize pretense. If these artists seem to stop a step sooner in the process of deception, omitting the polychrome camouflage, their quixotic choices of materials go further to question material existence.

Part of the deception in the work of Nelson and Yoshimura is that it has been crafted so painstakingly by hand. Using substances that cannot be manipulated or molded, they build their work part by part, carving, grinding, and gluing with time-consuming skill—to make it look like a factory-made, mass-produced object stamped out on an assembly line. It is an act of self-defense, countering the blueprint technology of Minimalism. It is Duchamp's readymades—found, instant, effortless choices—in reverse. The irony of the effect is part of the content. But then, even though Hanson and DeAndrea use the reproductive shortcuts of casting their structures from life, their skins are painted by hand, with great care. With the moon landing, it was time for other virtuoso displays of accuracy.[4] The robotic technician, the antiartist, emerged.

Duchamp's *Etant donnés* bracketed the beginnings of an unexpected illusionism, by coincidence. In retrospect it had been preceded by signposts along the way. Johns's beer cans are the earliest, the most obvious, and the most advanced, in that they were not what they seemed to be. Disguise was not an element in most of the other early impulses toward the real. Considering the entrenched anti-illusion stance of the time, it is not surprising that actual objects, like Rauschenberg's stuffed goat, were favored. Or that the tableau became the form to anticipate simulated reality. Work such as Segal's dining

room, Kienholz's more total Beanery, or Samaras's complete bed-
room—which, unpeopled and containing only real things, was the
most literal—emphasized displaced actuality.[5] When Segal cast fig-
ures in plaster he used the mold itself as the figure—the more lifelike
cast remained a negative space hidden within. When he used real
objects they remained actual—his plaster molds inhabited real sur-
roundings, sat on real chairs, used real props. As if breaking a Segal
open and casting the lifelike shape within, completing a process Segal
started, Hanson and DeAndrea (who openly acknowledge this rela-
tionship) took the next step. It is interesting that Segal himself started
making actual casts around 1969: his plaster relief fragments of fig-
ures are casts rather than molds, but the fragmentary form forestalls
any overwhelming illusionism.

If the figure sculpture of Hanson and DeAndrea relates to Segal
and to the posthumous Duchamp, and the object sculpture of Yo-
shimura and Nelson relates to Johns's reversal of the readymade,
there is a curious cross-reference: made in a uniform neutral uncol-
ored substance, the new objects are materially more like Segal's plas-
ter, while the new figures are cast and painted, like Johns's.

Like Segal's figures, those of Hanson and DeAndrea express mind-
lessness and isolation. DeAndrea's are nude models posing for pay,
tranquil and vacant, with no private thoughts—bodies for sale. Han-
son's are casualties of life, waiting to be thrown away. In his earlier
work, accidents or hostilities left the floor strewn with bodies, wreck-
age, violence. Now he has shifted to more passive wrecks, to menial
laborers, or the surplus old vegetating in Florida, playing solitaire,
staring into space, waiting. They use real props, like Segal's figures;
they also wear real clothes. But oddly, the presence of Segal's figures
becomes an uncanny absence in Hanson's and DeAndrea's—they are
the exact forms of people who aren't there, discarded inanimate bod-
ies, victims of the Body Snatchers. Their totally realistic appearance,
their wholly convincing surface, their deceptive illusion of being ac-
tual people complete with goose bumps, mosquito bites, or varicose
veins, makes the absence all the more apparent. The tension between
the formal and the lifelike that existed in the work of Segal has shifted
to a tension between lifelike and alive. Like the disembodied three-
dimensional images in Dali's or Nauman's hologram portraits, like
Body Art with its live performances and photographs, they are imper-
sonations of life. With literal mimicry the famous gap between art and

life snaps shut, but it leaves in its wake an unfathomable abyss—a credibility gap between object and image.

But then, could we really tell the difference between the live broadcasts from the moon and those labeled "simulation"? In life, the 1960s, with Lincoln in Disneyland and a wax pope in St. Patrick's, had been full of hints about illusion and reality. The Surrealist tradition of mannikins had been rediscovered during the Pop era by way of the amusement arcade, and numerous movies involved dummies in scenes of heightened unreality.[6] The cults of dead heroes accumulating through the sixties, from Marilyn and Kennedy to Guevara, Hendrix, and Joplin, and the controversy over heart transplants, indirectly tie in with the morbidity of the new objectlike body and ghostlike object existing as fixed images. Decades ago, Ortega y Gasset wrote with Modernist disgust of "the peculiar uneasiness aroused by dummies. The origin of this uneasiness lies in the provoking ambiguity with which wax figures defeat any attempt at adopting a clear and consistent attitude toward them. Treat them as living beings, and they will sniggeringly reveal their waxen secret. Take them for dolls, and they seem to breathe in irritated protest. They will not be reduced to mere objects."

Sculpture, pretending to be of this world, borrowing the existing forms of things in the world, is less an object than a ghostly image, all on the surface. It conceals its own reality by mocking another, arousing dread, confusion, and the shock of recognition. Its value lies in deception as much as resemblance: the degree of its lifelikeness corresponds perversely to the awareness of its deceit. To call it "verist" is misleading. It is the opposite of genuine—a synthetic counterfeit of reality. In fact, simulation could be said to be its subject matter. Plato claimed that art was thrice removed from the truth (removing himself by using the voice of Socrates). "Here is another point: The imitator or maker of the image knows nothing of true existence; he knows appearances only." But the awareness of the new sculpture's duplicity—the realization that it is not what it appears to be—is half the pleasure in this comedy of errors; the object has been found out, exposed as an image. And the spectator, released from an illusion, becomes a participant in a mystery as well as witness to a comic melodrama of mistaken identity.

Galatea wasn't waiting for Darwin in the Galápagos, but while art tries to come back to life, unrecognizable mutations may occur in the

development of forms: reality was never as real as a hybrid hothouse image. As art becomes an endangered species, sculpture resembles natural history. But the real sanctuaries of natural forms are overtaking it. In the Bronx Zoo's new birdhouse, life simulates itself: living birds exist in simulated natural habitats, imitating the displays in a natural history museum and recreating chunks of actual nature indoors in glassless cages. There is even one jungle tableau—complete with not a tinfoil but a real waterfall, simulated rain, and watchful birds—which the spectator enters, passing through at treetop level in the midst of total illusion.

"I am not satisfied with the world. Not that I think you can change it, but I just want to express my feelings of dissatisfaction," says Hanson. "I set up my own world, and it is a very peaceful world—at least my sculptures are," says DeAndrea, going further. A mouthpiece of 1960s avant-gardism, the Something Else Press, referred in a recent catalogue to "the collapse of the sixties in grand disillusionment." But the disillusionment of the late '60s is the illusionism of the '70s. With the advent of the new new Nixon—speaking of himself at times in the third person singular, as if he were someone else and launching Operation Candor—what could be more apt at this point in time than the appearance in sculpture of a synthetic realism which reveals itself to be total fiction? In art, at least, the believable image has been restored.

NOTES

1. John de Andrea and Duane Hanson quotes are from interviews by Duncan Pollock, Linda Chase, and Ted McBurnett in *Art in America,* November/December 1972. Fumi Yoshimura and Jud Nelson quotes are from conversations with the author, November 1973.

2. The post-Minimal artificiality of bringing nature into the gallery or sending art into the wilderness should not be overlooked.

3. Malcolm Morley, the first Photo-Realist, also moved into sculptural illusionism with *The Last Painting of Vincent van Gogh* (a mock easel with a hand-painted copy of van Gogh's painting, and palette, paintbox, and gun). Morley's postcards had led to the possibility of a flat object having a spatial existence.

4. The meticulous, time-consuming handiwork of Samaras or LeWitt provides an unlikely precedent.

5. Acconci's more recent act of transporting the contents of his apartment piece by piece to a gallery can be seen as reducing the tableau to a dismantling process: by way

of a Minimal climate, tableaux gave way to the isolated object. The environment became superfluous; the actual site was incorporated. However, instead of vanishing, the tableau has become miniaturized, continuing in work such as Robert Graham's or Darryl Abraham's, which, while seemingly realistic, could never be mistaken for reality because of its lilliputian scale.

6. The human replica or mannikin motif has pervaded film, from *House of Wax*, with its illusionistic attempt to make celluloid more real by means of cardboard spectacles, to *Westworld*, where ultrareal robots duplicate actuality in a fantasy retreat. Interest in the mannikin also has appeared in English sculpture, since Jann Haworth's Pop rag-doll figures. Since 1969, Allen Jones's chorus-girl mannikins contorted to function as furniture and Malcolm Pointer's painted and clothed plaster casts have appeared. Both, however, remain securely in the tradition of mannikins, not to be confused with real people; their surfaces look reassuringly hard, but this may be a technical shortcoming rather than an intention. Also, both seem less concerned with the subject of reality and illusion than with woman as a fantasy sex object, lewd, degraded, and obscenely used.

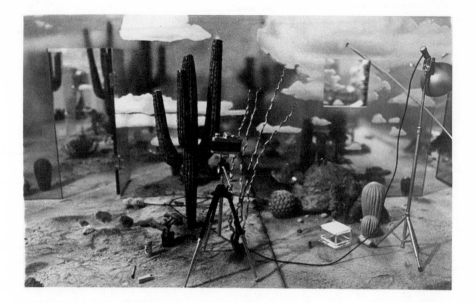

Roland Reiss, *Adventures in the Painted Desert: A Murder Mystery* (detail), 1975.
Collection University of Arizona at Tucson.

Ann McCoy, *The Night Sea Journey,* 1979.

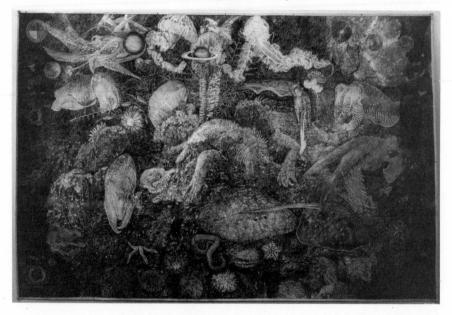

9 Narrative Landscape on the Continental Shelf

Notes on Southern California

The material world, in Southern California, is fantasy or illusion. There are constant reminders that it is nothing more than a function of light. It is bleached by strong sun, dissolved by smog, or obliterated entirely by enveloping white fog. The visible world is full of tricks: vision itself is trickery. Mountains appear one day, vanish the next. The landscape is unreliable; distance is capricious. Things are always shifting from visible to invisible because of the conditions of the atmosphere.

Art there has been aware of this: Bob Irwin's elusive white scrims of bright deceptive space, Larry Bell's panes of coated glass that shift from transparency to hazy obscurities, Bruce Nauman's illusions and sleights of hand, John Baldessari's miragelike photographs. Translucence and luminosity is its tradition. But art in Southern California can no longer be divided neatly between "Irwinesque reduction to the brink of mysticism" on the one hand and the "good-looking art object" on the other, as Peter Plagens categorized it. Perhaps it never could. It looks now as if it was landscape all along—cross-sections of the sky, chunks of smog, panes of atmosphere, radiant space.

"What I'd really like to do is take large sections of the sky and the sea and say here it is,"[1] says DeWain Valentine, whose transparent wedges and rings of plastic have been superseded by his darkened rooms with camera obscura effects dependent on natural light. "Like cloud, like mist, like dream" is how Eric Orr speaks of his soundless empty room spaces. Tony Berlant is making breaking waves and

Arts Magazine, October 1976. Research for this essay, and for "Video Art in the Television Landscape," was made possible through a Critic Grant from the National Endowment for the Arts in 1975.

mushrooming clouds out of shattered crockery. Peter Alexander has given up transparent plastics and is painting glittery sunsets on black velvet. Joe Goode is painting torn double skies. Ed Ruscha is drawing brooding clouds pierced by yellow sunbeams. Ecology has stigmatized plastics,[2] the good-looking art object is on the way to extinction, and skies—the objectless subject—are suddenly apparent in everyone's work. Nature is the new god.

Michael Asher's "altered space" at the Clocktower in 1975 gave New York a glimpse of California immateriality and the new landscape. He removed the windows and the lights from both gallery and tower, stripped each room bare, and left the space at the mercy of the outside light and the weather, opening it to the sky. Taking Irwin at his word about reducing art to point zero, he may have gone further than anyone to create an art of removal, of absence, of pure perception. In simply making a space visible, his work may be reminiscent of the earliest Conceptual art, but in the absences that Asher creates, nature—which abhors a vacuum—fills the void with a rare immediacy: lighting up the floor with changing parallelograms of sunlight, filling the space with cold, clean breezes from outside.

"When I was doing the walls with light it was like taking a piece of the sky almost," says Doug Wheeler, who more recently has delineated a space in the sky with an airplane as an artwork, making an invisible cube at thousand-foot intervals. "I used to feel claustrophobic on this planet," he says. The minimal room spaces he has been doing since 1969—pure light and empty space—are now including time, with altering light cycles that brighten, dim, change, and can compress the light effects of a day into eight minutes. His *Synthetic Desert Piece,* a mysterious sound-absorbing space, invisibly defines a central cubic area with atmospheric noise. His ambiguous, reticent drawings, studies for these installations, take time to decipher. Simultaneously ground plans and projections, they include layers of pale mapping or topography, wiring diagrams or illustrations of the phases of the moon or other private references to sites and cycles, to temporal and spatial orientation—as if they were envisioned in a specific landscape.

"If you watch a clock long enough, you can see it move. It's an elegant time," says Jim Turrell, who since 1972 has been working on an elaborate project to shape a volcanic crater in the Painted Desert into an artwork, "like a room in the sky," involving natural light

effects from the motion of the sun, the moon, and the stars, like a postliterate monument to time. "A piece will be made that interacts with the space of the sky and the events which occur within that space ... a piece that performs itself," states the documentation for this *Sun and Moon Space Project*. When it is finished, it will still have to be given time to make its revelations of stark planetary motion. "What's happening in the piece is so slow and its time is so different," he says.

Newton and Helen Harrison are working, in their Lagoon proposals, with slow global changes happening over millennia and with geological imbalances caused by man, involving art in a desperate fight for survival—not of art but of nature. "We need another Copernican revolution to move man out of the center," they say. And their tinted sepia-and-blue photo enlargements, like faded parchments of a distant earth, are huge overviews—maps, aerial photographs, or infrared satellite pictures—on a scale that diminishes humanity to invisibility.

Another kind of overview is accomplished by the miniature model-like scale of Roland Reiss's tabletop tableaux. "I never collected miniature toys," he says. "The point of making it small is to get more, to encompass the whole thing." His *Adventures in the Painted Desert: A Murder Mystery* is a vast desert landscape in miniature, compressed like a stage set into interrelating areas of time and space, containing evidence to be sifted, clues to be followed, lessons to be learned. Strewn with bullets, footprints, and cigarette butts, littered with artist's tools and chalk-scarred by detective work, this lived-in landscape is full of warnings of human violence. And it reveals itself as a narrative with multiple meanings and metaphors—a whodunit, a cowboy-and-Indian tale of the wild West, an allegory of the art world, and a philosophical homily about time and space—when read and traversed with caution, scrutinized with care.

"I wanted to make the works so that they, like nature, could not be perceived quickly," states Ann McCoy, whose immense landscape drawings are huge vistas with intricacies of tiny detail and marginal notations of natural forms that must be read like a naturalist's handbook. "I often wonder if a viewer who is used to looking at Stellas can have the patience to spend several hours looking at one of my drawings."[3]

It is no accident that artists in the West are turning to elusive natural light and space, to immaterial mediums like video, and to

time. Time and space are different in Southern California, slower, grander, more ponderous perhaps. There is none of the quickness of New York, none of the sudden instant recognition. Life and art unfold with a slow narrative duration and spaciousness that New Yorkers are not used to. In Southern California, space seems to exist only as a time gap on a freeway, measured by the clock, and distance is obliterated. And as time and space merge in a life-style that is a curious illustration of Einsteinian revelations, the landscape is insistently narrative.

Turrell's studio is a T-hangar at the Torrance airport. The Harrisons' is a cylindrical water tank in a grove of eucalyptus trees. Nature may be the new power, but Southern California is pure fiction, with its artificial, man-made environment and its illusions of living in a fairy-tale, storytelling, unreal world that includes Disneyland, Knott's Berry Farm, Magic Mountain—"only two gallons away"—Universal Studios' movie lot, artificial fingernails, toupees, and taxidermists. It is a world where feminist artists shed their surnames the way starlets used to, assuming glamorous place names—Judy Chicago, Lita Albuquerque, Wanda Westcoast—and missing the irony; where established male artists have posed in tuxedos for their catalogue photos like celebrities, drinking champagne at the Beverly Hills Hotel.

In the Palace of Living Art in Buena Park, art history has been reinvented as wax tableaux. Velázquez's cardinal, Michelangelo's David, the *Rokeby Venus,* and the Venus de Milo—with arms—are naturalistic life-size mannikins with flesh-tinted body makeup, glass eyes, and blond wigs. Even van Gogh's bedroom is there, complete with built-in perspective distortions, and on the rickety wooden chair by the bed sits Vincent himself in realistic wax effigy, one ear bandaged. But the so-called realism is as extraneous as the lack of authenticity—comparisons to Duane Hanson or Mel Ramos don't matter. It is as narrative visualizations that they exist.

If the public's idea of Great Art comes from the wax tableaux in the Palace of Living Art and the lifeless copies at Forest Lawn, the artists' idea of recent art comes from illustrations in *Artforum.* In Southern California, where Bob Irwin is spoken of as a "first-generation artist," where the universities are the shifting centers of the art world, and where art was mostly experienced as information in a magazine anyway, Conceptualism was the perfect solution. "California is two separate things, the reality and the state of mind," says John

Baldessari. But the restless, star-struck state of mind has shaped the reality; the real thing barely exists. Halloween is the one holiday that people take seriously.

Los Angeles has no memory. It is a looking-glass world, a land of grown-up children and instant gratification, where "meaningful play" has replaced "meaningless work."[4] There are no records, no history, no dates in the art world.[5] Ask an artist when he did something, and the answer is invariably "a while ago." No one ever knows exactly what year. There is no external change, no recurrence of seasons, no innate sense of time passing. San Diego may be the militant conscience of Southern California, but L.A. is its marshmallow heart and mind.

It is a nonlanguage city, laid back and spaced out. Intellectual conversation is supposedly rare; no one really talks except transplanted New Yorkers. Western literature is the literature of the Louis B. Mayer back lot, revealing itself in cinematography. The visualization of the story is its tradition. And so word art, language art, story art, literary art takes hold and thrives. And time enters the realm of visual art. Looking at art is no longer enough. The art that is being made now needs to be read.

It is not just the photographic Conceptualists, the so-called story artists, who are working with narrative visualization. Other artists are using literary forms to structure visual art. Newton and Helen Harrison's *Lagoon Cycle: 7 Steps to the Sea* is a continuing narrative, an epic saga of transformation. Roland Reiss's miniature environments are murder mysteries and parables. Eleanor Antin, whose *100 Boots* was the picaresque hero of a cross-country odyssey, is dramatizing novelistic autobiographies. Al Ruppersberg, making a handwritten copy of *The Picture of Dorian Gray* on twenty large canvases, or a photographic grid of books on shelves like a library wall, is resuscitating actual novels from the past, as if *Fahrenheit 451* had come true—questioning what visualization is. So is Alexis Smith, whose abbreviated commentaries on *Robinson Crusoe* and *The Scarlet Letter* condense the essentials for a nonreading culture, using sparse visual metaphors for the literary content like trademarks. And a number of young video artists are using the narrative structure of television shows, commercials, and news reports. A written text in the form of a footnote scrawls across the bottom of Ruppersberg's three panels of bookshelves, speaking of suicide. As the written word and linear com-

munication become obsolete, replaced by the episodic interrupted simultaneity of television, it is appropriate that art is becoming literary, in the midst of a media-oriented culture that never was.

As narrative becomes a new field for art, even artists like Doug Wheeler and Jim Turrell, whose work might seem to have nothing to do with storytelling, are making art that must be read in time. In fact, narrative structure may be replacing the outworn idea of form as an embracing concept. Just as form took over the job of content during the '60s, narrative structure may now be taking the place of formal considerations, in an art that is reasserting the right to be literary.

The connection between landscape and narrative—between nature and fiction—is less improbable than it might seem. A story needs a setting. Landscape first appeared in art as a function of narrative, as a means of placing the story, situating it in a specific space. And now with the emergence of a new visual narrative, the setting often *is* the story, as in Shiro Ikegawa's collages—diaristic documentations of man's imprint on nature, telling the stories of his fishing trips with diagrams, weather reports, and contour maps, or in Judy Chicago's creation myths, in which she paints the desert with gaudy explosions like a biblical extravaganza. The landscape can be narrator, telling the story, as in Reiss's work, or it can be performer, as in Turrell's, or suffering hero—with man the villain—as in the Harrisons'. Nature itself is now the protagonist.

The visible landscape in Southern California is so vast and aloof that the objects on it look miniature rather than distant, like a Monopoly board on which the little green houses and red hotels are proliferating wildly to the horizon. It is Reiss's tabletop landscape in actuality. The scale of the land and the scale of the human objects on it do not mesh.

Maybe because of this, a strange kind of deliberate isolation exists in the midst of all the apparent friendliness of Southern California. Isolation without privacy. In this friendly first-name culture, intent on acceptance, the facts of everyone's life are out in the open. Eleanor Antin's schizophrenic archetypes come out of a schizophrenic landscape. It switches suddenly from horizontal to vertical, from broad, flat valley to mountain peaks, where, perched up in the sky, an Alpine village nestles in the pines. Choose your climate, choose your fantasy: nothing is real. The grand inhuman inhospitable landscape has been

reduced to a scenic view, a panorama, a backdrop. It has been tamed, suburbanized, overcome. And yet there it still is: a vast excessive sublime landscape that resists description or assimilation. It is like being in the midst of a futuristic space colony that has imposed familiar habitations on an alien planet. Think of Wheeler's *Synthetic Desert*, with its implications of a lost original being synthetically reconstructed. Think of the plans for an orbiting space colony that were in the news not long ago, with an artificial earth, artificial gravity, artificial day and night. It will be manned by Californians, who will be perfectly at home in it.

Nature versus culture is a California notion, a distinction that can easily be turned inside out, probably to no one's satisfaction, but that nevertheless is significant in a place where almost everything is artificial, and anything is possible. New man-made lakes are taken for granted. The idea of clones is in the air. The blond, blue-eyed, tilt-nosed, baby-faced descendants of the Busby Berkeley chorus girls who flocked to Hollywood in the 1930s from all over America, unintentionally creating a new gene pool, are already a new race of Californians, interested only in surfing and hang gliding, in pitting the human body against the elements. For in the midst of man-made idealism and fictions, the elements are very present, as vast arenas on which human activity is irrelevant. Water, earth, air, and fire: the sea looks bigger than the Atlantic, vaster expanses of it are visible; the sky is unobstructed from horizon to horizon; the earth is grander; and fire is not a matter of a single house but can lick across miles, consuming the ground and spreading ashes over distant swimming pools.

The end of the world is a more believable idea in that vast inhuman landscape. Human habitation seems more recent, more temporary, and more alien. Somewhere out of the depths of the past comes a vague awareness that life there is existing on terrain that was meant to be a seabed. Southern California has no continental shelf; it is the continental shelf.

Art in Southern California is embodying the conflicts and confusions between nature and culture: it is what has made a narrative landscape art possible. The Harrisons' Lagoon proposals come out of a place where nature can be improved upon, where anything can be man-made. "We are process artists. Our work is about the future; it's a fantasy, but it's not science fiction. Technically, everything we propose is viable—is feasible with existing technology. It is important not

to be wrong," they say, at the same time that they align their art firmly on the side of nature. Rearranging the landscape, even if it is for its own good, is at least as artificial, and requires at least as much technology, as making minimal room installations that offer private and idealized perceptions of nature.

Nature, in those immeasurable, objectless, and highly controlled Irwinesque interior spaces, was so abstract it could pass unnoticed for years. Landscape, in post-Conceptual California, is a literary concern, overtly expressed by maps and maplike vistas as well as written words. But nature is still as empty as it is unreal: the sky, the sea, and the desert are metaphors for nature as limitless space—and for space as an unending surface of accumulated details, as the drawings of Ann McCoy or Vija Celmins also point out. And the mapped-out terrains in art are grappling with the presence and absence of nature in the world.

If the Harrisons' proposals are visionary Earthworks on an epic scale, with moral overtones, Eleanor Antin's performances are Body Art in search of a landscape, with psychological undercurrents. Dispossessed, detached from their settings, their backgrounds, looking for a suitable landscape, her living self-portraits play out their stories against inappropriate settings, alienated and isolated from history. In relation to theater they may be disappointing, just as the Harrisons' work might suffer in relation to real science. The Harrisons are concerned with the survival of the outer world; Antin is involved with the preservation of an inner world. The search for habitable spaces concerns them both, as it does Asher, Wheeler, Turrell, Reiss. It is in relation to the limits of art that their work must be considered.

Reiss's tableaux can be dismissed as craftsy by those who do not see the craftiness of his cautionary tales. Turrell's project can be seen as the ultimate decadent artwork, consuming vast expenditures of technology, money, and energy to create an illusionary device in an inaccessible desert, a magnificent extravagance. Wheeler's invisible cube in the sky or Asher's empty galleries may seem to take art past its vanishing point. But as adventures at the edge of art, "works using the real world,"[6] post-Conceptual art in California is daring to test itself against real experience—against nature.

This new narrative landscape that is forming in the West cuts across apparently diverse styles, joining the work of a number of

seemingly unrelated artists. It may draw some of its energies from the New York mainstream, if such a thing still exists. It has connections to Conceptualism, to Earthworks, to Body Art, to the recent provisional mergers of art with the world. But in the intervening gap of a continent, with filtered information warped by distance, it has undergone strange mutations and is emerging as something new and different. It isn't simply misunderstanding. Because of distance, de Kooning and Pollock could see implications in Surrealism that the Surrealists never noticed.

We have tended to assume in New York that the toughest art is our own. Toughness is not a California virtue. Life, and art, are easier, without New York's desperate sense of struggle. But the ground threatens to crack open, the landscape threatens to burn: nature is flawed, and art is probing its precarious and precious, temporal and possibly temporary manifestations in space. Perhaps the far West is the last frontier after all, the place where art will finally do what it has been attempting to do for a long time—inhabit the real world—and in fulfilling its aim will cease to be recognizable as art.

NOTES

1. Unless otherwise specified, quotes are from conversations with the artists in November 1975 or February 1976.

2. Both Craig Kauffman and Ron Davis have also given up plastics and are now using traditional materials. Other abstract artists are making use of slow natural processes: for example, Jay McCafferty, whose paintings are made by burning hundreds of small holes in rusted graph paper, using a magnifying glass and the sun's rays. Or Charles Hill and Brian Miller, who subject their work to natural decay by such means as burying it in the ground or exposing it to the elements.

3. From the artist's statement in the catalogue of her exhibition at the Institute of Contemporary Art, Boston, October 22–November 30, 1975.

4. William Irwin Thompson, *At the Edge of History* (New York: Harper & Row, 1971).

5. According to one version of the past, art started in the early '60s after the opening of the Ferus Gallery and ended around 1968 after *Artforum* moved to New York. According to a newer version, it started around 1969, when the first batch of artists, including Chris Burden, Alexis Smith, Gary Beydler, and others, graduated from Irvine, and now San Diego is replacing Irvine as the center. Irwin, Kaprow, and Baldessari may be the three magi of the West, the teachers of Southern California. Kaprow

brought Fluxus people and ideas, Baldessari imported the Conceptualists, and Irwin, who talks of the importance of dialogue and response, infused a longing for the cryptic simplicity of Oriental thought and space. It is out of this climate that narrative landscape has appeared.

6. In a statement in *Americans in Florence: Europeans in Florence* (videotapes produced by Art/Tapes/22, 1974), Baldessari, speaking of a growing disenchantment with video, said, "With enough disillusionment perhaps more artists will consider doing works using the real world."

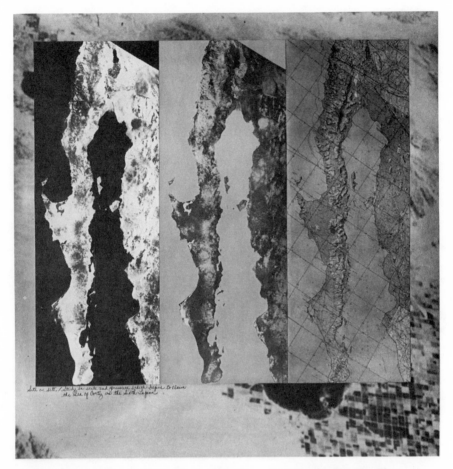

Newton Harrison and Helen Mayer Harrison. *On Site/On Site/On Site: Metaphorical Study in Scale and Pressure, (Sixth Lagoon Sketch),* 1975. Private collection.

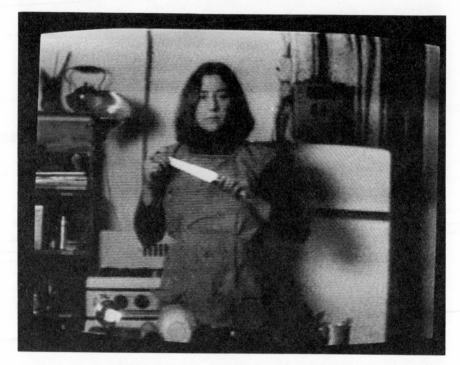

Martha Rosler, *Semiotics of the Kitchen*, 1975.

10 Video Art in the Television Landscape

It is no accident that young artists in Southern California are embracing video. If the artists who came to maturity there in the '60s have been dealing with the immaterial image—with pure light and empty space—a new generation has turned to the immaterial medium.

Video, the gorilla godchild of Warhol's Empire State Building, sabotages all attempts at artifice. It stolidly insists on retaining actual time. When Bergman showed a minute as an actual minute in a film years ago it was stunning. When Warhol abolished time in his unmoving movies it was stupefying. When video records an artist's private activities over a span of twenty minutes it is endless. If Warhol made boredom permissible, Conceptualism institutionalized it. Video adheres to an aesthetic of boredom. Appearing in the late '60s, at the same time the art object was being demolished in other ways, it seemed the perfect medium for ideas, for art without baggage, for explorations of real time and duration. And, for a first generation of video artists, it was definitely non-narrative.

At least so it seemed in the East. In California, where people style themselves after television characters and you can recognize the Rockfords and Barnaby Joneses at any local discount store, where people furnish their homes in Mae West modern or quiz show decor, television is a central fact of life. In California, where Allan Kaprow was teaching and the ideas of Fluxus were circulating, television is the model, as both John Baldessari and William Wegman realized. It is only natural that a number of second-generation video artists are emerging, whose use of the medium relates more directly to television

LAICA Journal, January/February 1977.

than to past art. "We're all children of the media," they say. In the East, television retains a certain distance, simply because it is Made in California. Those palm trees, stucco houses, and sunny boulevards where the latest car chase is happening just aren't our terrain. In California, not only is television true to life; life is true to television. It was inevitable that duration would turn to narrative.

Television offers a new kind of narrative structure, episodic and interrupted, which incorporates within itself nonsequential inconsequential interruptions. Breaks for station identification and commercials are recurring refrains, and within commercials these refrains are often in the form of mininarratives telling us intimate details of a family's personal hygiene. In the same way the episodes of any weekly series are separated by the rest of the weekly programming, so that the viewer carries chapters of unrelated stories simultaneously in his memory.

Life reinforces this interrupted narrative structure. Driving through the California landscape, you see an endless repetition of the same man-made scenery. Taco Bells, Sambos, Jack-in-the-Boxes recur with predictable regularity, like commercials on the TV screen. Indistinguishable suburban streets repeat with the familiarity of altered stage sets reused on different programs. Everything you do is punctuated by periods of being encapsulated in a car on a freeway, which takes the place in life of the station break. People think a lot about what they have just done, or fantasize about what they might have done. A lot of mental rearranging takes place. As narrative content enters art, it is taking the form that life and television have offered; as narrative time becomes a field for investigation, video is obviously an appropriate medium. Television is the real subject of video.

Billy Adler, with supreme awareness of the relation between video and television, has collaged (in collaboration with John Margolies) a bunch of actual Nixon news clips so that Nixon appeared to be host of a family variety show—playing the piano, doing a comic bit with a yo-yo, tossing insults and quips like a true trouper. Watergate turned into a quiz show, while "The Inauguration" and the "Impeachment" became spectaculars in his video collage. Adler knew that you can't beat the real thing; actual television is the original. He knew that nostalgia in L.A. is nostalgia for old TV—Queen for a Day, the Lone Ranger, Milton Berle, Captain Video—and gathered choice bits from antique TV shows like a collection of old postcards. Lowell Darling

knew it too. When he "acupunctured" L.A. he got coverage on the evening news, and he was divorced on network TV, wearing a bridal gown. Chris Burden purchased commercial advertising time on L.A.'s Channel 9, and aired his *TV Ad* nightly for a month.

Meanwhile other artists in Los Angeles are doing narrative video, structuring their work from television, intentionally or unintentionally. Ilene Segalove's *The New Room,* a sociological documentary in which a young housewife smugly shows off her home improvements, is like watching the girl on the game show who displays the fabulous prizes behind the curtain. Susan Mogul's tapes *Take Off* and *Dressing Up,* both overflowing with vulgarity, are like commercials gone berserk. In the first, parodying Acconci, she alternates inane sales talk with demonstrations of a vibrator and a repeated chanted refrain; in the second she chats about sales, discounts, and famous-maker brands, while munching peanuts and clumsily getting dressed in her bargains. Bill Leavitt's tapes have the brevity of commercials, and the visual fascination with surfaces and materials, making a fetish of genteel elegance like ads about spotless glasses or dishes you can see your face in, while on the sound track disembodied soap-opera voices, out of touch with their feelings, talk blankly.

While video pieces in L.A. are being structured on commercials and commercial programs, ridiculing the follies of a materialistic culture, a group of militant politically oriented artists in San Diego take the news and the documentary as their models. In San Diego, narrative is a populist stance, and art becomes investigative reportage, exposing the evils of the society.

"We all do a lot of research," says Martha Rosler, whose short tape *Semiotics of the Kitchen* turns a Julia Child–type demonstration of cooking utensils into a hostile display of weaponry. "Gourmetism as an imperialist endeavor" is her stated concern; she uses cooking as a metaphor for art. "If you're looking for drama you're not going to find it here," says the narrator of Brian Connell's *La Luche Final,* a long factual video piece about the attempted assassination of a U.S. ambassador in Latin America, using familiar news structures and eyewitness reports to piece together a story of sabotage.

Fred Lonidier uses photos, captions, texts, and video documentation to make vicious sociological commentaries that necessitate a kind of simultaneous episodic reading learned from television documentaries. Art is not immune from his commentary. "We're politi-

cos," he says. "The thing is that most artists are anarchists at heart, sort of carpetbaggers and fly-by-nights, particularly the whole Conceptualist thing." In an occupational-accident artwork, documenting the disabilities of victims of industrial mishaps, he is also calling attention to the fascist possibilities of Conceptualist performances. "Conceptual artists have mutilated themselves. It's only one step further to mutilate someone who doesn't want to be," he says. "My work is a critique. I'm just trying to up the ante a little."

Television itself is a subject for Phil Steinmetz's commentary in a picture book known as *The Evening News,* in which the bright cube of a TV screen in a dark room is the repeated format of the photographs. On the screen, images from the evening news are anecdotally paired with images from the interrupting commercials—war disasters are mitigated by odes to Lysol and Midol.

In Allen Sekula's photonovel, *Aerospace Folktales,* a visual biography in terms of ideology, sequences of photo reproductions make a confessional documentary about his father's unemployment. Toward the end of the book are several pages of images of bookshelves, a catalogue of the man's literary tastes.

There is a peculiar relationship between the book and television: television has made the written word obsolete. Many artists using video are also using the format of the picture book as a substitute for video. Allen Sekula's photonovels or Phil Steinmetz's picture books are part of the video culture: their sequential photographic images are seen as stills translated from TV. Pages are meant to be flipped rapidly. And if, as in *Aerospace Folktales,* the photo reproductions are gray and grainy, it is just one more reference to the lack of definition in an on-the-spot news report. While artists' books in L.A., like *World Run,* which Billy Adler made with Van Schley, tend to have the slick professionalism of commercial advertising, in San Diego they are less showy, as befits their didactic stance. Supported by the university structure, these artists are a radical academic segment of the California art world, producing a curious militant educational art—a strange offshoot of Conceptualism.

In post-Conceptual California, the medium is a matter of the content: skill is something you pick up when you need it. Artists have already learned from video. Al Ruppersberg, Alexis Smith, and Eleanor Antin have all used video to tell stories. Their nonvideo work reflects the interrupted narrative structure of television and at the

same time subverts it, acting as nostalgic commentaries of the once upon a time when people actually read novels. It is as if *Fahrenheit 451* had come true.

When Al Ruppersberg wrote a paperback novel that was mostly blank pages, he was commenting on the fact that the written word is obsolete. When he made a handwritten copy of *The Picture of Dorian Gray* on twenty man-size canvases, turning a book about a painting into a painting about a book, he questioned what visualization is. In *The Footnote,* his recent three-panel work, a grid of books on shelves, photographed in living color, mimics a library wall, while a written text in the form of a narrative footnote scrawls across all three panels, speaking of suicide.

Alexis Smith's abbreviated commentaries on *Robinson Crusoe* and *The Scarlet Letter,* with the pages spread side by side on the wall, condense the essentials for the nonreading video culture, using sparse visual metaphors for the literary content like trademarks. Too slow for the instant vision of the traditional art viewer, too quick for the true reader, they function as signposts of the changes in perception wrought by television. The instant identification of symbols learned from countless commercials, the quick cut, the interrupted story, and the station break enable us to read a desert island in a single segment of a jigsaw puzzle, or a whole story in an inky footprint.

Television may not be the ideal model, and video, in spite of its rapid proliferation, is not the answer to art's dilemma, not yet at least. But it is carrying clues to the new narrative. Baldessari, speaking in 1974 of a growing disenchantment with video, said, "With enough disillusionment perhaps more artists will consider doing works using the real world. Consider real experience rather than hiding behind the screen. And this may be the real payoff and what we have all been heading toward. The real world may not be so bad."

Eleanor Antin, *War Games*, 1977.

11 Eleanor Antin:
The Angel of Mercy
and the Fiction of History

In the spirit of an age that built quaint classical ruins and gothic follies, blithely imitating the styles of previous epochs when it wasn't imitating humble or exotic reality in its art, Eleanor Antin's *Angel of Mercy* recreates the eclectic mid-nineteenth century. "I see time as epoch and genre rather than as an unfolding process,"[1] she says, and the piece—which includes photographs, large painted cut-out figures, and a performance—is immersed in the Victorian past. Just as photography, a new medium at that time, imitated the paintings of the period—while the paintings looked back to earlier art—Antin's photographs paraphrase both early photography and Victorian painting. Her painted portrait figures, almost life-size, might just have stepped out of one of those salon paintings. And about her script for *The Angel of Mercy,* she remarks, taking more liberties with time, "I studied Oscar Wilde, commedia dell'arte, Brecht, Pirandello, and the utopian Fourier. I stole some lines from Wilde and Fourier, and the others acted as a dense musical background in my memory." So now as then the new can masquerade as the old, when what was really new, both in the mid-nineteenth century and today, was the fact that style itself had become obsolete. Bankrupt formal conventions were being cast off and past styles could be taken on and discarded at will.

Post-Conceptual originality often comes disguised as commentary on the past. And while *The Angel of Mercy* may appear to comment on the stylistic, social, political, and moral climate of Victorian England during the Crimean War, it is also commenting on the immediate past of art. "The early conceptualists were primitives," Antin wrote

Essay in the exhibition catalogue, *The Angel of Mercy,* La Jolla Museum of Contemporary Art, 1977.

a few years ago. "Contrary to their belief, documentation is not a neutral list of facts. It is a conceptual creation of events after they are over."[2] And so, with her living self-portraits, which are autobiographical fictions—the "performance selves" she has been creating since 1973—she turns art into the documentation of intimate personal obsession and, while commenting on Conceptualist fallacies, confronts broader questions of history and identity. Her seventeenth-century King and her early-twentieth-century Russian Ballerina were refugees in the present as well as revisions of the past.

With *The Angel of Mercy*, historical slippage takes place within one of her own personages: it is a revision of her earlier Nurse, Eleanor Antin, R.N., the "colloquial nurse," or the "little nurse," as Antin now thinks of her. That repressed childlike creature, who played with paper dolls and Clara Barton, Girl Nurse fantasies at the Clocktower early in 1976 has retreated further into the past, like Bridey Murphy, to emerge triumphant as a clear historical figure of Victorian England: the heroic nurse of the Crimean War, the first professional nurse. In fact, if we didn't know it was Grand Nurse Eleanor, we might mistake her for Florence Nightingale. While the King and the Ballerina slip in and out of the present, the Nurse slides into the past, splitting into two distinct personages. Meanwhile Antin is making plans to introduce a third Nurse, the "black colloquial nurse." "It finally appears now to me that my black self is not a profession. Black is a color, and it will color my other roles." The work of art can mimic the artist: multiplying into different selves like Virginia Woolf's Orlando, the Nurse seems to mirror the process of Antin's creation of the "performance selves." Personal history can be invented, but irreconcilable discrepancies with historical possibility may occur. As Antin puts it, "After the fact there is only history and history is always fiction."[3]

The Angel of Mercy marks a major step in Eleanor Antin's work. Her "performance selves" have all been portraits of the artist in disguise, with their own fictive oeuvres: each produced art, and literature, of a sort consistent with his or her nature. But now, instead of the King's rococo watercolors and noble sentiments penned in flowery script ("You see the King meditates in a style appropriate to a king"), or the "little nurse" 's paper dolls and "true romances," we are given an impressive collection of old album photographs and another of Crimean War news photos. "These pictures are proof that I was

there," she says. It is almost indisputable evidence.

The King and the Ballerina, portraits come to life, were detached from their background, existing in an unsuitable landscape. The King wandered through the modern world—a historical figure transposed into the present. In the checkout line of Vons, at the Bank of America, or sitting on a park bench drinking Budweiser out of a can, he was "the deposed King ranting about the loss of his kingdom," as one of his meditations notes. The Russian Ballerina was equally out of place in Solana Beach; self-taught from a book, not having learned how to move, she could only strike poses. But Grand Nurse Eleanor is integrated into the landscape: the twentieth century masquerades as the nineteenth, and Southern California is made to substitute convincingly for Derbyshire as well as the Crimea.[4] And while the King's subjects were the present-day inhabitants of Solana Beach, and the Ballerina's most appreciative audience was a hobo in a boxcar, the "little nurse" 's daydreams of tiny paper playmates signaled a desire for congenial companions.[5] No longer alone in her alienation, Grand Nurse Eleanor is accompanied by friends as well as scenery: she is surrounded by other figures—real people in period costume—existing within her fiction, reinforcing its reality. Just as the documentation is no longer the amateur artwork of her personas, the photographs are no longer the objective documentations of a contemporary artist's performance work. Instead of videotapes and eight-by-ten glossies, she gives us fictional documentation, period pieces, simulations of a past that never was. Even the photographic evidence has become absorbed in the fiction of history.

And instead of the improvisational psychodrama of Antin's previous performances as King, Ballerina, or Nurse, *The Angel of Mercy* is scripted, directed, staged, acted, not only by the artist herself but by two other live actors and the whole cast of realistically painted cutouts on wheels, two-dimensional stand-ins for the people in the photographs. The unpredictable soliloquys of past performances, during which one persona might appear instead of another, or might metamorphose into another ("It gives them a chance to talk to each other"), have been transformed into a structured three-act drama with suitably stilted Victorian dialogue and dialects.[6] Just as the photographs—costumed, choreographed, shot on location—required a directorial talent, the performance engages the directorial aspect of the artist as art fully accepts the implications of theatricality. "I did not want

creativity of an expressionist sort from my crew. *What director does?"* Antin asks.

Like enlargements of the "little nurse" 's paper dolls, the crowd of cutouts performs in the enactment of Grand Nurse Eleanor's story, a historical melodrama in which Antin is the animating spirit, speaking to them and for them, moving them and moving among them, bringing them to life by force of an insistent imagination. Sentimental, compulsively compassionate, full of clichés and moral indignation, she takes on roles and voices like a medium at a séance, conjuring up the fiction of the Lady with the Lamp. It is a kind of puppet theater of portraits inhabited by Antin's voice, gestures, theatrics—a director's dream. Split between Eleanor's life in England among family and friends and her heroic if sometimes misguided efforts in the Crimea, the performance parallels the two groups of photographs.

Apart from their roles in the drama, the cutouts are observers, historically misplaced spectators at an exhibition of antique photographs of themselves. They are also contemporary art world people. John Perreault is the suitor, Fred Lonidier is the Doctor, Jerome Rothenberg is Lord Raglan. Newton and Helen Harrison, Martha Rosler, David Antin, and others of the San Diego art community are cast in the roles of Victorian ladies and gentlemen, hussars and lancers and common foot soldiers.

The series of sepia album photos, dappled with sunlight and sprinkled with Victorian niceties, shows Eleanor Nightingale's carefree life in an innocent and superficial society before she found her vocation. Among ladies with parasols and gentlemen in frock coats, playing croquet and blindman's buff in tranquil gardens, there are hints of the future nurse in pictures like *The Sick Child* or *The New Arrival.* The war photos, in cooler tones, depict tender and tragic moments of Grand Nurse Eleanor's life in the army camp—a letter from home, a prayer meeting, the aftermath of battle, the execution of a deserter, and of course the Angel of the Crimea comforting wounded soldiers— all in a romantic desolate landscape. As Southern California substitutes for the Crimea, a pious nineteenth-century mentality is reconstructed with the irony of the present. Narrative, especially in San Diego, is a populist attitude, and Antin's work seems not only to embody but to comment on this emerging moralism in recent art.

"They weren't brown in the nineteenth century. Brown is the color of romantic nostalgia," remarks Antin about these enchanted photo-

graphs that reproduce the styles, the moods, even the flaws of early photography, with slow exposures and fine crystalline detail, with irregularities, faded tones, and sentimental titles in brown script. If the King might have stepped out of a Hals or a Rubens and the Ballerina flirted with Degas and Diaghilev, *The Angel of Mercy* photographs paraphrase not only Roger Fenton's Crimean War photographs but Mathew Brady's Civil War ones, as well as Winslow Homer's sketches of the Civil War and Eakins's Civil War painting *The Letter Home.* As English and American history merge, Cameron, Adamson and Hill, Sargent, even Fragonard, are echoed. Paraphrasing the art of the period and the art admired by the period, they look not only very authentic but also hauntingly familiar. Future art historians have waiting for them a rich trove of built-in research material, but Antin has planted her references to art's history so gracefully that their sardonic comments about the availability of the whole past and the inaccessibility of history might easily pass unnoticed.

Past and present, life and art, continually overlap, drawing strength from discrepancies and displacements between history and fiction, reality and role, figure and background, and from confusions between object and subject, image and self. Lord Raglan sits in the exact pose of an ancient news photo, but at the table with him—instead of the Pasha discussing terms of peace—is Grand Nurse Eleanor, and they are playing a Duchampian game of chess. *Lord Russell of the Times* is not a parody of the present art critic of the *New York Times* but the *London Times* reporter, the first war correspondent, who exposed the scandal of the Crimean War, the Vietnam of its day and the first war to receive media coverage. Philip Steinmetz, the photographer of Antin's pictures ever since *100 Boots,* is the only figure to retain his present identity intact as he is transported into the past: as Philip Steinmetz, Esquire, photographer of the Crimean War, he is immortalized in a stiffly formal self-portrait with smock and antique box camera, the collaborator in making Nurse Eleanor's fiction a reality. In traditional terms, all Antin's work is a form of portraiture. But in a narrative climate—a climate that her work helped create—portraiture makes its appearance as biography. "A biography is an invention, not to tell a lie, but to set up a psychological machine," says the artist. "Literature indeed! This is life, this is passion," as one of Pirandello's characters in search of an author exclaimed.

Before she began making art, Antin herself was a poet, and what

she calls her "baby poetry" was included in several anthologies. Before that she was an actress.[7] She carries these capabilities into her artwork. By splitting herself into separate "performance selves," by letting them, as amateurs, create their own dramatic roles and poetic words, she manages to fuse the multiple aspects of herself and to explore the possibilities of her own identity.

In 1965 she collected blood specimens from one hundred poets. It was her first work of art. In the guise of pure documentation, she displayed a very private, if anonymous, human substance.[8] But the title—*The Blood of a Poet Box*—gave away its narrative yearnings: it contained the genes of portraiture, the beginnings of biography. Her subsequent portraits of women, real and fictional, made out of "configurations of brand new consumer goods," went further: the impersonal objects combined to reveal the idiosyncrasies of specific personalities. With *100 Boots*, object became protagonist, hero of a cross-country odyssey, a biographical narrative, and the artwork itself was made to duplicate the journey, crossing the country through the mails. Structured like a novel, incorporating real time, the postcard saga ended at the Museum of Modern Art, where the actual boots camped out at the end of their trip. The boots, the blood specimens, the consumer goods—substances within the body or objects associated with the body—were metaphors for people, for personalities. The body itself becomes the object as biography becomes autobiography in *Carving: A Traditional Sculpture*, a photographic piece in which the artist documents her loss of weight over a period of time in a series of frontal nude photographs. In *Representational Painting*, her first videotape, she then uses makeup "to paint my face, to change the image of myself." The "performance selves" followed, self-portraits in fancy dress seeking their identities, and Conceptualist Body Art achieved its full narrative potential.

And so the severe seriality of the late '60s is turned inside out by the serialized fictions of the '70s. The myth of objectivity—minimal, literal, formalist—which propelled the '60s into the Conceptualist doctrine of art as pure information—nothing but the facts—is now being refuted by post-Conceptual subjectivities. While substituting historical fictions for Conceptualist facts, Antin is commenting on society's pretensions as well as art's. After insisting on all the quirks and illusions and narrative possibilities of the personal, the intimate, the psychological, artists are expanding their investigations to include the

social, political, and moral responsibilities of that self, and Eleanor Antin was one of the first to delve into the interactions between the private self and the public world. "I used to put the Boots out into the world. I put the King into the world," she remarks. "(In a sense all of my personas act as 'terms,' particularized nouns, socially loaded with a variety of significance for human identity)," she writes, and her parenthesis should not go unnoticed. For if history is fiction, identity is in question.

Confronting the invalidity of personal identity as well as history itself, she places reality in doubt. Eleanor Antin's nineteenth-century photographs, impressive as they are in their apparent authenticity, are simulations—like the King's faded reveries on tattered parchment or the Ballerina's hasty pages from sketchbooks. And the viewer, drawn into their life, their reality, their fiction, ought not to forget their duplicity.[9] The acceptance of illusion marked the beginnings of the 1970s. Antin's post-Conceptual narrative art is not just a reaction to Conceptualism, showing facts up as fictions. Oddly enough, it can also be seen as an extension of the literal self-exposing illusions of Super-Realism. It was unthinkable that a Super-Realist painting might tell a story, for form was still the issue, as it was for other post-Minimal art involved in the demolition of Formalism. However, the informal snapshot photograph—the content of the Super-Realists—could become a medium capable of conveying narrative content in more conceptually oriented art. "Literary" not so long ago was an insult to a work of art. "Theatrical" was an even worse epithet. But now it is the self-sufficient art object that is taboo: art for its own sake is over, and if art often seems to be elsewhere in the '70s—the aesthetic evidence of didactic speculations—it is because it has become responsible in the world, with social, political, ecological relevance, and a moralist stance. *The Angel of Mercy*'s excellent mimicry of nineteenth-century style is only its surface.

As convincing as it is in its pretense of belonging to the nineteenth century, *The Angel of Mercy* is also totally appropriate as a 1970s artwork. Art in this decade has taken any number of disguises to evade looking like art; style has become voluntary and anachronistic in this informal time. History, as Antin shows us, is nothing more than personal fantasy, carried to extremes, revised at will. The same could be said for identity. And the production of art and literature is make-believe, a nostalgic vestige of the past. Life is all that remains.

Art in the '70s is mimicking life. While intellectuals watched *Mary Hartman, Mary Hartman* and *The Gong Show,* while rock and avant-garde musicians created operas, while everyone talked on the CB, art was becoming a narrative endeavor, structured by time rather than form. The popularity of soap opera and country music is not insignificant. The new sensibility is attuned to the demands of performance, and it values the amateur. It incorporates memory and whatever mediums it needs, synthesizing irreconcilable elements into grandiose and incongruous tours de force. It is episodic, and it is involved with context—with art and life alike taken out of context. And Eleanor Antin, moving in and out of different lives, sending art through the mail and giving performances in galleries, has been at the forefront of this development. Art has moved into the world: Rauschenberg's gap has been, finally, closed. Impersonating the past, Antin personalizes the issues and dilemmas of the present. Her work is, probably more than we yet realize, a portrait of our time.

NOTES

1. Unless otherwise noted, quotes are from conversations with the artist in November 1975, January and June 1977, or from a letter written by the artist to me in June 1977.

2. Antin, "Notes on Transformation," January 1974.

3. Ibid.

4. The fact that she recently moved from Solana Beach inland to Del Mar, a more old-fashioned area, is relevant to her Nurse's move back in time. The Harrisons, who also moved to Del Mar, describe the area as "like going back a hundred years." Her living in California is also relevant to her work. Where else would an artist be as free to invent fictitious pasts that are timely and compelling truths? In California—where history has been replaced by current events, where almost everybody is displaced, transplanted by choice from somewhere else, where "back East" implies that the East is the past and distance is time—life and art have traditionally been magnificently confused, not only by Hollywood and Disneyland but by obsessed amateurs, visionaries such as Simon Rodia and Baldesare Forestiere.

5. Says the artist about the role: "If something pains me too much, I tear the doll up, which I used to do as a child, by the way."

6. As well as the sources she mentions for the script, there is of course Florence Nightingale's diary, which is paraphrased in some of the dialogue. Eleanor Antin began scripting parts of the scenario of the King's performance, *Battle of the Bluff,* for the

1976 Venice Biennale so that her "cavalier-translator," Massimo Mastacci, could follow her. "The decision to use many actors—both the large and small figures—was the final death blow to my improvisatory style," she writes in her letter.

7. "I was a terrible actress. My great triumph was at an NAACP convention in something Ossie Davis put together. I brought the house down with an improvisation. It wasn't planned, it just happened because the script was so awful." Another reminiscence is relevant to her art. "I had gone to Music and Art [high school in New York], and the only thing I was good at was costume design. My relation to art was—I used to go around Music and Art defending the Renaissance."

8. Its relation to the literal Minimal climate of the time may or may not have been intentional: "I obviously thought about Cocteau, I liked the pun, I liked the blood—I can't remember. Now that I think about it, they were all Dada works, the early ones," she says.

9. "It seemed to me that a perfectly anglicized face in a halo of long light hair might suggest a true Victorian image when you came upon it in life but in art it would probably look like a fake," she writes about her staging of the photographs. "It is not the real thing which suggests the real in art. It is rather the slight disparity, the unexpected even, that will give the appearance of truth."

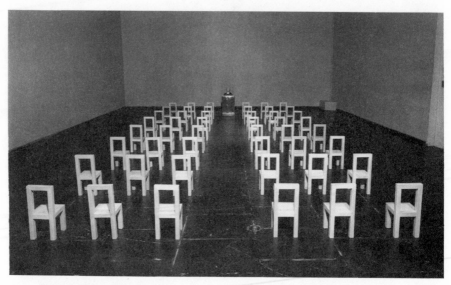

Dennis Oppenheim, *Lecture #1,* 1976–83. Collection Whitney Museum of
American Art.

12 Dennis Oppenheim: Post-Performance Works

When *Theme for a Major Hit,* the first of Dennis Oppen-
heim's "surrogate performance pieces," appeared in a group show in
1974 like some bizarre apparition, no one could understand why a
Conceptual artist, a pioneer of earth and body works, had produced
an eerie mechanical puppet suspended from strings, awkwardly
doing an endless song-and-dance routine on a cylindrical platform.
It ain't what you make, it's what makes you do it, it sang, and its sound
was as startling as its theatricality.

While we were exclaiming over the surprise reappearance of nar-
rative content in art, we missed the fact that along with narrative,
which could be comfortably traced to Conceptualist antecedents and
Victorian ancestors, came something totally new: visual sound. We
are living, though we may not know it yet, in operatic times. And the
synesthetic phenomenon of visual sound—aural art—has been
around, more or less unremarked, for some time now.

A dialogue can be constructed, a symposium simulated. Art has
been talking to itself. Out loud. Start with Robert Morris's *Hearing,*
which in 1972 put art on trial and threatened to electrocute the specta-
tor, who should have been shocked to find that he was not only a
viewer but a listener. When no one got the message, he did *Voices* two
years later, with almost nothing to look at, just the sounds of madness.
Vito Acconci answered from the prison, from the madhouse. Les
Levine answered from the funeral parlor. Oppenheim answered, art-
ist-fugitive-assassin, victim and perpetrator. Perhaps he was imagin-
ing that it was he who might have been on trial. As if in fear for his
life, he sent puppet surrogates to perform for him—to try to retrieve

Arts Magazine, September 1978.

the past, to warn of the future, to render the present less opaque.

A decade earlier, that most maverick of cubes—Morris's *Box with the Sound of Its Own Making*—was emitting noises of hammer and saw. And Rauschenberg's *Soundings* at the end of the '60s was activated by the sounds of its spectators, making itself visible only as they made themselves audible. It was ignored in embarrassed silence as a stray offspring of technology. Cage had demonstrated that music could be silence, but because we were not trained to listen in an art gallery, we have been slow to realize that art has found its voice. We were too busy with the dawning realization that art is now a narrative endeavor, structured by time rather than form, to think about the voices we were hearing. Oppenheim had been working with sound since 1969, quietly. "For instance, I did a piece where I walked around a certain part of Milano and it was called *Sound in Enclosed Land Area.*"[1] It was just that: footsteps enclosing a rectangle of land.

The new art sensibility, dissolving boundaries, projecting itself, is attuned to the demands of performance, and it values the amateur. Like punk rock, it is tough, threatening, hostile, with a defiant unconcern for professional finish or visual refinements. While Acconci created scenarios for the absent artist and insinuated the spectator's suicide, offering planks to walk and spaces to fall into; while Les Levine held a gaudy requiem for the death of the art world and hung the absent artist's clothes on a line for drip-dry purification; while Eleanor Antin staged melodramas by her "performance selves," assuming layers of aliases and disguises—Dennis Oppenheim, speaking through his surrogate performance figures, committed fictional destructions of himself and other artists. The new art sensibility has been talking about the artist.

The absent artist: it is a theme of the mid-'70s. The art that was still being produced in the name of sculpture was being miniaturized (Joel Shapiro, Richard Tuttle), was hiding behind the walls and under the floor (Barry LeVa), was pretending to appear without the aid of an artist (Charles Simonds), lurking in unexpected places, nearly invisible, or stretching to equally nonvisual global scale. Think of the opening show at P.S. 1 two years ago. An uninitiated observer could not have distinguished the art from the natural decay of the decrepit building. And in a natural environment like Artpark—where Oppenheim's tar fingerprint covers an area of a thousand feet—the art hides in the landscape, indistinguishable except to initiates. As art intersects

life and professes populist concerns, moral responsibilities, synes-
thetic perceptions, it obscures itself more and more until it can no
longer be seen without a guide dog. Art has been trying to make itself
invisible. And as it vanishes, sound enters.[2]

By the early '70s, Formalism was being condemned as guilty,
insane, dying, or dead. That was the message of the dialogue between
artworks by artists who had come of age in the Minimal '60s. That was
the nature of the impasse Dennis Oppenheim speaks of, describing the
period when he did his whirlpool in the sky and his first surrogate
performance figures: "I think this was a desperate time for a lot of
people although they might not admit it. But simply because the '60s
had snowballed work at such a high velocity and the artists were all
suffering withdrawal symptoms, I mean they were all shell-shocked.
At least I was."[3]

The "surrogates" emerged out of this impasse. The content of
Oppenheim's earlier work, like Bruce Nauman's and a lot of other art
in the late '60s, had been its criticism of Minimalism, its attack on a
purely structuralist, Formalist art. Content entered through a ques-
tioning of form as artists imposed Minimalist severities on body or
land or the workings of their own mind. From the beginning, for
Oppenheim, "art was always a thing to be attacked."

Modern art had begun when it was rumored that God was dead:
the artist took over, assuming the godlike role of Creator, becoming
all-powerful inventor of styles and forms. When Formalism was
played out and Modernism began to recede into the past as a historical
style, it seemed as if art itself were over. That was the mood of the
early '70s. According to Oppenheim, "The suspicion was usually the
artists' own suspicion about their own work and it was a unique
period of re-evaluation and very sensitive and extreme paranoia."[4]
The artist, no longer creator, had become critic, commentator, per-
former in absentia, like a puppet responding to invisible impulses,
while post-Minimalism slid into Postmodernism.

With Oppenheim's surrogate performance pieces, Minimalism is
no longer the content: artmaking is. They can be read as narrative
episodes about the postmodern artist's dilemmas, a new kind of self-
portrait. Their metallic faces have an uncanny resemblance to his
own. The puppets are substitutes, metaphors of the absent artist.

The puppet in *Theme for a Major Hit,* jerkily going through his old
song-and-dance routine, may have been telling us that the artist him-

self no longer could. Unless, mindless as a marionette, he was to endlessly repeat himself, making the old art. "I usually talk about that work, which eventually developed into the other surrogate pieces, as post-performance," says Oppenheim. "It's a device or agent that can perform in such a way that the individual cannot."

The sharp clang of a large bell sounded a more strident note in the second piece, *Attempt to Raise Hell,* as the puppet, activated by magnets, hit his metal head against it suddenly and repeatedly, like the artist still hitting his head against the solid object—unable to pass through it, unable to avoid it, producing painful noise. "The sound of metal clashing against metal fills the room as well as the mind," noted Oppenheim. He may have been implying that sound could be as sculptural and spatial as solid form. Stringless, the second surrogate figure had an autonomy that brought it closer to life. The definition had shifted; the small figure made by strings to perform mock drama had given way to the puppet as a tool, subject to the will of unseen forces. It was our empathy that was painful. It was a graphic demonstration of that sense of blockage or impasse that seemed to be pervading the art world.

"It oscillated between sculpture and theater," commented Oppenheim about *Theme for a Major Hit.* Aligned to Body Art and performance, continuously repeating, vacillating between real time and theatrical time, his first two post-performance works were also sculptures on a pedestal, even though the symbolic figures were less object than conceptualization. *Table Piece* (1975), a hostile dialogue of opposites, was more elaborate, more fully narrative and theatrical. The pair of surrogate figures, one black, one white, at either end of an immensely long table (which paled gradually from black to white), were part of a tableau, an installation; claiming their own space and their own time, they performed for an hour and a half. And they were even more independent: with speaker systems inside their heads and jaws activated in lip sync, they were like ventriloquists' dummies without a master. *Table Piece* was about tone and lack of color, coloristically, and about color, racially; the black and the white figures carried on a threatening dialogue about osmosis, attempting to merge, inhabit, and destroy each other. The unease was enhanced by the intermittent beat of primitive drums.

Though they may appear a total break from his past work, the surrogate performance pieces are amplifications of earlier work, re-

stating recurring themes. For example, like *Table Piece,* his 1970 sun-
burn piece was about color—paint color and body color. It had "its
roots in a notion of color change. Painters have always artificially
instigated color activity. I allowed myself to be painted—my skin
became pigment."[5] There are also connections between the attenua-
tion of the elongated table and a long metal pan of turpentine in
Recall, a video installation that immediately preceded the first surro-
gate performance works in 1974.[6] In spite of its attacks on Formalist
art, visual work cannot totally escape from form. The video close-up
of the artist's mouth recalling art school experiences at one end of the
pan and the spectator listening at the other end paralleled the pair of
surrogate figures at the table. The nostalgic smell of the evaporating
turpentine was, like the shades of gray, a remnant of the old art. And
the content of *Recall* was also osmosis. "Instead of thinning down
pigment, I'm absorbing the material into my sensory system, and
thinning out layers of repressed memory." It is another dialogue with
the art process, a commentary on artmaking dislocated from the art
object to the artist's body and mind.

The surrogate performance figures are substitutes, projections,
but Oppenheim's work has always had to do with projection: with
changes in scale, material, or behavior, transferrals of characteristics
from one thing to another. Just as land was a surrogate for canvas or
paint, skin was a surrogate for land; the idea of the substitute material
led to the idea of the substitute body. Dogs or cows could be surrogate
performers in his land pieces, and when he used his offspring as
"biological extensions" of himself, they, too, became his surrogates.
Even when he used his own body in his work, there was an "element
of externalized manipulation."[7] Somewhere within all his work is a
sympathetic magic having to do with likenesses. "Likeness has the
most powerful ties with the man it represents," wrote Kurt Seligmann
in his history of magic.

Theme for a Major Hit was made as a multiple: it could perform
in several places at once. *It ain't what you make, it's what makes you
do it,* its tinny rock sound track kept telling us. But his work had been
trying to tell us that for years: going back to raw materials, returning
art to its origins, delving into its motivations, seeking the impulses
that make artists make art. For Oppenheim, art is "a device to interro-
gate itself. In other words, the artworks were essentially put in motion
to look into the varying activity and process of artmaking." His Earth-

works were about art, his body works were about art. All along, his work has been talking about art: it is the metaphoric content that unifies an otherwise erratic oeuvre.[8] His questioning of art as a process and an activity led to the verbal and visual dislocations, and to an autobiographical psychological context: to the artist himself. The performing puppet, the surrogate figure, was not such a break from his past work after all. As we look back at his "land transplants," "material interchanges," "identity transfers," it now seems an inevitable result. As a boy, Oppenheim actually used to make marionettes; between the ages of eight and twelve he put on shows with them. He disclaims any connection.

After the eerie animation and threats of *Table Piece* came the lifeless, inert surrogates of 1975 and '76. *Search for Clues,* with its murdered dummy stabbed in the back on a magic carpet, and *Broken Record Blues,* with its inert dummy dragged across a blue sand floor, leaving scratchy musical notations in its wake,[9] were strong metaphors for the absent artist, as if even the puppet could no longer be animated. In the latter piece, a second surrogate figure sits in the corner like a naughty child. "No matter what sound I make it sounds the same, no matter what note I play it's been played before—like fingerprints that never change," says the voice track, which fades in and out while a phrase of music repeats like a record stuck in a groove. In the former, the role of the second surrogate is taken by Oppenheim's daughter, Chandra, who tells a tale of patricide on a video monitor. "All those dreams you had of an art that could not die . . . an art so liquid . . . I could drink it . . ."

The format of the next two pieces was the art historical lecture, the slide talk. The content was the afterlife of art—its future extinction, its vanished past. The mixture of straightforward art content and paranoid fantasy was allegorical and surreal, sideswiping metaphor. *Lecture #1* was the lecture hall tableau, with rows of little chairs that occupied the ground-floor gallery of the Whitney during the 1977 Biennial. A dummy lecturer stood behind a podium at the front; a dummy listener slouched in the last chair at the back. A taped lecture played; the lecturer's jaw moved in sync. His face, like the others, was modeled after Oppenheim's *(hypocrite lecteur—mon semblable, mon frère).* The lecture—a fantasy and fiction—a history of "recent" art supposedly spoken in 1995, begins in 1973 with Smithson's actual death and recounts in measured tones a series of assassinations, "the

slow but complete annihilation of the American avant-garde." De Maria and Heizer are early victims, perhaps because they grew up in the same part of California as Oppenheim, perhaps because they were rival earth artists.[10] A long list of Conceptualists and Minimalists vanish, appropriately, into thin air—the manner of the deaths is always appropriate—when a 747 explodes in 1979. In 1980 Acconci falls down an elevator shaft. Ryman and Sonnier are "taken" in the '80s, avant-garde dance companies and musicians go into hiding, galleries close—and motivation is given for Oppenheim's surrogate performances: fear of his own assassination. It may be an alibi as well. "There was an artist behind these acts," intones the spooky little lecturer, mouth moving, spotlit in green while the sound equipment is spotlit in blue. "The individual acts were facets within an evolving larger work."

A strange stretching of space was caused by the smaller-than-life-size, bigger-than-miniature, puppet scale. *Lecture #1* shared with *Table Piece* and *Search for Clues* a vast dreamlike emptiness and unreality. It looked even stranger with real people sitting on the floor listening to the lecture. "The '80s bred 'the art of survival.' Artists became investigators. The purpose of the American avant-garde was to break the code, trace the connections, feel out the rhythms, and shed light on what seemed to be an untranslatable masterplan set into motion by presumably an artist."[11]

Lecture #1 was a projection into an imaginary future, expanding on the idea of the lifeless surrogates. The puppet figure behind the podium in *Lecture #2* was in the dark, speaking about the past, giving a slide talk, and while it was Oppenheim's past artworks that were being described, the slides that were projected were of solid colors or empty sky. The past is as unreal and menacing as the future: art exists in neither. Between them, the Lecture pieces wiped out past artworks, present artists, and future art world, making art a conspiracy and the artist both victim and perpetrator. Done in 1976, *Lecture #2* was the last of the surrogate performances before Oppenheim rejected them and returned to the landscape, though related installations, such as *Early Morning Blues, Twin Wells,*[12] *Dayton Falls,* and *Well,* without figures but with voice tracks, continue to talk about the same issues.

Instead of the traditional end product—the art object—it has always been the energy of the process that matters to Oppenheim. The amount of energy in a work is his determinant of value. Explaining

why he is no longer doing surrogate performance pieces, he says, "It just couldn't hold the energy it was asked to." The notion of art as an act involving energy and risk can be traced to the Abstract Expressionist teachings of the late '50s, when he was at art school. His transplants, interchanges, and transfers are reciprocating gestures—literal translations of positive-negative painterly space, Hofmannesque push-and-pull.

Energy is also a concept of magical thought. With the surrogate performance figures, the body is replicated as a symbol of the artist—an extension of himself. Like his use of his children and other living creatures, it is an attempt to go beyond limits[13]—to do the impossible. Behind his transferrals between art and life, body and land, earth and sky, thoughts and events—his stars in the grass or words on the ground—are impulses to merge and mix, to influence and control the world of matter. It may be the sculptor who wants to merge with matter, but it is the magician who has the ability to control matter, to disappear. As Mircea Eliade pointed out about the role of puppets in primitive magic, "The magician is, by definition, a stage producer."[14] Theatricality is essential.

Like the African masks on his walls, Oppenheim's art approaches magical purposes. The significance of energy is a clue. Art for him is a causative tool to predict, protect, destroy, change: to project desires. Interacting with natural forces, it is an attempt to manipulate the external world, to mediate between man and nature. His earlier work has been called shamanistic, but it is more than that: the surrogates extend the idea of magic power. They speak to the sources of creation, the unconscious processes of art, like incantations to invoke continued creativity. They are not only likenesses, substitutes for the absent artist; they are magical similars. And they are defensive, evasive shams—to make him invulnerable.

Oppenheim's retrospective of work from 1967 to 1977 minimizes the surrogates—perhaps because of the amount of space they need, perhaps because no one, including Oppenheim himself, has quite come to terms with them. "There are only a few of them, they aren't being continued," he says. It is hard for an artist trained on real time and literal acts to accept a new illusion, artifice, symbolism, and theatricality—even if it is his own. But the retrospective makes it infinitely clearer that sound has become sculptural, taking up space. The ear-splitting clang of the bell resounds throughout the museum,

a motor throbs and clacks, the boots pound incessantly at the walls, a projected hand slaps other walls, and *Theme for a Major Hit* relentlessly plays its funky tune. It is no longer true that art should be seen and not heard.

"If I were a younger man, I'd be getting into Punk," Oppenheim told *The Village Voice* last winter. In a way, he is. His sound tracks have some of the deliberately rough amateur awkwardness that is a refusal of accepted technique and form; his words express a similar destructive aggression and alienation. The same climate that was producing a younger generation of Punk musicians gave birth to an angry proto-Punk art—Oppenheim's, Acconci's, Chris Burden's. There was Punk viciousness in Oppenheim's early art thefts of hubcaps or use of rat poison and disinfectant as art materials; hostility in his delineation of spaces with guard dogs, marksmen, or marching feet; disregard in his use of a dead dog, cattle, or even his own children as tools of art. Critics have toyed with the political—antiliberal, fascist—provocations of his work, and certainly he invites this when he equates a circle of Ku Klux Klan hoods with a ring of tepees, proposes a tar-and-pigment feather as if to tar and feather the earth, plans an Iranian commission titled *Death Hole,* or imagines a fictional "aesthetics of assassination."

The '70s are more hostile than the '60s: patches have been replaced by rips and safety pins, flower power has been transformed into something mean and surly. Oppenheim's surrogate figures with metallic faces and hands, with bodiless little tailored suits—moving with sudden spastic gestures or speaking with snapping jaws—are not only like marionettes, like ventriloquists' dummies. They also have something in common with Elvis Costello. The new art is self-conscious, autobiographical, psychoanalytical, an art of commentary and criticism. Just as the true content of Modernist art now seems to be form and style, the underlying content of perhaps all Postmodernist art so far is its analysis of its own origins and awareness of its vulnerability. Its deprecating tone, its apparent mockery, is a metaphor for its loss of faith. Its narrative fictions allow it to speak about itself. Its use of sound exposes its own workings, swathing visual forms with aural content. Art has become an allegory about itself, and in Oppenheim's work that symbolic content is very close to the surface.

NOTES

1. Unless otherwise attributed, quotes are from a conversation with the artist in May 1978 or from the artist's notes accompanying the reproductions in the catalogue of his 1978 retrospective at the Musée d'Art Contemporain in Montreal.

2. Making possible, for example, totally nonvisible work such as the recent recording of artists' soundworks, *Airwaves*.

3. From an interview by Alain Parent in the catalogue of Oppenheim's retrospective in Montreal.

4. Ibid.

5. From an interview by Willoughby Sharp, *Studio International*, November 1971. *Color Application for Chandra* (1974) was also about color, "not applied directly to a surface but transmitted directly onto the memory track of a child," and then mimicked by a parrot—anticipating the ventriloquial aspect of the speaking surrogate figures.

6. There was also the long conveyor belt of *Wishing Well* (1973), another installation with a sound track, which spoke of osmosis (between figure and ground) in its efforts to bodily sink into the sidewalk. The doubling as well as the elongation occurred in *Shadow Projection* (1972), a performance in which Oppenheim stood at the end of a 2,000-foot-long beam of light, blowing a trumpet. His body, blocking the carbon arc, produced a dark shadow image that extended the whole 2,000 feet. "As I blow into the horn down this channel, the sensation of being in two places at once takes hold." A similar doubling of the body occurred in *Two Right Feet for Sebastian*, a 1970 installation in which two boots, ceaselessly kicking opposite walls, were also surrogates—feet for his friend Sebastian, an amputee.

7. Willoughby Sharp, op. cit. About his use of his children, he said in that interview: "It's like being in two places as one, I become both sender and receiver. It gets close to magic."

8. While his pieces have often had implications of social transgression or military attack, he has always explained them purely in terms of art: the stolen hubcaps were "a reductive sculptural process," the guard dog piece, *Protection*, was "guarding land in the same way that museum officials guard art objects." His early site markers, viewing platforms, and gallery decompositions attacked the art object by turning it into its own location or material. His arrow of white pigment pointing to a calcium mine returned an artist's material to its place of origin. "Planting and cultivating my own material is like mining one's own pigment (for paint)," he noted about his *Directed Seeding/Cancelled Crop* of 1969. "Isolating this grain from further processing . . . becomes like stopping raw pigment from becoming an illusionistic force on canvas. The aesthetic is in the raw material."

9. Like the dead dog in a piece at the Clocktower in 1974 which also left a track across the floor and provided a sound track by its decomposition.

10. De Maria was a classmate in Richmond. Was there something about the flat industrial Standard Oil landscape of refineries and storage tanks that provoked the three artists to use the flat surface of the earth in the late '60s? The metaphor of the oil industry seems to be surfacing in the four riglike towers of Oppenheim's recent *Dayton*

Falls, his *Twin Wells* gushing steam, his associations of liquid with creativity, and the fears of drying up expressed most recently in *Well*, a giant conical inkwell whose dark liquid could be oil as well as ink. "I like oil wells," he says when asked about this.

11. The comically sinister predictions had been anticipated in his 1973 model-train piece, *Predictions*. In that tiny doubling track with its two speeding trains and its prediction of a collision on the LIRR at a specific time and location in the future, he was creating, as he said at the time, "a surrogate system that relates to a real exterior location."

12. The steam emitted by *Twin Wells* is created by an enamel teapot on an electric burner concealed within the piece. This functional device reappears as symbolic object—the oversize teapot on neon burners—in *Early Morning Blues*, also done in 1976–77. The interconnections among his works are devious dislocations, just as the work itself is based on dislocation. The voice tracks of these pieces, too, speak of osmosis, of breaking through boundaries, trying to get out, detonating, erupting, or overflowing.

13. As boundaries between art and life are erased, all the edges that safely kept the arts apart are dissolving. Oppenheim shares his concern with the issue of crossing boundaries with other recent artists, such as Smithson or the Harrisons, but where they aligned their art with science or science fiction, his can be seen in terms of magic. It is tempting to compare these recent mergers of earth, body, and words—of man in nature—with the Emersonian literate landscape, but they are not as optimistic. While nature may still be beneficent, man no longer is. For Oppenheim, art is a demonic force. His impulses derive from the two basic premises of sympathetic magic, which are, according to J. G. Frazer, "the law of similarity" (like influences like) and "the law of contagion" (things that have once been in contact with each other, like a person's fingernail paring, continue to act on each other).

14. Mircea Eliade, *Mephistopheles and the Androgyne: Studies in Religious Myth and Symbol*, transl. by M. Cohen (New York: Sheed and Ward, 1965).

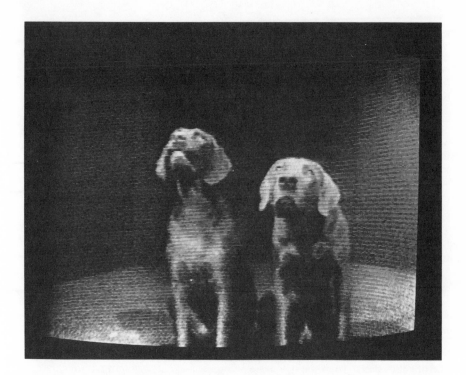

William Wegman, *Duet*, 1975, from *Selected Works*.

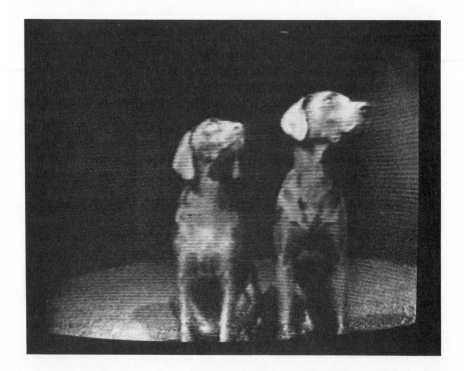

13 Wegman's Video:
Funny Instead of Formal

William Wegman's video work is full of booby traps. If you crack jokes—and the temptation is to make quips about man and dog, Wegman and Man, Bill and Ray—they never quite match Wegman's own inarticulate humor, or his dog's comic eloquence. And if you expound on his work seriously, you risk sounding ridiculous. Wegman's own insistently idiotic cornball stance rubs off on our words. By playing the fool, he reduces us all to blathering idiots. No wonder critics writing about his work often resort to the form of the interview. It's not that we look at his goofy videotapes with any sense of superiority; rather with dumbstruck wonder, with smiling acquiescence, with puzzled delight, with vague discomfort, and with pleasure. Somehow he manages to deny not only his own critical faculties but ours too. He overrides what used to be called the superego. That's no mean feat.

But let's start with a brief description. Two nearly identical dogs—one of them Wegman's own faithful weimaraner, Man Ray—sit side by side facing the camera. They perform nearly identical movements. They turn their heads, roll their eyes, twist their necks in almost perfect unison. They're like puppets, mesmerized by some unseen force. A doggy duo, a canine version of the Bobbsey Twins or the Rockettes, absolutely transfixed. The choreography is as exquisite as it is absurd. After a few seconds, we realize that they're visually tracking some moving object with total concentration. That's all. And that's all that happens, except once. Just when we've become perfectly conditioned to their twinned actions, there's a twist: the dogs thwart our

Essay in the exhibition catalogue *Wegman's World,* Walker Art Center, Minneapolis, 1982.

expectations by suddenly swiveling their heads in opposite ways, only
to end up focused on the same point in space. For some reason that
moment is excruciatingly funny, maybe because the dogs' momentary
confusion mirrors our own: we're the ones who have been reacting,
as we watched, like Pavlov's dogs. And at the end we get our reward—
a quick glimpse of the moving object as it passes, as if accidentally,
into view. It is a tennis ball Wegman has been waving in front of the
dogs. Not just the dog lover's ploy, the prelude to "Go fetch," but
the simple old-fashioned portrait photographer's trick—"Watch the
birdie." Except instead of a box camera, Wegman is using video equip-
ment.

Modest, black-and-white, of unremarkable technical quality,
scarcely longer than a TV commercial, this piece might seem unexcep-
tional. He's done little more than illustrate a time-worn visual cliché,
a trick of the trade of the hack photographer—using dogs instead of
babies, carrying things a little further, and exposing his own offscreen
trick. And yet this double dog dance, which he made in 1975, may be
Wegman's video masterpiece. Or maybe it's just my personal favorite
because it was the first of his video works I ever saw and the first work
of video art I had seen that didn't depend on an aesthetic of boredom.
Like the rest of the video pieces he made between 1970 and 1978, it's
very short. It's hard to pin down why it works, or what relationship
it bears to fine art or to commercial TV. Wegman's video art doesn't
lend itself to formal analysis. It doesn't present itself as an art of ideas.
Perhaps, then, the first thing to say about Wegman's video is that it
plays dumb.

"It completely simplified my life when I got into video. I stopped
thinking about floors and ceilings and walls," says Wegman. He got
into video in 1969 while teaching at the University of Wisconsin. As
he tells it, "My paintings got flatter and flatter and turned into sculp-
ture: floors, environments. I was rearranging the furniture. I was
floating Styrofoam word pieces down the Milwaukee River. I floated
a hundred commas down the river. I made a word piece combining
every four-letter dirty word you could think of." Those word pieces
weren't exactly the Duchampian puns popular with other artists at
that time. His indoor floor pieces weren't the usual post-Minimalist
"scatter works" either. Instead of emphasizing raw materials and nat-
ural substances, they had, Wegman says, "some sort of formal flip
using non-raw materials—doors instead of wood, nails instead of

steel, something that already had some history to it. There were size differences, for example, big and little pots and pans."

Wegman documented these temporary pieces with photographs. The photographs led to photo pieces: the initial impulse was documentation. "Video had a more mesmerizing effect. I started playing with it." And on video those formal flips looked more like the old switcheroo. "When you put them in time, automatically big and little, inversions, shifts, and structures come out funny instead of formal," he explains. "As soon as I got funny I killed any majestic intentions in my work."

In 1970 he moved to California, really got into video, and bought a thirty-five-dollar dog. Between 1970 and 1978 he made thousands of video works, and with few exceptions, none was longer than a minute or so.[1] He describes his early tapes as "innocent." He says they were often "an action, a simulation, and a combination of the two. Those little math numbers made me feel I was doing real art. My first tape took two years to make and I didn't know how to edit. Each time there's a different reel, there's a technical change—a new camera, a better microphone, different equipment. In the first reel I couldn't focus more than six feet, so everything was close up. I had a twelve-dollar microphone, so there wasn't much talking. I really went downhill when I started adding too much equipment too fast."[2]

In one of his early tapes, Wegman crawls backward on all fours, away from the screen. Drooling milk, he leaves a white liquid line on the floor. He exits and Man Ray walks in, licking up the line of milk as he advances until his nose fills the screen. It doesn't pay to scrutinize Wegman's video works too closely: it falsifies their intentions, which are most of all purely visual and improvised. But this "little math number" could be a comment on floor works, and on the way line was being made actual by artists in the late '60s. It could also have to do with psychological reversals: dog takes nourishment, man makes art. Whatever it is, it's captivating. Wegman simply comments that the video quality is more "milky" than a Portapak, which has sharper contrast. "I never used the Portapak. I always had the monitor on. I never wrote scripts. I would just pass something in front of the camera and see what I would do with it. The second take is usually the one."

It's possible that milk appealed to Wegman for its connotations of infantile regression, but another tape from *Reel 1* makes it clear that

for him, pouring a white line equaled drawing. This tape shows Wegman drinking milk, but instead of pouring down his throat, it pours visibly down in a straight white line in front of him, missing his mouth. In a tape from *Reel 5*, Man Ray laps up a glass of milk with his tongue.[3] He's sloppy about it, painterly. Says Wegman: "It's like a painting. Why I stopped painting is I couldn't tell whether the paint should be thick or thin. A real painter knows that." But in his video, he's solved another painterly question: when is the work finished? Wegman's tapes, using real time and actual sound, stop when the incident is over. And if there's any illusion, it's always exposed.

Another early tape, known as "Stomach Song," is a close-up of Wegman seated, bare-chested, his torso filling the screen. As he breathes in and out, the torso resembles a rudimentary face: nipples for eyes, navel for mouth. Wegman puts words in the mouth. "Hey you," says the navel, "hoo hoo hoo hoo hum." He raises his arms and the torso's face, altered, raises its voice an octave, creating a duet between the deep-voiced torso and the falsetto one. "I wouldn't have done that if I wasn't working in California with my shirt off and the monitor on," he remarks.[4] "There was something yucky called Body Art back then, remember that?"

Another tape from *Reel 1:* A photographer's lamp says, "Hey, Mom, I think Randy's gonna be sick." A second photographer's lamp tips over. Why? "It looked like a sad character," Wegman says. But a theme begins to emerge. Wegman anthropomorphizes his dog, his torso, his work lamps. They all acquire human characteristics and do human things—the sort of things a child might imagine. As if Wegman, starting with nothing but his bare room and his blank screen, has decided to play let's pretend, aimlessly amusing himself out of pure boredom. But that was the condition laid down by Minimalism and Conceptualism, and by Andy Warhol's films such as *Empire*. Boredom was the given of video art in those years; it wasn't supposed to be enjoyable. That was what distinguished it from real TV.

Then there's a tape that's a still life of sorts: a book and a dead fish. The book is by Borges. The fish recites the text, but it takes the viewer a moment to realize that the fish's mouth is moving, mouthing the words.[5] Add to the anthropomorphizing a further wrinkle: the animation of the inanimate object as well as the personification of nonhuman form. Impersonation is part of it: the dog Man Ray impersonates

Wegman, becoming an alter ego for the abdicating artist, just as the fish impersonates the absent author.

Another. Wegman enters, covered with handbags that hang from his arms and legs. He divests his body of one handbag after another. A puzzling tape: is he playing bag lady, confounding male and female, or is he the sorcerer's apprentice, multiplying something that only makes sense as a single thing, casting off something meant to be clung to? "I just went to Goodwill and bought forty pocketbooks and brought them home. The man takes them off as if they're his work clothes. The first narrative things are very sketchy that way."

A similar activity carried to extremes takes place in his mock deodorant commercial on *Reel 3*. An underarm close-up: Wegman sprays deodorant in a continual stream while extolling the deodorant's virtues. It's only a minute or so long, but it seems as if it will never stop. Eventually the deodorant is running in rivulets from his armpit, a TV cliché gone askew. The sorcerer's apprentice again, but the multiplication—or exaggeration—takes place in the realm of real time rather than actual objects.

In a piece that he calls his "Mies van der Rohe tape," Wegman, playing TV pitchman, gives a demonstration of "the new massage chair." What we see is a plain old tubular-steel kitchen chair. "It works on the same principle as a tuning fork," says the pitchman. He demonstrates, sitting on the chair and hitting it with a stick.[6] The do-it-yourself technical aspects of the work infiltrate the narrative here, as do the false promises of TV commercials. Wegman's tapes are full of false promises: see one thing, say another. There's always some discrepancy, some unbridgeable gap between what's going on and what's being said, between what we are led to expect and what we get. Wegman's humor has a large quotient of frustration in it. His wonderfully puzzling nonsense conveys and hides a great deal of psychological sense.

The psychological content of Wegman's humor is sometimes overt. In a tape on *Reel 3* known as "Rage and Depression," Wegman sits with a silly fixed smile on his face and talks about being given shock treatment because of fits of rage. Smiling all the while, he describes the shock therapy, the result of which was a permanent smile: he's still depressed, only it no longer shows. This pseudo-confessional tape isn't just goofily funny. This piece, too, deals with

false promises and deceiving appearances—discrepancies between visible surfaces and the invisible depths, and failures of intentions on the way to results. Wegman's tapes may be sight gags, but they're also double binds—quixotic illustrations of what lies at the roots of schizophrenic behavior as well as consumer dissatisfaction.

On the other hand, that may be reading too much into his deadpan art. He might simply be saying that what counts is the surface effect. By equating the meaningless form of an upturned mouth with a happy expression, he is making connections between being "formal" and being "funny."

The implications of an art that is funny instead of formal are more complex than simply a switch of emphasis toward psychological content (and viewer response) and away from structural form. "Formal"—whether in the sense of formality or Formalism—and "funny" have something in common: both require detachment, both take the long view. Both can be means of distancing, disengaging mind, hand, or eye from the immediate involvements of reality, subjectivity, and the world of appearances. Slipping on a banana peel isn't funny when you're involved. In Wegman's very informal work, humor may well be a substitute for Formalism, shifting our attention from subject to object. For as he humanizes his dog and animates inanimate objects, he also reverses the process, depersonalizing himself, impersonating defective patterns of behavior—using himself as a comic object.

Wegman's working process starts with an empty screen, a blank monitor, an open mind. Whatever comes into view when he starts the tape running is fair game for his video vignettes, so he says. Like other video artists who started out in the late '60s, he adheres to certain conventions: he uses real time, incidental sound, "real simple stuff." But he takes real time—that basic tool of Process Art—and turns it into comic timing.

You could say that Wegman, like a maverick post-Minimalist, was taking Minimalism beyond itself into some ultimate reduction: in his case, the reduction of intellect. You could even say he was going further, opposing the rigors of Conceptualist logic with the *tabula rasa*—the blank mind, the empty slate. The Minimalists reduced their art to stolid object. The Conceptualists reduced it to idea. Process artists reduced their work to raw material, and performance artists to the even rawer material of their own bodies. Wegman, always

contrarily carrying things one step further, reduced his body to a stolid object, emptied his mind of ideas, gave human attributes to objects, and handed over the role of creator to his dog. He allowed things to happen, acknowledging the humanity of process and viewer. He started a chain reaction that released psychological and narrative elements, triggered by undirected imagination and improvised play. The "end game" art of the late '60s led Wegman to a comically vacant, playful, behavioral act.

While most of his contemporaries were still in the thrall of an aesthetic of boredom—exploring formal repetitions, serial permutations, and cyclical monotonies, and using their bodies as embodiments of abstract concerns—Wegman realized that the narrative inanities of real TV and real life were more to the point, that the unpredictable and the inept were more moving than logical moves. From the aesthetic of boredom, he arrived at the cosmic joke.

Wegman's video was at the forefront of a subtle shift from the aesthetic of boredom to the aesthetic of the amateur that reigns today. He was, in a sense, ahead of his time. During the 1970s this aesthetic of the amateur sprang up in the real world as well as in art. Saturated with specialists of all sorts, with slick technology as well as sleek art, and disillusioned by the turn of worldly events, people—and artists—began wanting to expose flaws, foibles, weaknesses, and failings: they wanted to see human imperfections. They began to cherish the defects in homemade things. This went along with the beginnings of the end of the idea of progress toward a utopian future, and with a newly critical attitude toward modernization—and Modernism itself. The '70s can be seen as a criticism of the optimistic 60s: it presented antidotes. It was a reformation as well as a rebellion: the do-it-yourself decade.

Contrast, for example, the camp TV hit of the pop '60s, *Batman,* or the high-tech '60s *Star Trek,* with the camp hits of '70s TV: *Mary Hartman, Mary Hartman* and *The Gong Show.* Contrast Sean Connery's suave James Bond with Woody Allen's schlemiel. Or contrast the professionalism of '60s rock music with, in the '70s, the absurd excesses of glitter rock, the mindlessness of disco, the deliberate ineptitude of punk.

Or, to get back to art, contrast Nam June Paik's video art of the '60s with Wegman's of the '70s. It's state-of-the-art versus seat-of-the-pants. If Paik's work takes a loud counterculture stance, Wegman's is

modest, making no claims. Where Paik's work seduces with ultra-smart wit, Wegman's rolls over and plays dead, beguiling us by proving it's no threat. Instead of Paik's unending analogies between object and image, Wegman plays on the failure of images to live up to words—and plays it for laughs. Instead of Paik's formal juxtapositions, Wegman informally offers anecdotal incident—the bare bones of some illogical situation logically completing itself, or vice versa. There's something persuasively passive about Wegman's work: what structure there is seems makeshift and incidental. His compositions are usually centered, not for purposes of composition but, as he points out, to allow for different video viewing systems, which sometimes crop edges.

Perhaps it's not fair to compare the video guru of the international avant-garde with the homegrown work of an all-American boy and his dog. Nam June Paik's video is also sculpture; Wegman's is simply the barest sketch. And yet that's its appeal and its strength. His video works are like his doodled pencil drawings—quick, easy notes with instant results, casually testing what lies along the path of least resistance. By using video unabashedly as do-it-yourself TV, he anticipated the advent of cable TV coming into the home with an aw-shucks low-budget mentality. His sad-sack, deadpan, comic video art may play dumb, but by doing so it sets itself squarely against high-tech culture and high seriousness in art. If during the '70s a great deal of art was modest or truculent, reticent or brash—and deliberately, insistently anecdotal and amateur—it was to rebuke the grandiose pretensions in color-field painting and Minimalist sculpture. Or, as Wegman would say, "majestic art." Playing dumb was Wegman's renegade version of the post-Minimalist breakdown of style and refusal to construct forms. It was also an anti-Conceptualist refusal to have any bright ideas.

"The tapes aren't dealing with ideas but with visual process. I don't know what specific qualifications I was using. I think I decided I didn't want to deal with anything too hot, like sex or the war. I liked dumb TV: Ozzie and Harriet, California used-car ads. Baldessari used 'in' jokes in terms of art. I taped Bob and Ray off the TV. My tapes were like a hole."

The Bob and Ray Show provides a fruitful, if unlikely, comparison. Just as Wegman started out in the late '60s as a serious post-Minimalist, Bob Elliott and Ray Goulding started out as serious news-

casters in the late 1940s. But they began to amuse themselves on the air and soon became a comedy team on radio and early TV. Like Wegman, their deadpan humor involves a flat delivery, a deliberately clumsy parodying of radio dramas, TV talk shows, and commercials, and leaves you wondering why it's funny. Like Wegman, they're an acquired taste. Their humor, too, is based on absurd expectations, inadequacies, and things that don't work. They enact the drama of "Mary Backstage, Noble Wife." (One of Wegman's recent photographs of Man Ray is titled *Noble Dog, Paint by Numbers.*) They bumblingly promote things like The Bob and Ray Burglar Kit, a sack containing a screwdriver, a glass cutter, a pair of gloves, a toilet plunger, and other not quite appropriate objects. (Think of Wegman's massage chair, or an early tape of his starring a toilet plunger and an old console TV set.) They advertise The International House of Toast. (Another of Wegman's early tapes involves "spitting bread" instead of buttering it.) Or, as Mary McGoon, Ray gives a cooking demonstration: "Alternate little pieces of shish with pieces of kebob," he/she instructs, while ramming tomatoes onto a broomstick. Wegman's video work has the same contrarily awkward relationship with domestic objects and the clichés of commercial TV.

Wegman's idiosyncratic humor, like Bob and Ray's, is off-center, vaudevillian, droll rather than witty, based on apparent incompetence rather than skill in repartee. In a way it's the reverse of Duchampian wit, for as William Hazlitt once said, wit is the product of fancy, while humor is the growth of accident. Instead of cryptic comments and esoteric meanings, Wegman's humor is about disappointment and failure. Not only Man Ray's failure to spell correctly in his famous "Spelling Lesson" tape (the failure of a dog to be a person) but the failure of words to correspond to images, feelings to expressions, actions to results. Wegman's humor works in the realm of discrepancy—with substitutions, reversals, accidents, and shifts—which is why it's hard to sort out what's dumb from what's smart.[7]

There are even closer resemblances between Wegman's video and Bob and Ray's skits. On one of their programs, Bob interviews a dog. On another, a *What's My Line?* skit, the man with an unusual occupation runs a fleet of dogs trained to run onto the field at football games—to delay the game so the TV sponsors can insert more commercials. Wegman's tape of the two dogs following the offscreen tennis ball in unison might even recall Bob and Ray's McBeeBee Twins,

who say the same things a fraction of a second apart. Which leads to the question of the dog's role in Wegman's video work. Wegman sees himself and Man Ray as "something American, sort of a team—Bill and Ray. Me speaking, him responding. He was real easy to use. Sometimes he'd trick me into doing something better than I'd intended to do. He was a working dog." Man Ray was not just the star of some of Wegman's best videotapes; the canny canine was also Wegman's collaborator. "There's always the risk in video of putting yourself on TV, being narcissistic. I think Man Ray diverted all that."[8]

In 1977 Wegman started using color. The heat of the lights was a problem for Man Ray. "He couldn't stand being under the lights very long." In the color tapes, Wegman extends the concept of the amateur into the realm of the defective. Some are close-ups of Wegman's mouth conversing with itself, like the torso in "Stomach Song." The dialogues, which are deliberately vacant, suggest mental deficiencies or subnormal mentality. In one, the mouth tries to recite the alphabet, getting progressively more confused and making mistakes. More disturbing than funny, these tapes emphasize the pathos underlying humor and the close connection between comedy and tragedy. Other color videotapes, like shaggy-dog stories cut short, involve Man Ray's failure to respond to cues, or to learn how to smoke, or Wegman's failure to give adequate street directions (while absently smoking four cigarettes at once) or to memorize some lines from a book. The recurring theme: not just stupidity but the progressive disintegration of logical and narrative structures in time. In 1978 Wegman stopped working with video. Man Ray has since died, and recently Wegman began using video again, making longer tapes.

His video works of 1970–78 may be as good-natured, as eccentric, as willing to try anything—and as lovable—as his late dog Man Ray, but they also have teeth. In a conceptualized, process-oriented video climate, Wegman played the fool. Against the cerebral humor of Bruce Nauman's body-as-sculpture puns or John Baldessari's artist-as-wise-man parables, Wegman acted the buffoon. Into a milieu of narcissistic performance video, Wegman brought his dog. In an art world saturated with ideas, he affected ignorance. Ridiculing the pretensions of high art and the debasements of mass culture, questioning distinctions between professional and amateur, public and private, using human imperfections and behavioral quirks, his video works are not as simple as they might seem. He showed the way to a new

generation of young video artists involved with mock entertainment, amateur TV, accessibility, and critiques of mass culture. The smartest thing he ever did was to play dumb.

NOTES

All quotes are from a conversation with the artist in the summer of 1982.

1. There are seven twenty-minute reels of *Selected Works,* plus a recently selected alternative to *Reel 1. Reels 1–3* were made in California. "I moved to New York during *Reel 4,"* Wegman says. There is also a ten-minute *Anthology* of his work from 1977–78; four longer tapes *(Man Ray Man Ray, Gray Hairs, The Accident Tape,* and *Semi-Buffet);* and a reel that is a compilation of his greatest hits, called *The Best of Wegman.* He has also made one film, *The Bubble Gum Film.* It is three-and-a-half minutes long. In it, a little girl blows a very big bubble and the bubble bursts.

2. On the other hand, the early equipment had its drawbacks. Wegman's first video pieces, made in Wisconsin on Craig equipment, can't be replayed. Wegman explains, "The half-inch equipment wasn't uniform yet. The camera signal was mixed up and it only worked on one particular deck. Real quirky stuff you ran into back then. No one knew the industry was going to develop into Betamax." *Reels 2–5,* made on a Sony 3600, can't be time-base-corrected for copying, and have to be shot off a monitor. Wegman also made a reel previous to *Reel 1,* in California, before he got Man Ray. Shown in Pomona in 1970, it was accidentally erased.

3. Wegman tends to return to various household props, doing variations on related themes. Milk is only one of these. There is also a tape on which he drinks a glass of water and talks about swimming. Related to this is another, on which he sits with his feet in a bucket of water, listing his material possessions. "The only thing I don't have is a swimming pool," he concludes.

4. The California sensibility is relevant to his work, even though, as Wegman points out, it was Man Ray who came from California and not himself. Nevertheless, Californian qualities of laid-back informality and easy familiarity seem to have rubbed off on his work. His video art has more in common with the work of Bruce Nauman and John Baldessari than it does with any video art of the same time in the East.

5. From "Anet and Abtu," in *The Book of Imaginary Beings* (New York: Dutton, 1979), by Jorge Luis Borges.

6. Wegman admires the video work of Bruce Nauman, and it is interesting that Nauman's recent sculptural installation, *D.E.A.D.,* was a hanging chair that acted as a tuning fork when struck at designated spots, clanging the notes D, E, A, and D. Whether this is coincidence or acknowledgment of mutual admiration, or whether they both refer to some popular source, remains to be seen.

7. Wegman's four longer—and atypical—tapes clarify some of his more serious concerns. *Semi-Buffet* (1975), his first color tape (using actors and shot by a Boston television crew), deals with formality and behavior as well as substitutions. Derived from Emily Post's text on the etiquette of a semi-buffet dinner, this tape shows three

successive groups of people eating the same dinner (at the Fannie Farmer School) with differing degrees of formality. *Gray Hairs* (1976) also has a layered texture, but the layers are simultaneous and involve actual surface texture rather than narrative, and Formalism rather than formality. In it, a double-exposure close-up of Man Ray's fur is accompanied by two layers of sound, both of which are the dog's panting. Almost totally abstract, it ends with a shot of Man Ray's nose and the microphone, exposing its subjects. In *The Accident Tape* (1977), three people tell the story of an accident. One was a witness, the other two try to repeat what the witness said (but this isn't explained). The story is told backward, and the layers of reality and simulation, as well as the discrepancies in the repetitions, give an odd texture to the narrative. In *Gray Hairs*, you're not quite sure what you're seeing; in *The Accident Tape*, you don't quite know what you're hearing. Another kind of doubling, with substitution and confusion, occurs in *Man Ray Man Ray* (1978), which opens with the dog turning his head from side to side as his name is called. A mock documentary, this tape mixes facts and images of Man Ray the dog and May Ray the artist, such as, "His closest friends besides Bill and Gayle were Picabia and Duchamp."

8. Video, like Polaroid and the quick pencil sketch, gives immediate results. All are mediums of instant image feedback, intimacy, and immediate gratification, open to questions of narcissism. Rosalind Krauss, writing of the narcissistic implications of the video medium, has described video art as "consciousness doubling back upon itself." Wegman's video, however, might better be described as the unconscious doubling back upon consciousness.

William Wegman, *Blue Period*, 1981. Private collection.

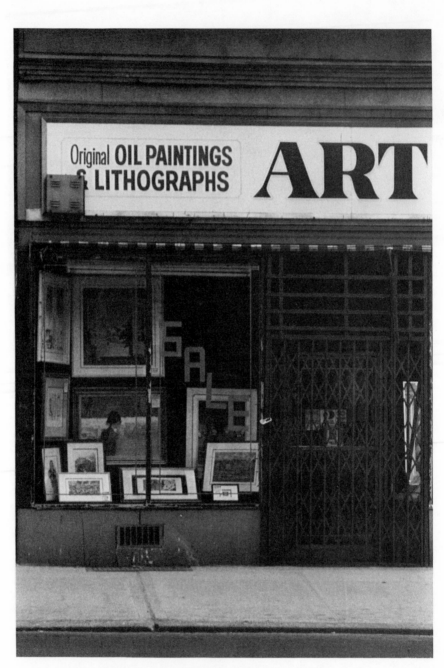

Storefront Art.

14 Sofa-size Pictures

On a shiny abstract sculpture in front of the family court building on Lafayette Street, someone has scrawled, "Modern art is meritricious [sic] and mostly bad." I was going to write about the popularization of art. I was going to say that piece of graffiti raises a big issue: people never understood abstract art. It's the end of the Modernist era and we still haven't faced the fact that the man in the street—who proudly proclaims he doesn't know anything about it but he knows what he likes—wants something else. I still don't know what he wants, but I found out what he's getting.

I started at the top—Bloomingdale's art gallery, on the fifth floor with all the furniture. I asked a salesclerk what people wanted. "A little bit of everything and a lot of abstract art," she said, blowing my theory, "but I think people are moving into a more modern thing, like Art Nouveau posters."

I spoke with the art buyer, who was previously the hat buyer. She told me about art. There were four kinds, "One is the very, *very* commercial end of it. It's everything from the kind of original art you see in the Village outdoor show to the pussycats with the yarn balls. It's still what is in ninety percent of your department stores. There's an entire business which is really the picture business." She preferred the decorative arts, things like framed kilims and Chinese embroideries, "a market that is growing by leaps and bounds," and the graphics business, which has "become respectable because over the years some of the major painters, like Chagall, have gone into graphics. Then you get into the really one-of-a-kind fine fine art, and the gallery world,

The Village Voice, December 10, 1979; titled "Sofa-sized Paintings."

which has to do with promotion and investment. It's a tricky, complicated business."

But what do people want? "I think people are beginning to understand art more. I think tastes are running more toward the minimal. People want one good thing that makes a statement. It's true in clothes too," she said. There was a large gilded parrot hanging from the ceiling, and on the wall a big *thing* made with mirrors had been reduced to $175. Minimal means one thing at Bloomingdale's and another in *Artforum*. When you talk about art as merchandise, everything sounds slightly askew. Minimal becomes a commodity latching onto the jargon of an ethic. What people get is more interesting than what they want.

When I moved into a loft once, the man who was moving out showed me his paintings. They were in four different styles, signed with four different signatures, none of them his own. Every year he hired four unemployed actors to play artist for him at the Washington Square sidewalk show. The semiabstract square-riggers riding palette-knifed waves and the barns under full moons sold best. He was moving because he had made enough money to buy a big house with wood-paneled walls and murals on the ceiling.

All art is merchandise. The Conceptualists made that clear. People buy and use it. Some art is also Art, and some isn't. And out there beyond the rarefied atmosphere of the art world is a universe of ersatz art—of "original oil paintings," of pictures made to match sofas and sold in furniture stores—where values are reversed. It's an embarrassment to the art world. We always pretend it doesn't exist.

Until a few weeks ago, there was a flower and plant shop on the corner of Madison and Seventy-fourth, on the same block as the Whitney. Now it's a garish store festooned with the kind of banners you see in used-car lots and stocked with posters and stacks of "original oil paintings" for forty-five dollars. They come in two standard sizes— 24 by 36 inches, and a wide-screen version for people with long couches—and they have nothing to do with Art. Popularization? It's unadulterated contempt, and it's hard to ignore when it's within spitting distance of the Whitney and jokes are being made about it being the museum annex.

It isn't just a dime-store business selling cut-rate cheap pictures. The rent is astronomical. One of twelve branches, the salesman informed me, it's "an unusual location for this type of operation." What

type of operation? "We sell a little bit of everything; it's no different from any other product. I really wouldn't be inclined to do an interview. There's something for everybody. It's decorative art that people buy the same way they buy a couch." He also wasn't "inclined" to put me in touch with any of the people who make the pictures. He referred me to the main store. He mentioned Chagall.

In the world of ersatz art—where Chagall is the key to legitimacy, where LeRoy Neiman and Simbari are big names and Delacroix isn't Eugène but Michael—everything looks strange. "We will not be undersold," proclaim the big yellow, red, and black signs of Nouveau Artists Ltd., est. 1967, on a half-demolished block of Third Avenue that must be a hustler's paradise at night. "Professional artists." "Original oil paintings." To the uninitiated, there is a ring of authenticity to those words. "Large sofa-size, most under $35." The main store. Pictures like the ones that were forty-five dollars on Madison Avenue were thirty-five dollars here, but then, the guy in the store didn't have the savoir faire of the salesman on Madison. What sells the best? I asked innocuously. "A little of everything and a lot of abstracts," he replied. How do you choose the pictures? "That is my business," he answered. How do you find artists? "None of your business." Are you the manager? "I'm not answering any more questions. It's none of your business. Leave. Walk out of this store right now."

I went next door to a small shop crammed with "imported oil paintings" and five-dollar miniatures of slightly better quality, where a charming old-world gentleman was eager to be of help. "We sell classical merchandise, traditional paintings. We don't buy manufactured art." Eager, that is, until I asked if I could talk to some of his artists. "No," he said flatly. "In this business nobody gives addresses. We are holding them and hatching them like little chickens."

Manufactured art? Art factories where "original oil paintings" get knocked out in twenty minutes or less on a kind of assembly line: either one "artist" works on a whole row of similar canvases or several share the work, one specializing in trees and another in skies. Everyone knows they exist. Getting to see one is another matter.

I started out to write about popular art and found myself in a world of secrecy, suspicion, and sofa-size paintings, playing Nancy Drew, girl detective. The plot involved hidden artists, secret studios, automatic alarms, whispered insinuations, and constant evasions. But I never got beyond the first chapter—I got scared. After all, an art

critic may be trained to investigate, sifting the clues of art history for stylistic or iconographic evidence, but this was different. This was real life.

"I'll be amazed if they let you see it; it's really weird," whispered an employee at a store while the manager was phoning frantically for the boss. And a tough character had planted himself squarely between me and the backroom door, watching my every move, as if he thought I might make a run for it. I discovered by a phone call—my one attempt at imitating Rockford—that they had a studio behind the shop, and I had asked to see it. The boss don't want no publicity, I was informed.

I looked elsewhere. The Picture Business has its own hierarchy. As the prices go up the people get more polite and sofa-size pictures are transformed into "accessories for interiors," but the evasions are the same. Karl Mann Associates, Inc., where prices start at $450 and sales are "strictly to the trade," has its own studio and employs nearly twenty-five artists. "I don't think that would be possible," said a man with a cultured voice, when I asked if I could see it. "We don't let people talk to our artists while they're working."

I was given the name of someone in the Picture Business. Tell her Randy sent you. I stepped out of the elevator in a run-down building on the edge of the garment district and a loud alarm went off. But it wasn't the proverbial art factory, and I wasn't kicked out. It looked more like an art school. A rough loft space with people at easels working on big canvases, worktables covered with paper cups of paint, the sound of an airbrush, and stacks of magazines. There was a bearded bohemian and a boy with magenta hair. They even had cats. Everything was authentic. Except the art. There were trompe l'oeil canvases, abstract illusionist ones, lyrical abstractions, color-field stain paintings, impressionist landscapes, realist still lifes, all looking vaguely familiar. There were Paul Jenkins—or was it Morris Louis?—look-alikes in one corner and James Havards in another, except the Jenkins-Louis ones had pink and yellow airbrushed grounds and the signature on the Havards was Sanchez. There was a still life of baskets and wooden spoons that could almost have been the work of Stephen Lorber. They weren't forgeries; it was more a matter of cynical emulation. It was ersatz art with a B.A. You see it in the pages of *Architectural Digest*, in *House Beautiful*. Convincingly deceptive, it looks like real art. As with Ohrbach's copies of designer clothes, you get almost

everything except the label: the look but not the content of the real thing.

The five people who work in this studio are real artists, using assumed names, creating more than one style each of pictures to sell to decorators and interior designers. They were very friendly and open about it. They were pleased with their work. "If I work in a factory I make maybe sixty dollars or seventy dollars; this way I enjoy what I'm doing, and we do it not just to make money but to make revolution in art," said Elba Alvarez, who runs the studio and who under her own name will be showing her own work at a museum in Venezuela next year. "We're showing the commerciality in high art," explained her partner, genial, paint-splattered Peter Mackie. "In this business you make paintings that look good, but the higher artists think about salability too. We try to inject a contemporary air to what we do. Most of the styles have been designed by us or researched. A lot of this stuff you see in SoHo selling for a lot more money, and it's very similar." How much does their work sell for? "We do a lot of price juggling," said Mackie. It's in the five-hundred-to-thousand-dollar range, cheaper to galleries. To galleries? "All of us try to produce work that makes sense in a series. A lot of people collect us. Sometimes we develop an actual look for a gallery and we just become their artists." What galleries? They wouldn't say. They also do commissions. "Sometimes we have clients who've been to Leo Castelli or another gallery and don't want to pay so much."

Can one condemn this because a perverse marketing system makes it possible? Or is this perhaps a criticism of the system? It's hard to be indignant when you think of all the intrigue within the art world and all the talk of art as investment or tax shelter, or the offense of Nelson Rockefeller's high-priced reproductions. As Mackie says, "A lot of things sold in the name of art are without value." Art has become big business and scruples are negotiable on all sides. It's a tricky, complicated business. But leeching onto authentic art and usurping its most salable looks may be more subversive than tasteless store-bought art or sofa-size schlock pictures, for when the Picture Business reaches its highest level—when it can be passed off as genuine art and sold in galleries—it becomes indistinguishable from the real thing. It's like the quandary of Captain Kirk confronting his evil double in the world of antimatter.

While critics talk about art intersecting life, about antiform and

nonart and postmodern accessibility, ersatz art is being made for all levels of purses and tastes—without artists, without ideas—by mercenaries working for a living, hidden, anonymous, pseudonymous, and by "revolutionaries" beating the commerciality of real art at its own game. Its only motive is profit. All art may be merchandise, but all merchandise is not Art, even if it's made of oil and canvas. The Conceptualists were right: it's the idea that counts. And it's not a matter of snobbery; it's more like fraud. Even the worst real art has something that ersatz art lacks—an artist's mind behind the work.

It can't be dismissed as cheap: it's the Picture Business. Is it really what the people want? The funny thing is that while real art moves into other regions, these imitations of modern stylization and abstraction—debased and misunderstood—are polluting countless living rooms.

III AFTERLIFE: THE '80s

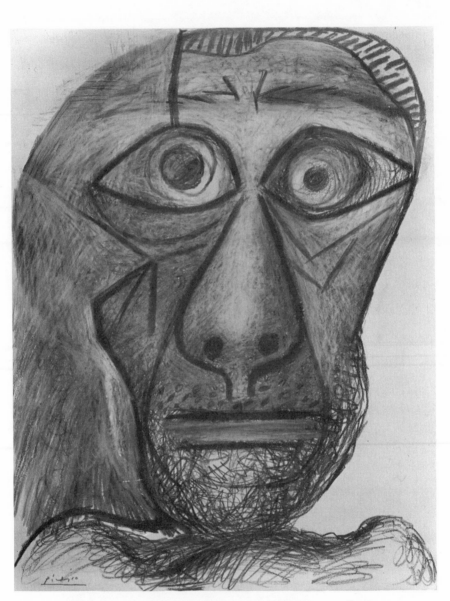

Pablo Picasso, *Self-Portrait,* June 30, 1972. Private collection.

1 Primal Picasso

Picasso was buried on April 10, 1973. He didn't live to see the large exhibition of his last paintings that opened in Avignon the next month, or to hear the widespread condemnation of that work. Nineteen seventy-three was not a good year for brushstrokes, or spontaneity, or Expressionism—real, neo, or pseudo. In fact, it was not a good year for painting. The post-Minimal, post-Conceptual climate had blown the other way. Artists were claiming Duchamp as an ancestor, not Picasso. And painting, along with modern art, was rumored to be dead. Quite apart from that, the message for years had been that Picasso burned himself out early. Most critics in Europe agreed that the final Picassos were terrible: "hurried and disjointed," they said. "Careless," "sloppy," expressing "the horror of growing old." These geriatric paintings were greeted as coldly as Monet's water lilies or Matisse's cutouts once had been. The consensus was that the last works were "pabulum."

In 1980, while the art world debated whether Modernism was truly defunct, Picasso, who personified modern art, was deified in the most comprehensive exhibition ever: the mammoth retrospective at New York's Museum of Modern Art. His "paraphrases of the old masters" and a few examples of even later paintings were stuck in at the end, like embarrassing afterthoughts. In the aftermath of that show, Clement Greenberg remarked: "His quality began to fall off after 1925, but stayed high enough till the end of the '30s. Then it did more than fall off, it sank, and it stayed sunk, at least in his paintings."

Adapted from "He's Just a Kid at Art," *The Village Voice*, February 18–24, 1981; "Die 'Avignon'-Bilder," essay in the exhibition catalogue *Pablo Picasso: Das Spätwerk*, Kunstmuseum Basel, 1981; and a lecture at the Guggenheim Museum, April 10, 1984.

That pretty much summed up the prevailing opinion. The feeling among most artists was expressed by Conceptualist Joseph Kosuth, who said that Picasso had become a negative model—"a kind of warning"—because at some point he had stopped making paintings and begun painting Picassos.

But Picasso's last works, which looked to many people in Europe in 1973 like the evidence of decline, if not senility—loose copies of copies of copies of his earlier work, with all the stuffing taken out—ten years later look remarkably fresh, fierce, and free. In fact, these paintings now make some of his earlier work seem overly stylized, almost contrived. In 1981, when I wrote enthusiastically about the last Picassos, I was going out on a limb. Now, among all the other revisions of taste in the '80s, Picasso is the ancestor more and more artists want to claim, and critics are going overboard hailing him as the forerunner of German, Italian, and American Neo-Expressionist art. One art journalist went so far as to say that without Picasso's last works, Neo-Expressionism would have been unthinkable.

It's easy to mistake Picasso's ultimate refinements and simplifications—his chunky shorthand figures and graffiti-like gestures—for crudeness. It's even easier to mistake affinities for influence. Chance resemblance is one thing; paternity is another. And admiration does not necessarily imply a relationship. Did the 1980 retrospective really make the new so-called Expressionist painting possible? Or did Neo-Expressionism make it possible for us to appreciate the late Picassos? Our own change in sensibility has opened our eyes to Picasso's exuberant late work.

At this moment for revisions, let's first remember Picasso's earlier effect on American art, or rather the love-hate relationship American artists have had with his work. Everyone knows by now how formidable Picasso was to the Abstract Expressionists when they were coming of age. He was the all-powerful father figure that had to be assimilated and overcome. Gorky emulated him like a good son in the 1930s, painting his own variations of Picassos that were only a few years old. Pollock grappled with him rebelliously. So did de Kooning, ending up with his own frenzied Women. And in de Kooning's *Attic,* as art historian Harry Gaugh recently noted, there are buried "at least seven Picasso-like 'heads.' " By the 1950s Picasso's work had become, if not irrelevant for American artists, at least unmentionable. He was no longer an acknowledged threat. The '60s and '70s belonged in large

part to Duchamp. But what the revelation of Duchamp's *Etant donnés* was to the '70s, the discovery of these late Picassos may be now.

Picasso may not have fathered the art of the '60s, but he had become a pop icon. In 1963, the year he painted the first of his extraordinary late paintings, Lichtenstein was doing *his* Picasso pictures. By then Picasso's formal manipulations were so familiar that they'd entered the realm of pop culture. His style was a cliché to be quoted, as much a public image as any comic book or ad. Lichtenstein, who was one of the first to irreverently parody Picasso, was appropriating a style Picasso had abandoned twenty years before.

In 1973, the year of Picasso's death, George Segal—explaining his use of a Picasso etching (from 1933) as a blueprint for his sculpture *Picasso's Chair*—said: "Picasso has intimidated me all these years. He was so enormous and staggering that no artist could hope to compete." The defacement of *Guernica* in 1974 by Tony Shafrazi coincided with a low point in esteem for Picasso's work. Whether the red graffiti message he sprayed on *Guernica* was a "conceptual action," a political protest, or wanton vandalism, it was also the symbolic slaying of a dead hero, a violent rejection full of mixed feelings. Said Shafrazi later: "I never disliked Picasso by any means. On the contrary, he is absolutely the master that I look upon." He may have the dubious distinction of being the first to revive Picasso as a relevant ancestor.

In 1984 Picasso's work is full of resemblances to current concerns. Not just the Expressionistic painterliness of his last works, but his restless questioning all along with regard to style. His omnivorous paraphrases and appropriations from other artists also make him the perfect ancestor. Deliberate allusions and joking references to classic Picassos are cropping up more and more lately, along with coincidental resemblances. For recent artists, Picasso's no threat, but fair game for impudent homages and fond travesties.

The current spirit of revisionism has been taking care of late Picabia and late de Chirico. Late Picasso is another matter. Around the same time that Picabia and de Chirico, after the end of World War I, became eccentrically and radically conservative, Picasso briefly did too. For them this anti-Modernism was a conversion and a late style. For Picasso it was merely a brief episode, one of many atypical moments in his work that have been rendered invisible by our preconceptions about modern art. The excessively embellished paintings of the

1950s, which for years we had assumed were his late works, weren't the final Picassos either. But even those, which made people say the Midas of form was losing his touch, have been oddly underestimated: A revised look at them is overdue.

Hardly anyone—except Leo Steinberg—ever took those works seriously, or noticed, in spite of recent seasons of "Pattern Painting" and "decorative art," the way Picasso used patterning: the dots—deliberately, pointlessly Pointillist—that could sabotage a Cubist plane or dissolve the bronze sugar cube of his *Glass of Absinthe;* the patterned wallpaper he sometimes collaged to his work; even the coiling ropy stripes of paint and taut repetitions of wiry lines that assaulted his painted forms in the late 1930s. And strangest of all, almost no one saw that his paintings of the 1950s—those "paraphrases" of old masters and the ones of his young children Claude and Paloma at play—were not the fussily overdone things we once imagined them to be but monsters of wildly proliferating ornamentation.

In the 1950s Picasso was turning Courbet's sleeping *Demoiselles* into elaborate Spanish lace, Delacroix's harem women into cactuses and grilles, Velázquez's maids into madly coffered patchworks, and Manet's *Déjeuner* into a frenzy of ornamental arcades. Picasso was digesting his heritage of folk art—wrought iron, the embroidery of mantillas and matadors' jackets, the decorations on peasant carts— the way he had earlier gobbled up African forms. His patterning was not an old man's camouflage, which merely disguises. It was more like tribal scarifications to permanently transform. In his eighth decade, Picasso wasn't losing his touch, covering up weaknesses; he was relishing the aggressive possibilities of pattern as an almost hallucinatory means of manipulating surfaces and possessing their forms. And the challenge he had earlier flung at the old masters in more than one of his Cubist collages—with painted parodies of bronze name plaques spelling out his name—was being renewed. By the time Lichtenstein began to paraphrase Picasso in his own dotted style, Picasso himself had already become a Pop artist of sorts, and a Pattern Painter.

But this outbreak of patterning happened periodically in Picasso's work. It had occurred in his Cubist paintings around 1914 and 1915, and in his work of the late 1930s, as well as the '50s. Perhaps whenever he came close to mining the last vein of form from one of his styles, he signaled the onset of his restlessness—or boredom—by elaborating decoratively on his own forms, like tapping a finger while waiting for

the next inspiration. Only he did it with his brush. There's another way to look at it. It's possible that in these aggressively patterned paintings he was foreseeing the end result of the modern obsession with abstract form. A young artist like Frank Stella in 1959 could paint stripes that were dictated by the physical shape of his canvas, following the edges of its surface: Stella moved from the outside in. Picasso, back in the late 1930s, seems to have reached the opposite conclusion, moving from the inside out: his formal embellishments or repetitions were dictated by the internal shapes, by the image's outlines.

But these aggressively embellished late paintings of the 1950s and early '60s weren't his last works after all. In the last decade of his long life, Picasso did the most extreme about-face. His work became vulgar, frenzied, and artless, with rubbery twists of paint and slapdash wedges of color. The last paintings are earthy, uncomplicated feats of manipulation that look absolutely effortless. No more complex mythologies, no elaborate compositions, no embellishments at all. Just one or two figures, archetypal Picassoid images, human beings transformed into amorphous shapes after a lifetime of form and style—Pygmalion in reverse. Having thoroughly elaborated the surfaces of his forms, having eaten into the compositions of old masters with ferocious decorativeness, he was free to go beyond form—into unmitigated gesture and expressionistic paint. His brushstroke had become so pliant, his images so pliable, that he could dispense with considerations of style.

These final Picassos make Dubuffet's childlike stance look like contrived pastiche. Next to them de Kooning seems tired. They have something in common with the gruff cartoony figures that Philip Guston began to paint at about the same time. They have animated outlines, lumpy comical forms. Ludicrously contorted, Picasso's chunk-footed figures have kindergarten fingernails and toes, and genitalia rendered as crudely as locker room graffiti. Assholes become exclamation points on his nudes. Faces have animalistic features as malleable as Silly Putty, with wandering flounder's eyes and silly snout noses, as if he's some schoolboy doing impudent takeoffs on Old Master Picasso. Making savage graffiti of his own grand gestures, he finds startling childlike solutions to the mysterious intercourse between solid and flat. Picasso was still creating new hybrids. He even turned his own Minotaur into a teddy bear.

In his early work he had consumed Degas, Toulouse-Lautrec, Modigliani, Renoir, and Cézanne, as well as African sculpture. In his late work, as Gert Schiff has pointed out, he thought about artists as far from each other as Rembrandt and the Douanier Rousseau. The insatiable Spaniard, who long ago digested everyone else's art, spewed out the rest of the twentieth century, and then cannibalized and regurgitated himself. Do those thin stained washes come from his own ceramic glazes, or had he seen the work of Hans Hofmann or the color-field abstractionists? Are his sweeping brushstrokes simply the result of decades of wielding a brush or a nod to de Kooning? Was he thinking perhaps of Dubuffet or even Ben Shahn? The fact is that Picasso seeded everything a whole generation did, and in the end he simply harvested himself.

If in the '70s his last works were seen in terms of "the horror of growing old," it's tempting to interpret them now in terms of a freedom that comes with great age. Part of the power in these last paintings derives from their voids and lapses: from hasty abbreviations, brusque disruptions, and simplified shorthand effects. And from the fact that they dare to forget as well as remember, to be silly and even infantile. The dense interlocking quality of mid-life has faded from his art, leaving free-floating memories and absences along with a childish scatology of orifices and a childlike desire for instant gratification.

There's no extensive literature on the psychology of the aged, but Jane Hollister Wheelwright, a Jungian analyst in her late seventies, writes in the journal of the Jung Foundation: "A central experience of old age, I have found, is that the opposites are close together. Take, for instance, wakefulness and sleep . . . or the rapid alternation of opposing states of being. I may have a feeling of being very present and focused, and then suddenly an hour later I am lost in vagueness. This proximity of opposites accounts for many happenings, odd feelings, odd sensations, and images difficult to understand. . . . old age is simply a heightened counterpart of the rest of life. . . . In my opinion, what makes an old person seem young is rather the emergence of . . . latent abilities and openness to new attitudes. . . . When these assert themselves they are bound to appear at first in the awkward, clumsy characteristic of youth."

I don't want to fall into the El Greco/Soutine astigmatism trap, and a geriatric psychiatrist has assured me that there are no stages to

old age and that second childhood doesn't exist. Nevertheless, it seems likely that someone in his eighties or nineties might be on closer terms than the rest of us to ideas of beginnings and ends and divine nothingness. Picasso knew his own immortality in art history had long been assured, and perhaps that knowledge set him absolutely free—even from his own lifelong involvement with style. He could reinvent his old themes on Expressionist terms—or even pseudo-Expressionist ones. As usual, he was a decade or two ahead of everyone else. He had been preoccupied most of his long life with inventing new styles in which to clothe the instinctive naked power of his art. At the end, he abandoned them all. He could paint as if he didn't care: he had nothing left to prove, and nothing to lose. His paintings could undergo the most extreme stylistic ruptures from day to day. Picasso—the quintessential modern artist—had become in a way postmodern.

Picasso's advanced age is relevant to this last work, but it's more like the summation of ninety years of satisfied desires. He played with gray as if to refute the idea of "old and gray," making paintings without color so rich we'd never notice its absence if it weren't for the way he rubbed it in by signing his famous signature in red, or wiping a bit of stray yellow around a nose. But those furry grays can also be traced back as far as his Cubist work—or even his student work—and they recur periodically in his paintings all along. He toys with impossible colors, creating figures out of nothing but harsh purple and green, or sweet pink and blue, but they, too, are recycled from his past: whatever seems unique to these last works can be traced back to earlier ones. Even his late Musketeers are reinventions: they're close relatives of his early Pierrots and Harlequins.

If his youthful Blue Period paintings looked old as well as melancholy, his late work is elated and young. Childhood—first or second— seems a more appropriate metaphor than impotence and old age. These are primal paintings, awful yet wonderful. André Malraux called them "Tarots," but the elemental secrets to be divined from them are not occult but psychological ones. A "primal scene," in the world of Freudian analysis, takes place when an infant accidentally witnesses the parents making love and, unable to comprehend this fusion of bodies, misinterprets it. Some psychoanalysts believe there's a "primal scene schema" in dreams or literature, in which hybrid creatures—centaurs, minotaurs, even sometimes mother and child— are representations of the primal scene, and certain spectacles, in-

cluding bullfights, are ritual reenactments of it. Picasso's faces with split and doubled features, his composite bodies, and his simultaneous transformations of parts, can be read as Oedipal elements of this infantile fantasy. From the beginning, his work offers evidence of this unconscious theme.

In *La Vie*, Picasso in 1903 grappled with parallel couplings of mother and child, man and woman. A sketch for this painting shows a bearded fatherly artist figure standing where the mother and child are in the finished work, and the youthful male with a mate was Picasso himself. The sketch suggests a confrontation between son and father—creator and procreator—with an easel between them. But in the painting, Picasso got rid of the father (and the easel), replacing him with mother and child; he also substituted a friend for himself, sublimating the primal content, perhaps, but at the same time emphasizing it with the central couple and the single fetal figure.

There's also the seemingly innocuous academic painting he did at the age of sixteen, *Science and Charity*. A sick mother in bed—object of concern—is flanked by a man on one side and a child on the other. Picasso's father posed for the figure of the man, supposedly a doctor, and the child is held by an inhibiting nun. Picasso's use of his father may, of course, be practical rather than symbolic: he may have been using as model whoever was at hand. But in the 1890s, a year or two before Picasso did this painting, his artist father had handed over his own palette and brushes in abdication to the adolescent son whose talents had already surpassed his own—an Oedipal dream come true.

By the time Picasso was deified in the MOMA retrospective, he had been a rejected father figure himself for more than one generation of artists. Yet now the paintings of his last decade have made Picasso once again a contemporary artist, whose work looks younger and more vital than it has in half a century. The sum total of a lifetime of deliberate destructions and regressions, his final work is ablaze with primal passion. The child prodigy who could paint with the skill of a grownup had, as an ancient adult, recaptured the ferocious spirit and immediacy of a child. After a lifetime of primal imagery, Picasso finally found a primal style to match.

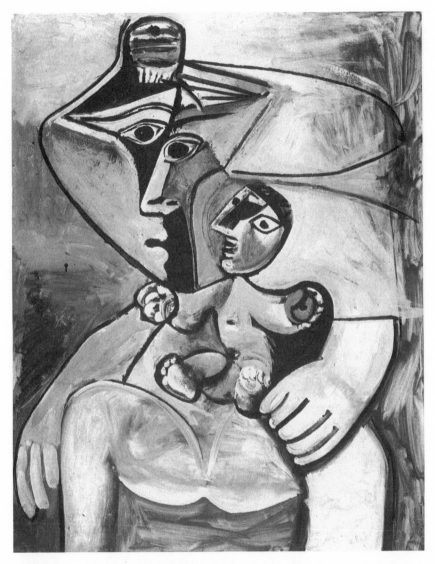

Pablo Picasso, *Mother and Child,* Mougins, August 30, 1971. Musée Picasso, Paris.

Mark Tansey, *Forward Retreat,* 1986. Private collection.

2 The Agony and the Anomie

In 1817 Goethe proposed that all cultures went through four stages. The first was one of powerful communally shared symbols and visions. The second and third were progressively analytical, formalized, and abstract. And the fourth—and final—stage is, according to him, as follows: "Human need, aggravated by the course of history, leaps backwards, confuses priestly, folk, and religious beliefs, grabs now here, now there, at traditions, submerges itself in mysteries, sets fairy tales in the place of poetry, and elevates these to articles of belief."[1]

The start of a new decade doesn't necessarily match up with a sudden shift in sensibility, but 1980 did. The analytical and the formal were rejected, and weird new kinds of historicism, primitivism, and Expressionism were irrationally embraced.

In the real world, the decade started out in the shadow of a number of events that could be read as warnings against modern hubris. Three Mile Island nearly melted down; Skylab fell out of the sky. But technological accidents weren't the only signs and portents. There was the hostage crisis in Iran, which had recently undergone a violent revolt against modernity. Cultists, extremists, and terrorist acts were on the rise; supernatural horror movies were the rage. Religious fundamentalists right here at home were militating against Darwin in favor of Adam, and an old-fashioned movie hero was elected president—as if appropriating biblical stories and Hollywood fictions might save us from unnerving realities. Even the sudden fad for roller

Arts Magazine, April 1986; an expanded version was published in the exhibition catalogue *An American Renaissance: Painting and Sculpture Since 1940* (New York: Abbeville Press, 1986; Museum of Art, Fort Lauderdale).

skating gave evidence of a brand-new nostalgia for a past that never was. The utopian future had evaporated. Rationality was on the wane. The ideals of modernity were on the defensive.

In the art world, the '80s began in the wake of a proliferating array of simultaneous art movements. Including Narrative Art, "Bad Painting," Pattern and Decoration, New Imagism, New Wave, Naive Nouveau, and any number of personal "retro" revivals spontaneously generated and often instantly obsolete, these new movements made it look as if the future would be built on the cast-off taboos of the Modernist past. The decade began with the "rebirth of painting," the discovery of Europe's new German and Italian painters attempting to come to terms with their national pasts—and with the emergence of an informal expressionistic aesthetic in New York's East Village, which embraced rowdy street art and rough graffiti. The decade also began amid heated debates about Postmodernism and whether we might stand poised at the start of a new postmodern age.

Suddenly, out of the welter of overlapping styles that had competed during the so-called pluralistic days of the late '70s, Neo-Expressionism emerged dominant both here and abroad. The antiquated concept of a Zeitgeist found favor again. But the spirit of the times was not confined to Neo-Expressionist art. It involved a widespread rejection—or at least an apparent rejection—of the experimental, the original, the inventive, the analytical, and anything that was obviously "avant-garde." By 1980 the characteristics Goethe described so long ago were becoming apparent in the most recent art. The heady idea of a postmodern culture starting over from scratch was supplanted by the physical fact of a retrogressive art that seemed to look back.

"Art in our time is malice," remarked Clement Greenberg in 1980.[2] "Pictures," "statues," "figurines," and other conventional art objects were beginning to reappear, along with outdated materials such as bronze, marble, and oil, and a new interest in bases, frames, statuettes, and monuments, all of which had fallen into disrepute. The human figure reemerged as anachronistic protagonist, either desultorily bare of skills or clothed in some obsolete style. Apparently abandoning Modernist ideals of originality and progress, artists were starting to recycle the past, returning to traditional materials, conventional formats, reactionary figuration, equally reactionary abstraction, even sometimes academic techniques. With the return to de-

valued conventions came the use of secondhand forms, borrowed styles, and repossessed images. The emphasis was on familiar human content rather than innovative form.

Anomalous aspects of twentieth-century art that were ignored or in disfavor during Formalist days began to be noticed and reappraised: not just Expressionism and Surrealism but other unwillingly modern styles of the 1930s, including Social Realism, Socialist Realism, and Fascist neoclassical art. The perversely philistine late work of Picabia and the grandiosely cynical late work of de Chirico were being admired by artists and searched for clues, as were the blithe superficialities of those easiest of modern masters, Chagall and Dufy. Besides delving into the historical past of previously not quite respectable styles, painters began to explore the collective past of cultural archetypes, and the personal past of infancy, ancestry, roots. Craving perhaps to return to states of effortless innocence, ignorance, and unconsciousness, they didn't just retrieve devalued conventions: they embraced the primal and the primitive in any number of ways. Rudimentary images, infantile impulses, childish icons, adolescent idolatries, totemic objects, and metaphors of crude physicality abound in recent work.

Retrogressive, regressive, and unrepressed, this new sensibility recycles what devout Formalists would have considered visual trash. Schlock, kitsch, animated cartoon stylizations, television trivialities, mass-media slickness, and commercial clichés are often the most fertile source material. The trite, the degraded, the simplistic, and the debased now have a perverse allure.

If the politicized experimental artists of the '70s tried to do things that had never been done, in order to break down boundaries between art and real-life concerns, artists now are involved instead with reclaiming that which has been rejected or popularized, and redefining the separateness of art. It's as if they're taking stock of our collective visual vocabulary, seeking twentieth-century myths, reverting to mock heroics in the face of adversity: they know our shared mythologies come from movies, cartoons, advertisements, and television. When the generation that cut their teeth on Warhol, the Flintstones, and Dr. Seuss—and their older cousins who grew up on Disney, Dali, de Kooning, and Dr. Spock—discovered Walter Benjamin's insights on art in the age of mechanical reproduction, it was love at first sight.

This wasn't simply a generational shift, due to the emergence of

a new crop of younger artists who share a prefabricated unconscious implanted by childhood TV. Artists who in the '70s had done ephemeral, unconventional, and often unsalable work using the land, their own bodies, or other nontraditional mediums began working in valuable permanent materials. Conceptualists and post-Minimalists started to paint. Painters—and only a few years earlier painting was widely rumored to be dead—switched from acrylics to time-honored oils. Even Conceptualist performance artists, who had once quietly documented their own improvised, often private acts, began staging elaborate spectacles, reviving the idea of art as entertainment.

Sensation and sensationalism, not intellect or technical prowess or formal or narrative logic, are the hallmarks of the new art. Ideas aren't what many artists are looking for right now. They're after more visually substantial, if shallower, thrills. Overblown metaphor, sensuous color, material pleasure, and the ridiculous romance of the making of art have replaced formal and narrative logic. Grandiose technique often accompanies crude or banal imagery; grandiose subjects and crude execution go together too. After more than a decade of post-Conceptualist thought in art, there are still all kinds of ambivalences about the relationship between the art object and the image. Between the mind and the hand, the new painting and sculpture tends to be a conceptually deconstructive act.

At the core of all the appropriations from the trivialized present and the discredited past lies a complex desire for "the illusion of normalcy," as well as more than a touch of malice toward the Formalist rejections that Clement Greenberg championed. Recent art can be seen in terms of neoconservativism, ultratraditionalism, antimodernism, as well as Neo-Expressionism. It can also be seen as a species of primitivism, which the *American Heritage Dictionary* defines as "a belief that the acquisitions of civilization are evil or that the earliest period of human history was the best." In this respect a primitivizing stance is thoroughly in the modern tradition, the latest in a series of episodes in which primitivist elements have been incorporated into modern art. We're now being reminded that the twentieth-century tradition of Formalist reduction has been paralleled all along by a tradition of reduction to the rawest content, the most elementary expression, in a quest for primal authenticity. While one branch of Modernism went ever purer, the other branch went ever messier, cruder, and more impure. The first ended up flattened against the

canvas. The second may still be willing itself to savagery, following the precedent of such artists as Nolde, Picasso, and Dubuffet. The recent fascination with subway graffiti is an update on Art Brut.

The noble savage is a concept dreamed up by sophisticates. The desire for innocence is a by-product of its loss. And the thirst for pictorial content is felt by the progeny of those who drained it from their work. But subject matter doesn't automatically confer meaning. It can lead instead to the deliberate exploration of meaninglessness, the exploitation of cliché. It can result in forms that are purposely intrusive, inadequate, or inappropriate, and in images that are undeveloped, unnatural, or incomplete. Any attempt to recapture lost values of the past suffers from omissions, inconsistencies, lapses of historical memory—but also creatively benefits from these misunderstandings. The result: works that are conservative and progressive at the same time.

After nearly a century of Modernism, art in Europe as well as America seemed to have reached a point where the only means left for radical innovation was to be reactionary. In one sense this is a provocation thoroughly in the modern tradition. As Marshall Berman sees it in *All That Is Solid Melts into Air:* "To appropriate the modernities of yesterday can be at once a critique of the modernities of today and an act of faith in the modernities . . . of tomorrow."[3] But the situation in art isn't as simple as that. The art of the '80s so far may be aggressive, cannibalistic, and crude, but it's hardly dumb. With its variable mixtures of Neo-Expressionist, neo-abstract, and neo-Surreal elements; its post-graffiti, pseudo-primitive, or mock-commercial leanings; its less than flattering imitations of popular culture and the media as well as of previous periods of art, it exudes an unwillingness to make something new. It's as if painters and sculptors are now paraphrasing the statement Conceptualist Douglas Heubler made as a work of art in 1969: "The world is full of objects, more or less interesting; I do not wish to add any more. I prefer, simply, to state the existence of things." Artists now are expressing a similar feeling, not toward objects but toward images. As another Conceptualist, Joseph Kosuth, observed in 1982, the rebirth of painting is "not simply painting but a reference to painting, as if the artists are using the found fragments of a broken discourse."[4]

Earlier in our century, when Expressionists and Surrealists ex-

plored the subjective and the "subconscious," it was in a spirit akin to the then new science of psychoanalysis, and in an age of rational ideals. Artists working now in Neo-Expressionist and neo-Surrealist modes have different motives, whether they know it or not. Acting out the compulsions of the psyche physically instead of dissecting them analytically, they're attempting to retrieve or at least to represent atrophied instincts, as well as critiquing the images bequeathed to us from styles of the modern past. The same can be said for the neo-abstractionists. Their work seems less involved with abstract form in itself than with representing the externalized images of abstract forms. For abstract modern form has become just another kind of used-up, devalued image—to be depicted, critiqued, liquidated. In that sense, "What we are witnessing," as Craig Owens wrote in 1982, "is the wholesale liquidation of the entire modernist legacy."[5]

Along with the feeling of bankruptcy that permeates our art and culture lately goes a sense of detachment and loss. A desultory intransigence—a refusal to claim significance—accompanies the insatiable appetite for grandeur in much of this work. Forms and images often appear meaningless, disoriented, or mute—reduced to insincere gestures, pulp heroics, crass impieties, or slick mockery. Yet more is going on in many of these offhand works than immediately meets the eye. Besides hidden skills, such as the painterly and coloristic subtleties that lurk within crude or apparently careless surfaces, there are messages that hide behind seemingly callous or inconsequential imagery. At a moment of higher stakes and lower expectations, the new picture and statue makers are confronting the powerlessness of forms; in an atmosphere overloaded with mechanically and electronically replicated images, they're striving to simulate and stimulate the power of emotions—and to express that endeavor's futility. Recent art partakes of our late-twentieth-century malaise: "psychic numbing," as it has been called. Exuberance may mask despair in some of this work, but it also expresses anomie.

Manipulative, sometimes bombastic, recent art plays on the emotions—on our cultural conditioning—rather than venting personal agonies. It makes the most of hyperbole and innuendo as signifiers of emotionality. In fact, "pseudo-Expressionist" would be a more accurate term for much of this manically histrionic work, if "pseudo" weren't in some quarters still a derogatory word. One of the chief new virtues in the complicated, contradictory '80s is shallowness; "simplis-

tic" is becoming a term of praise. Phony emotions, images, and styles are highly valued qualities right now. Artificiality and inauthenticity are the twin poles toward which the most genuine recent art is oriented.

Along with the recent unwillingness to experiment with new forms goes an emphasis on preservation. After nearly two decades of impermanent art, a preservationist attitude is in force. The recent interest in frames and monumentality is one evidence of this; the insistent physicality of the iconography, and the muscularity of even abstract shapes, are others. Out of a sense of helplessness, human beings are asserting themselves physically: the bodybuilding craze, the wrestling mania, the emphasis on physical fitness and muscular development—on preserving the flesh to fend off deterioration and decay—are counterparts to the new art. Right now wrestling and bodybuilding seem the sports of metaphor, the first with its rituals of artificed aggression and spontaneity, the second with its emphasis on swollen spectacle. The phoniness of actions or positions doesn't detract from the fascination with these displays of bulky physicality. In fact, the fakery is part of the attraction: the craving for inauthenticity extends far beyond the world of art. Smack in the middle of the energetic, creepy, boisterous, expressionistic, manipulative, surreal '80s, we don't have the benefit of hindsight. So we take our cues where we find them, pick up clues as we go—in wrestler Hulk Hogan's mock agonies, or in rock star Madonna's junk jewelry, her message of being a material girl in a material world.

We can think about recent painting and sculpture in terms of a new Zeitgeist, a sudden break with the past, an unexpected reversal of taste, or we can call it a last waltz with Modernism. We can say that the grand Picasso retrospective at MOMA in the summer of 1980 (and the revelation of his late work) gave artists permission to be painterly, instinctual, and expressive again. Or we can cite in retrospect "The New Image" exhibition at the Whitney in 1979, which now seems to have heralded the return to recognizable painted imagery, or the New Museum's "Bad Painting" show in 1978, which proposed an aesthetic of apparent ineptness and dubious taste. We can also point to a number of big international exhibitions in Europe, which gave credence to the new agitated, histrionic, painterly art.

A number of critics and curators have claimed lately that recent

art with all its excesses is a reaction against Minimalist reductions. But between the Minimalist structures and surfaces of the '60s—now perceived as repressive—and the regressive painting and sculpture of recent seasons there lies the elusive post-Conceptual art of the '70s. And it may be more useful and more accurate to ask what was germinating in the '70s that sprang to life in the '80s. How did the so-called pluralism of the '70s evolve into what one critic has dubbed the "puerilism" of the '80s? How did high-minded social-protest art and highly intellectualized investigations into the nature of signs, signifiers, and semiotic structures give way to what another critic has called "cultural cannibalism"?

In a convoluted way, the adventurous experimental art of the '70s can explain the newly conservative—and sometimes ultrareactionary—art of today. The '70s began with an escape from the traditional art object (and the gallery system) but ended up with big, handsome art objects hanging on gallery walls. At the start of that decade, Conceptualism, post-Minimalism, Earthworks, Body Art, eccentric performance work, and unwieldy site sculpture turned our attention away from man-made abstract forms and back to the frailties of the natural world. Photo-Realism, though no one likes to admit it, raised the possibility that art could be imitation of images rather than invention of forms. And in the desire to make work that was something other than a formal art object, many artists during the '70s turned to projects and actions having to do with human behavior, moral responsibility, social consciousness, populist accessibility, and survival. Their activist and feminist concerns with human content and contexts coaxed expressive elements and figuration once again into art. Wanting their work to be useful, playful, accessible, they embraced a feminized, hands-on aesthetic of the homemade, the handcrafted, the improvised, which admitted human imperfections and awkwardness.

By the end of that decade, accessibility came to mean decoration and a return to traditional formats; social responsibility was co-opted by various kinds of asocial if not antisocial expressionism, including graffiti; and survival became a matter of worldly success. Nevertheless, the concerns of the '70s have had their effect. The Neo-Expressionism, primitivism, and historicism of recent art have to do less with reacting belatedly against Minimalism than with reacting to what happened in art during the spacey '70s. Recent artists have been subjecting those concerns to almost unrecognizable revisions, which

imply that the immaterial art of the '70s may have gone too far afield too fast.

The new sensibility, addressing itself to the contemporary clutter of sensory stimuli, is an odd mutation of post-Conceptualist concerns, reinterpreting the need for content in terms that are visual instead of intellectual, sensuous rather than severe. Satiated with ideas, artists no longer want a thinking art that needs to be read; they want something easy to look at again. If linguistic structure was a logical model for many artists in the '70s, those of the '80s tend to find their models in the inchoate workings of the memory and the psyche: in irrational splices and displacements, subliminal associations, discontinuous fragments whose connective logic has long since dissolved, and forms whose structural integrity is a matter of faith. Playing fast and loose, drawing on detached physicality and sheer nervous energy, artists have been dealing recently in deceptively easy imagery that seems hastily drawn, sketchily brushed, or just as rapidly taken from commercial photographic techniques. The aim is apparent effortless ease as well as instant gratification.

Identity may have been a central concern of the '70s; nonentity is more like it now. When a work of art is inhabited by preexisting images and forms, or simulates emotional gestures to express an angst of emptiness, it's lack of identity and authenticity that comes to the fore. That's one of the consequences of the loss of faith in the Modernist ethos of originality. But when the reactionary is seen as the radical, the past as the future, the old as the new, and the spurious as the genuine, broader issues of individuality and authenticity crop up. The present retreat, with its desire for clumsiness and falsity, for manipulated images, repossessed styles, prepackaged forms, is an ambivalent attempt to return to old values. Grappling with Modernist belief systems in which it has become increasingly difficult to believe, this complex reversal of values is also a warning of the increasing rarity of direct unmediated experience.

Opting for manipulative images in a world of degenerated forms, artists are scavenging among styles, hiding their skills behind gaucheries, seeking reconciliations. They're trying to integrate the abstract and the representational, the artificial and the natural, the replica and the original, wanting everything at once—and they're creating a truly synthetic art, in every sense of the word. In the late state of a culture cast adrift in contradictions, haunted by myths of history and style

and omens of human vulnerability, artists are uneasily grabbing hold of traditions, however spurious, in order to stave off extinction. Creation is disguising itself as commentary.

NOTES

1. Quoted from Kathleen Agena, "The Return of Enchantment," *New York Times Magazine*, November 27, 1983, pp. 79–80.

2. In an interview in *Flash Art*, March–April 1980.

3. Marshall Berman, *All That Is Solid Melts into Air: The Experience of Modernity* (New York: Simon and Schuster, 1982), p. 36.

4. Joseph Kosuth, "Necrophilia Mon Amour," *Artforum*, May 1982.

5. Craig Owens, "Honor, Power, and the Love of Women," *Art in America*, January 1983.

Mike Bidlo, *Untitled,* 1982.

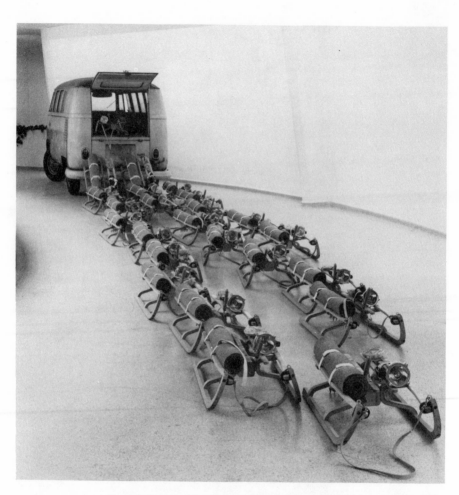

Joseph Beuys, *The Pack*, 1969. Private collection.

3 Joseph Beuys: The New Order

> I am interested in transformation, change,
> revolution—transforming chaos, through movement,
> into a new order.
>
> *Joseph Beuys[1]*

Joseph Beuys would probably have labeled his own death, of heart failure on January 23, 1986, as his last piece. A controversial cult figure—the ultimate artist-as-creator—he made the events of his life into his works of art, starting with his birth in 1921, which he claimed as his first performance. If Duchamp at the start of the century demonstrated that the most ordinary objects in the world could be art, Beuys insisted that art could also be the ordinary actions of life in the world. The art object for him was just a by-product, a relic.

With his grandly utopian ideology, his belief in creativity and the therapeutic potential of art, and his hopes for improving humankind, Beuys may have been the ultimate modern artist. But in shifting the terms from progress to survival, in dredging up the horrors of history as well as the errors of art history, his work not only ceased being modern but almost ceased to be art. Of the first-generation Postmodernists with social consciences, he was not only the most influential but the most extreme.

The Beuys retrospective is over. We have seen his disciples in red overalls, listened to his economic theories, watched his "participatory democracy" in action as he turned an audience of almost a thousand at Cooper Union into an intimate group-therapy session. We have been exposed to the objects, the utopian social ideology, and the superstar status of the former Luftwaffe pilot who called himself a "local boy"[2] and refused to bring his art to America until the Vietnam war

Arts Magazine, April 1980.

ended. And we still don't know what side he's on. "The logical result of fascism is the introduction of aesthetics into political life," wrote Walter Benjamin. Does it follow that the politicization of art is its corollary, or is it an antidote?

The opening of the retrospective at the Guggenheim in November 1979 was an elaborate media production, with lights, microphones, cameras, cordoned-off walkways for filming. German television crews were everywhere. The spectators lined the spiral ramp, looking not at the art but over the edge, a little like an audience at an opera, waiting for the Walküre, or like the layers of cherubs in the spiraling clouds of a Baroque German church ceiling, waiting for some holy ascension. The transformation of Frank Lloyd Wright's structure into the chance metaphor of an anachronistic gemütlich German past was the first clue.

Joseph Beuys himself was at the bottom, in the middle of the maelstrom, the image of the survivor—skeletal, pale, and hollow-cheeked, wearing his famous hat and his lifesaver vest. By now we have been told countless times how his materials relate to his wartime trauma of being shot down, left for dead in the snow, and rescued by Tartars, who wrapped him in fat and in felt to warm him. But we hadn't been warned that his oeuvre is about not only lifesaving but death.

His work reenacts over and over again that experience of survival, with its fat and felt, its red crosses and ambulance sleds and references to heat and cold, its tubings and membranes and intimations of broken bodies. Joseph Beuys is the good German: he redeems all of Germany with his suffering transformed into art, and his affirmations of the value of all life. In other words, he is great propaganda, he is good for a guilty conscience. Which explains the German government funding, the German media attention, the official approval of his eccentric acts.

He is also quintessentially Germanic. If he looks as if he stepped out of a medieval altarpiece and as though he came back from the dead, his work—heavy, somber, haunted by private demons—is suffocating, stifling, disturbing. His art wallows in morbidity. It resonates with the dark Romanticism of Caspar David Friedrich or Richard Wagner, the agonized torments of German Expressionism, the alienated despair of the Weimar Republic. It is powerful, personal, and painful—an exorcism of secret horrors, a therapeutic act—and it ex-

udes a Teutonic cruelty. There is something slightly maniacal in its continual reliving of that extreme experience of being saved from death. There is also something elemental about the human condition, which we'd rather not confront. And there is a specific symbolism, of which we have been ignorant.

Ten years ago and more, Beuys was an underground name in the American art world, and a hero to art students. His reputation preceded him to this country. When we saw bits and pieces of his work—a felt suit, a silver broom, a blackboard with scrawls—we related it to Oldenburg, to Pop Art. When we heard of his use of fat, we thought of our own post-Minimal involvements at the time in nonart materials and informal structure. When he came to New York in 1974 and talked to a coyote in a gallery, we interpreted it in terms of our own performance art. The parallels were misleading. In our literal climate, we never suspected that he was a symbolist, an expressionist, a mystical romanticist. It was our mistake.

Beuys made of his retrospective at the Guggenheim a new artwork: a series of twenty-four Stations on a spiral path. The little birth tub, bandaged and tubed and full of pain, is Station 1, as if to proclaim that the artist's life is the art and the art itself is only a prop—and most of it is: relics of past actions. For Beuys has taken on a Christ-like suffering-savior image, not only in the work itself but by referring to the Stations of the Cross, by the cross he attaches to his signature, by the red crosses affixed to his felt, and by his ritualized presence. For him, life is a matter of coming back from the dead, and art is a way to heal the wounds of society.

But his art is more than religious: it is political. And its political content is specific. While reviewers of the retrospective commented broadly that his work moves into the realm of political and social life, and while they related the story of his wartime adventures as a Luftwaffe pilot, they sidestepped the question of that historical background by using his words—"everyone went to church and everyone went to Hitler Youth"—as if to prove that saintliness triumphed. But his politics and his art have to do not only with an idealistic vision of the creative future but with unforgettable memories of a destructive past. Speaking of the late 1940s and his postwar impulses to become an artist, Beuys has said: "The whole thing is a therapeutic process. For me it was a time when I realized the part the artist can play in indicating the traumas of a time and initiating a healing process."[3]

His belief in the therapeutic powers of art—art as medicine—leads to strange certainties. He calls his art "dutiful." He asks, on a video documentary, "Is my thinking the right thinking or is it false?" He speaks of "social sculpture," of "shaping a new world," of creating "a society of living beings." But the society he comes out of is not the bourgeoisie but a world of stolid righteous burghers who never came to terms with being on the wrong side of a monstrous war. And by displaying his work as the remains of past horrors, by creating images of suffering and death—hares' hearts and skulls, crosses with stop-watches, a bandaged knife, a kneecap—he is attempting to purify the past. By making toenail clippings, molds of teeth, back braces, charred sausages, and stained gauze into art, he's exorcising his own and his country's collective guilt. Ambivalent images of putrefaction remain.

Station 1 was the tub: wash it clean. Station 23, down in the rotunda, was five mammoth slabs of fat, white as icebergs, hooked up to wires and transformers and a digital thermometer: twenty tons of tallow having its temperature taken every day, collapsing from within, and necessitating that the museum be kept frigid, as a mute, shivering guard informed me, showing a thermal undershirt beneath his uniform. Twenty tons of tallow like a sick patient, a living dying thing, losing its heat like Beuys himself buried in the snow and left for dead. But it is more than autobiographical. Although we are informed that its form was cast from a useless architectural space under the ramp at a German university and is a comment on urban planning and social malaise, its allusions to the millions of people melted down in concentration camps is inescapable, particularly in view of the fact that also in the exhibition is a small work in a vitrine called *Auschwitz,* which is simply a two-burner hot plate with a chunk of fat on each burner.

There is a secret narrative in the work of Beuys, of which no one dares speak. Autobiography is by now an acceptable content for art; the atrocities of Nazi Germany are not. But with a little effort, the Stations—which are neither chronological nor exhibited in numerical order—are decipherable in terms of what is now euphemistically called the Holocaust. Station 22, *Tram Stop,* is an iron track alongside a rusty cannon. Besides the purely autobiographical childhood memories mentioned in the catalogue, *Tram Stop*—with a head protruding from the end of the cannon—suggests the end of the line at

the concentration camps. Unraveling this hidden narrative backward, Station 21, *Hearth II,* is a large pile of felt suits: the clothing the victims stripped off. And although Station 23, *Tallow,* seems the culmination of the show, there is also Station 24, *Honey Pump,* with its tubes full of honey, vats of honey and fat, and generators. Beuys calls the *Honey Pump* "the bloodstream of society" and says it is "only complete with people." In its metaphor of regenerated energies and transformation, there is a curious echo of Nazi concepts of the New Man. Hitler, who also saw himself as a messiah, spoke of "the bloodstream of our people"[4] and thought he was restoring his people to "racial health." It makes us look at the iconography of Beuys in a new light: a suffering bathtub may be referring less to Duchamp's urinal than to the gas showers.[5]

The content of his work includes not just the atrocities but the ideologies of the Nazi past. For in the progression of stations along the way of Beuys the suffering godlike artist—the post-Minimal savior of human content who sees himself as shepherd of living things—there is a political program calling for the transformation of the human race. The Christian allusions are a decoy. Beuys's doctrines as well as his objects can be seen as conscious parody, critical revision, or ambivalent reflection of early exposure to Nazi teachings. He himself has laid hints for such a reading, stating that "the human condition is Auschwitz," and proposing, on the twentieth anniversary of the attempt to assassinate Hitler, to raise the Berlin Wall by five centimeters.[6] His art is indicating the specific traumas of a specific time, and it is doing so by subtle mimicry.

His references to Celtic and Nordic mythology recall the idea of Aryan ancestors; his use of Tibetan symbolism relates to the belief that the original Aryans came from Tibet; his insistence on the atavistic and irrational restores elements exploited by the Nazis and discredited after the war. His *Siberian Symphony* and *Eurasian Staff,* performance pieces referring to the continuous landmass of Europe and Asia, relate to Nazi desires for expansion to the east. Beuys mentions, in passing, a "Rosicrucian intention" in *Siberian Symphony,* and this may be more than a reference to an occultist red cross: the Vril society, a mystical pre-Nazi group in Germany, had been inspired by Rosicrucian ideas in a novel, *The Coming Race,* by Bulwer-Lytton.[7]

Beuys has a concept of *Lebensgefühl,*[8] or "living-feeling," which calls to mind the Nazi cries for *Lebensraum,* playing the need for

mental room against the old desire for physical space and "race-feeling." The divided crosses and modified crucifixes that he makes carry memories of the hooked cross that was the swastika. Even his use of scattered rods and an ax in his art may be symbolic:[9] the word "fascism" derives from the Roman *fasces,* a bundle of rods (originally sheaves of wheat) bound around an ax. Beuys's political activities in the name of "social sculpture"—the fact that he founded his own political party, the "Greens," that he was dismissed from the Düsseldorf Academy on grounds of "demagoguery," that he launched his own Free University and formed an Organization for Direct Democracy, working within and outside the political system, running for office and becoming a folk hero in the process—compound the curious connections.

An unlikely parallel can be drawn between Hitler, who wanted to be an artist, and Beuys, who claims the creation of a political party as his greatest artwork. Hitler came out of World War I with the ambition of restoring order to a people; Beuys came out of World War II wanting to restore order to humankind. Perhaps "parallel" is the wrong word. The similarity is more like a parallax: Beuys, subtly appropriating the symbols and catchphrases of an odious ideology, shifts the direction, alters the meaning, and by a corrective change in observational position, provides a new line of sight. If Hitler sometimes looked comic, Beuys, who has been described as "between clown and gangster," seems to be reenacting history.[10] The performances of both have been described as "mesmerizing," but history, repeating itself as art, is transformed from tragedy to farce, which may be the therapeutic process of which Beuys speaks.

His iconography is elusive as well as ambivalent. For example, in Beuys's deceptively Dada-like score for *24 hours ... and in us ... under us ... landunder,* a Fluxus action that has been explained as being about the development of expanded perceptions of space and time, and during which Beuys listened to wedges of fat, the words "chief of the stagleaders" appear in proximity to "warmtime machine." *24 hours* is about more than a potential mystical physics of the future going beyond Einstein and Planck: it is full of references to the wartime past, and the enigmatic term "stagleader" may well be one of them. Besides the obvious reference to the animal that, according to Beuys, "appears in times of distress or danger," "stagleader" could be a bilingual pun on the *Reichstag,* the German parliament responsible

for giving Hitler power when Beuys was twelve years old. Beuys, who speaks English as well as German, could easily pun between his two languages the way Duchamp did.

Also in that same score, along with an "energy plan" that includes ominous instructions for operating an oven, Beuys mentions "the great Khan." Genghis Khan is a name that recurs elsewhere in the work of Beuys, and this, too, is probably a reference to Hitler: In 1932 Hitler was being called "a raw-vegetable Genghis Khan."[11] And when Beuys writes that "the formulae of Planck and Einstein urgently need expanding," he may be referring to the fact that Hitler discredited those scientists.

Later in the score for *24 hours*, which Beuys performed during the twenty-four hours preceding the anniversary of D-day, there is a passage about warmth and cold and "life after death," in which the cryptic message "PAN XXX" occurs. Just as "SOS" is a distress signal, "PAN" and "XXX" are the international urgency signals, indicating an urgent message about the safety of an aircraft or a pilot. Beuys was trained as a radio operator before becoming a pilot, and besides those cryptic signals hidden in a written score, his work is full of references to batteries, antennae, transformers, radio equipment. "I am a transmitter, I radiate," he has said. His objects for transmitting energies, his materials that carry current—copper, lead, zinc—and others that insulate sound, his acts of listening to fat, and the acoustics of his actions, all relate to his wartime activities.[12]

We knew about his fat and his hat, but we didn't know about the quasi-mystical private meanings of his materials and actions or their mock-historical political symbolism. We never imagined that his work contained ideas about "generators," or that it was based on his "Principles of the Insulator," as the catalogue informs us. Beuys has a theory of sculpture that rivals Wölfflin's in complexity, and an obsession with heat and cold that is not just autobiographical—as the catalogue would have us believe—but is strongly reminiscent of the doctrine of a mystical German scientist named Hans Horbiger. Horbiger's theory of the frozen world (*Welteislehre:* the doctrine of eternal ice) became a widespread belief in Germany in the late 1920s and the '30s.[13] His doctrine that ice was the elemental matter of the universe—that moon, planets, and Milky Way were made of ice—was promoted with newspaper announcements, wall posters, and pamphlets delivered by volunteers from Hitler Youth. As a child interested

in natural science, Beuys must have come in contact with Horbiger's ideas that transformations in the state of water (liquid, ice, steam) fueled the universe. Beuys substitutes warmth as an antidote for cold and speaks of changes in the state of fat, but his ideas of transformation and of magical relations between man and the cosmos are oddly similar.

"It is impossible to understand Hitler's political plans unless one is familiar with his basic beliefs and his conviction that there is a magic relationship between Man and the Universe," wrote Rauschning in 1939.[14] Hitler, in the aftermath of the chaos of the Weimar Republic, promised a "moral rebirth" and spoke of a superior future race and the regeneration of the German people. "The doctrine of eternal ice will be a sign of the regeneration of the German people," wrote Horbiger in 1925.[15] "I believe the ailing earth must be regenerated, and I believe man must be regenerated," said Beuys recently.[16]

Buried somewhere in the depths of Beuys's self-created image are echoes of those Nazi beliefs that the way was being prepared for a higher being, a superior species—a godlike superman who could command the elements. When Beuys speaks of the transformation of humankind and of the necessity to create a higher level of consciousness, to shape a new world and prepare "new soil," he echoes the idea of the *Volk*—the "folk," the essence of the German people—a romanticized concept of the healthy peasant and the native soil that was popular in the 1920s and '30s.[17] Hitler promised Volkswagens to the people; Beuys brings a Volkswagen bus to the Guggenheim and brings the basic idea of German nationalism to all humankind. He speaks of "the social body as a living entity" and of working "with organic prototypes." He talks about money as the cause of social oppression, calling people "the real capital." His intention: healing chaos.

Hitler, too, talked of money as evil and felt he could mold a better race, and he, too, believed in education. "The entire work of education is branding the race feeling into the hearts and brains of youth," he said. Education in Germany, in the time of Beuys's adolescence, served the state, and learning was dominated by Nazi ideologies. Beuys may have rescued a book from the fire, but he could not have escaped the teachings of that time. If the iconography of his artwork deliberately indicates the traumas of the past, the rhetoric of his own teaching may echo that past less consciously, or it may be a deliberate corrective process. Instead of molding a master race, Beuys wants to

make everyone an artist. Substituting internationalism for nationalism, creativity for destruction, humankind for the *Volk*, "living-feeling" for "race-feeling," Green for Brown, and warmth for cold, Beuys may be modifying Hitler's ideas, correcting his errors.

Beuys presents himself as the New Man, teacher and savior of society, and exhibits his work as relics of himself. He even generates the adulation and the hostility saviors incur: he is accused of being a fraud, the dates of his work are suspect, his grand political pronouncements are greeted with derision as well as awe. His retrospective was viewed in New York with a mixture of fascination and distaste. Spectators reacted with nausea or headaches, with strong visceral responses, and didn't know why.

I don't mean to imply that Beuys is a Fascist, or that his art is neo-Nazi, but wish to suggest that there is another level of meaning in his persona and his work beyond the purely autobiographical and behind his idealistic visions of future society. And that this cultural, political, historical iconography and rhetoric relate—intentionally and, I think, sometimes unintentionally—to discredited embarrassing beliefs in the German past that for thirty-five years have been unmentionable.[18] It is time someone exhumed and examined these skeletons in the German closet, and that is what Beuys is doing. "Similia similibus curantur: heal like with like," Beuys has said more than once. "That is the homeopathic healing process." His art mimics the symptoms, echoes the causes of the trauma; his intention is therapeutic. The effect is harder to assess. Like may cure like, but likeness can also be mistaken for emulation. And homeopathic remedies—wolfsbane for fever, arsenic for ptomaine—work only in small doses. Otherwise they can cause the symptoms they are meant to cure.

Although rumors of his activities were reaching us in the '60s, and his actions—incompletely understood—may have instigated some of our own,[19] Beuys was speaking to a different culture, was coming from a different past. We may have made use of his eccentric materiality, but we never knew his intentions. He has stated that "art is a pill," and by referring to vanquished Nazi beliefs and their results in the fictional guise of art, it may be an antidote to German postwar traumas. But as we suffer from different symptoms, it may be too bitter a pill for us to swallow.

NOTES

1. Quoted by Gerald Marzorati, "Beuys Will Be Beuys," *SoHo Weekly News*, November 1, 1979.

2. His comment about being a "local boy" is apt. In Ireland he sandwiched peat brickettes with Irish butter and Welsh coal. In the U.S. he chose a coyote and the *Wall Street Journal* as materials. The retrospective, however, emphasized the predominantly Germanic content of his work.

3. Unless otherwise indicated, Beuys is quoted either from the Guggenheim Museum catalogue by Carolyn Tisdall or from his remarks during the panel discussion at the Guggenheim on January 2, 1980, or his Cooper Union dialogue with the audience, January 7, 1980.

4. Hitler quotations are from *Mein Kampf*, translated by Ralph Manheim (Boston: Houghton Mifflin, 1943). Beuys had earlier used hares' blood in tubes in a 1960 piece called *Horns*. The emphasis on blood recalls Bismarck's "blood and iron," which by the 1920s had been transformed into the mystical Volkist doctrine of "blood and soil," as well as Hitler's "Law for the Protection of German Blood." *Honey Pump*, with its metaphor of heart and arteries, is a relic of Beuys's hundred days of social workshops at Documenta 6.

5. The tub could also be an allusion to an event that took place in Germany shortly after Beuys's birth. When Hitler was sentenced to imprisonment after the Beer Hall Putsch in 1923, "several [women] requested permission to bathe in Hitler's tub. The request was denied," according to John Toland in *Hitler: The Pictorial Documentary of His Life* (New York: Doubleday & Co., 1978).

6. Besides this proposal, which commemorates a wartime anniversary, there may be other significant but unacknowledged commemorative dates in Beuys's oeuvre, which might be obvious to a German audience. For example, it would seem to be more than coincidence that in 1967 Beuys founded the German Student Party on June 22. June 22 was the date on which, in 1941, Germany's ill-fated invasion of Russia began. And it may be significant that his *24 hours . . . and in us . . . under us . . . landunder*, an "action" full of hidden wartime references, ended at midnight on June 5, 1965: D-day was June 6. Or that on October 14—the date on which Hitler was wounded in 1918 in World War I and hospitalized, and on which in 1933 Hitler announced Germany's withdrawal from the League of Nations—Beuys performed *Eurasia, 34th Section of the Siberian Symphony* in 1966 and *Vacuum-Mass* in 1968.

7. Louis Pauwels and Jacques Bergier, *The Morning of the Magicians, Part II* (New York: Avon Books, 1968).

8. Beuys's concept of *Lebensgefühl* is mentioned by his former student Johannes Stuettgen in "The Warhol-Beuys Event" (three chapters from a forthcoming book), published in Xerox by the Free International University in 1979. He translates the German word as "a conscious feeling of living."

9. The ax appears most notably in *This is my axe and this is the axe of my mother*, in 1967. About this action, Beuys says: "Implied are the mysteries of blood lines, families, races and what is passed on through history." The rods appear in several pieces. They surround the pile of felt suits in Station 21, *Hearth II*. The his-

tory of this piece further clarifies the hidden narrative. The catalogue tells us the hearth idea first appeared in 1956, as a small fire warming *Genghis Khan's Cradle,* and that Hearth II was carried through the streets during the Carnival in Basel in 1978. A photograph shows a procession of men dressed in the felt suits, carrying the rods and wearing pig's-head masks. They are marching alongside pallbearers carrying a large object in the shape of an upside-down fireplace or tombstone, which appears to be painted with flamelike forms and is emblazoned with the title *Feuerstätte II. Feuerstätte* translates more literally as a sacrificial fireplace or fire-spot than as "hearth." "The rods were later clamped into bundles," Beuys informs us in the catalogue.

10. Even his hat may have something to do with childhood memories of Hitler, who in photographs from the 1920s was almost always wearing or carrying a fedora. John Toland in *Adolf Hitler* (New York: Doubleday & Co., 1976) quotes Eva Braun's recollection of meeting Hitler in 1929: "a man with a funny mustache, a light-colored English-style overcoat and a big felt hat in his hand."

11. Friedrich F. P. Reck-Malleczewen, *Diary of a Man in Despair* (New York: Collier Books, 1970).

12. According to Brian Johnson in *The Secret War* (London: BBC, 1978), the long radar aerials on some German fighter planes were "known as 'Hirsch-geweih'—stag's antlers—to the German crews." "Action," the term chosen by Beuys for his performance events, was also a term used by the Nazi military in reporting on the roundup and liquidation of "undesirables." As for Beuys's choice of the defenseless hare as an emblematic animal, it counters Hitler's identification with the predatory wolf (he called his hideaway "Wolf's Lair," he named his dog Wolf).

13. Pauwels and Bergier, op. cit.

14. Hermann Rauschning, *The Revolution of Nihilism: Warning to the West* (New York: 1939).

15. In a letter delivered to the scientists of Germany and Austria in the summer of 1925. "While Hitler is cleaning up politics, Hans Horbiger will sweep out of the way the bogus sciences," the letter stated. Hitler supported Horbiger's theory and called it Nordic science, and his inexplicable Russian winter campaign—in which Beuys was wounded and thousands of German soldiers were frozen to death—has been explained by Bergier and Pauwels as the result of Hitler's conviction that he had formed an alliance with ice and could conquer the cold. This Nordic science may also account for the large number of "freezing experiments" among the medical experiments carried out on concentration camp inmates, as described by William L. Shirer in *The Rise and Fall of the Third Reich* (New York: Simon and Schuster, 1960).

16. Quoted by Marzorati, op. cit.

17. "The Germans were in search of a mysterious wholeness that would restore them to primeval happiness, destroying the hostile milieu of urban industrial civilization," according to Lucy S. Dawidowicz, *The War Against the Jews, 1933–1945* (New York: Holt, Rinehart & Winston, 1975).

18. The subject is still taboo, in the U.S. perhaps even more than in Europe. At his Cooper Union dialogue with the audience on January 7, 1980, when someone in the

audience asked Beuys about the Nazi past, the auditorium erupted with hisses and shouts, and the subject was quickly changed.

19. Robert Morris's use of felt is an often mentioned example. Morris was familiar with the work of Beuys through Fluxus. In December 1964 Beuys did a Fluxus performance in Berlin that was done simultaneously by Morris in New York. Eva Hesse, who spent 1964–65 in Germany, also must have known Beuys's work, and her own imagery of human fragility is at times reminiscent of his. It is also possible that Beuys was in turn influenced by American artists. His piled squares of felt and copper, the earliest dating from 1969, may reflect the work of Carl Andre. His *Vitus Agnus Castus*, performed in June 1972, in which Beuys lay on the floor symbolically rubbing a piece of copper for several hours, with the herb that is a homeopathic remedy for excessive sexual desire fastened to his hat, may have been a response to Vito Acconci's masturbatory *Seedbed* of January 1972.

Joseph Beuys, *Tram Stop* (detail), 1976. Private collection.

Laurie Anderson, clay figure from *At the Shrink's,* 1975.

4 Laurie Anderson: That's Entertainment

Like a ventriloquist I've been throwing my voice
Long distance is the story of my life
And in the words of Joseph Beuys
If you get cut you better bandage the knife.
<div align="right">Laurie Anderson, Jukebox</div>

Ten years ago, the art world's multimedia waif had her first show at Artists Space because Vito Acconci selected her. How then did Laurie Anderson come to be such a pop celebrity that people ask for her autograph? If we set aside her multifaceted talents, the answer is obvious: Anderson, one of the hermetic post-Conceptual performance artists of the '70s, crossed over—from the art world into the world of entertainment. And it may be that in the midst of the materialistic art of the '80s, the cutting edge of Conceptualist art has become entertainment.

In 1979 she gave her first performance in Carnegie Recital Hall, a conventional theatrical space, instead of in an art space or on the street. Context, as I've said before, has a lot to do with everything. The big "mid-career summary" (or retrospective) at the Queens Museum brings her work back to an art world context. It's an interesting and pretty impressive show, disappointing if you're expecting the high-voltage charge of her recent performances, enlightening if you want to know where those performances came from, and how what was avant-garde art in the '70s could become grand entertainment in the '80s.

One of the most interesting things about this show is its serious, "difficult," '70s look. Some of her music fans might be puzzled, but she isn't just a recording artist who can do her own MTV videos and record-cover graphics. The room installations, photo-documentations, drawings, altered objects, sound sculptures, and photo pieces

The Village Voice, July 24, 1984; titled "O Superwoman."

with texts have the familiar sparse look of casual documentation that was pervasive in the '70s. This no-nonsense work-in-process style exposes its own artifices with penciled or penned texts, scrawled notations, diagrammed notes, Xeroxes, grainy or unfocused black-and-white photographs, and contact prints with sprocket holes. It's a look that reminds you of the '70s work on paper of artists like Acconci, Beuys, Oppenheim, Baldessari, Peter Hutchinson, and the Photo-Conceptualists. It exudes an aura of avant-garde experimentation and can be traced back to Rauschenberg and the Fluxus group.

Laurie Anderson does this mode well, though she's not an innovator. She arrived on the scene at a time when Conceptualism was shifting its focus from objective facts to a subjective, confessional, storytelling art that included installations and performances. The photos and texts that had documented earlier ephemeral, temporal artworks were becoming Photo-Conceptualist works in themselves. If the form was a received one for her, she turned it to her own purposes, taking the whole bag of verbal and visual tricks, repetitions, alterations, reversals, and inversions, adding a pragmatic, whimsical, innocently shrewd slant, and making it all accessible.

For those who've forgotten what an ordeal art could be in the '70s, this is an exhibition that asks to be read and listened to as well as looked at. It's art that takes time and intellectual effort, and demands that the spectator participate as performer, none of which we're accustomed to right now. You can select a song on her *Jukebox* such as the reggae tune for Chris Burden ("It's not the bullet that kills you, oh no, it's the hole"), read the accompanying photos with text, or pick up the phone of her *Numbers Runners* to listen to her voice and talk back. You can listen to a pillow by pressing your ear against it, or to a table by putting your elbows on it and listening through your palms. And you can see other seeds of her recent electronic wizardry in her self-playing violin, her viophonograph, her "film songs in 24/24 time," or in the magical shrunken figure that tells its tale in the installation called *At the Shrink's.* Like much other art in the '70s, hers may have aspired to invisibility, but it wanted to make itself heard. She managed to make post-Conceptualist art lyrical, romantic, and lovable. She took the shock out of the new and replaced it with delight.

The exhibition goes back to the days when, influenced by Eva Hesse and Sol LeWitt, she was weaving strips of newspapers into potholder grids, molding newsprint pulp into little sculptural objects

based on sign language gestures, making bookworks, and doing quirky street solos such as *Duets on Ice.* It goes back even further, to some peculiarly illustrational but technically impressive and meticulous etchings and political caricatures for posters she did in 1969. Reprocessing media information is what her work is about: languages, sign systems, body language, and the conventionalized languages of cliché, jargon, and slang. Making simple connections that speak of lack of connection, she sets streams of consciousness to work in a game of associations and non sequiturs that short-circuits systems of communication and resembles that old parlor game of whispering telephones. Her work has gone from modest beginnings to epic extravaganza. It's a Conceptualist success story: multimedia artist (whose subject is the media) merges with the popular media to become an "electronic cabaret" star. And her post-Conceptual spectaculars, texts set to music and performed with a light show full of visual treats, are accessible to rock fans. Because her work is so all-inclusive, you can enter it on any level, from sheer spectacle to semiotic analysis, or from any angle (as shown in essays from the point of view of photography, language, music, and art in the admirable catalogue). You can even argue that her work is a late flowering of the good old avant-garde, as well as one of the first sprouts of the postmodern hybrids to bear fruit. I doubt that the paradoxes of her situation are lost on her.

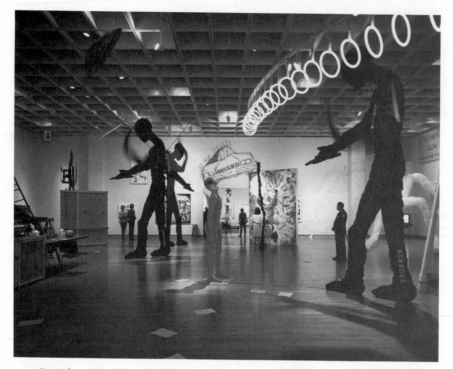

Jonathan Borofsky, installation view, 1984. Philadelphia Museum of Art.

5 Jonathan Borofsky: Dream of Consciousness

"I dreamed I was taller than Picasso," reads one of Jonathan Borofsky's pieces in the mid-career retrospective that premiered at the Philadelphia Museum of Art and has gone to Los Angeles for its grand finale. The singing painting, the dancing clown, the motorized hammering giants and chattering, lockjawed, wooden spectators, the figures flying through the air, the scribbles, the numbers, the pictures and dreams tumbling across ceiling and wall, the messages littering the floor, all come together in yet another of Borofsky's wildly exuberant, chaotic environments—a totally activated, unnerving carnival space.

There are split paintings, tilted paintings, upside-down paintings (done in 1976, before any of us had heard of Baselitz), half paintings, unfinished paintings (including a deliberately amateurish vase of flowers roughly wrapped in bubble plastic). There are temporary wall drawings, reversible video images, references to current events (one or "another of the absurdities on the planet that get to me"), a politically astute Ping-Pong table, and sculpture of all sorts. Cats crawl off one canvas onto the wall, life preservers bob in space, a projected magenta shadow of a spinning horse's head lights up the floor, blue neon hoops jump through the air. And an absolutely enormous bubble-wrap giant on all fours inhales and exhales incessantly.

For a retrospective, this is an impressive installation, but then, all Borofsky's installations ("I think of these as walk-in three-dimensional paintings," he says) have been retrospectives of sorts. His work is cumulative and inclusive. The growing stack of number-filled pages

The Village Voice, January 15, 1985. A revised version appeared in *L.A. Weekly*, March 21, 1986.

of *Counting from One to Infinity* (begun in 1969) reappears as a centerpiece in most of his shows, reminding us of the obsessive Conceptualist origins of his work. *Age Piece* (conceived in 1972) summarizes his artistic development and diversity from the age of eight on, by means of key samples of his work over the years. And *Continuous Painting* (1972–73) predicts the subsequent course of his work: the first scribbled image he made on a page of numbers—as a break from the tedium of counting for hours a day for four years—initiated a lopsided string of paintings, each signed by the number at which he left off.

His work deals not only with chaotic space but with the ordering element of time. The unexpected outcome of his early numerical meditations is Borofsky's inclusion of all the stray components of an artist's psyche, from the most private dreams to global concerns. Aural elements entered his work in 1980, by chance, in the pinging, ponging table-tennis piece. And now mundane "sounds of the world" mingle with numerically generated computer music as well as with the chattering of the wooden robots, and with Borofsky's own songs coming from the painting called *Sing.* The grotesque ballerina-clown dancing in a spotlight not only gets to the heart of what's horrific about clowns but gets to the core of Borofsky's aesthetic. Its tune, "I Did It My Way," incessantly hummed, whistled, and sung by the artist himself in a minor key, haunts the exhibition.

Borofsky's hyperkinetic environment takes the physicality, spirituality, political conscience, psychological consciousness, and narcissistic tics of the '70s and makes them function in terms of the energetic, creepy, boisterous, expressionistic, surreal '80s. Is he the missing link between Conceptualism and Neo-X? Between Sol LeWitt and Penck, Haring and Scharf? This installation, with its overlapping orchestration of sound, sight, and movement, is almost as operatic as Robert Wilson's *Einstein on the Beach* or Laurie Anderson's *United States.* It's another example of Conceptualism's apotheosis into art that's spectacle, entertainment, and *Gesamtkunstwerk.* "To see, hear, touch, smell and taste all at the same time was very difficult . . ." reads part of another Borofsky dream (about a "nazi-clown") on the wall. It's impossible to take in all of this at once. As in any three-ring circus, you're bound to miss something: the Polaroids affixed to some of the paintings, or the metal ribbon that billows out from *Sing,* bent into an outlined profile of a singing head. Or the anxious bird that reminds

us that Picasso's dove has become a bit world-weary.

At the so-called end of our modern era, while other artists flaunt the impossibility of original creation or spontaneous conception, Borofsky's art seems predicated on it. Creativity, however, is his subject matter, spontaneity his theme. Originality is the refrain of his whole repertoire of images. The contents of the artist's mind provide the content of his art, which keeps condensing the spaces between initial mental image and finished work. The recurring animal-eared and split heads are containers of thoughts. In fact, much of Borofsky's work can be understood in terms of left hemisphere/right hemisphere brain dualities, starting with the difference between counting and doodling. "Really our whole body seems to be run by this control center up here," he once told me.

One reaction to Borofsky's work is to quip: I dream, therefore I am. Another is to note that he has twined together all the loose strands of recent art history and greedily made them his own, from Conceptualism, Process Art, scatter works, and site-specific installations right up to '80s-brand Expressionisms (neo, pseudo, and *vrai*), making use of anything and everything in an indiscriminate synthesis that bridges all recent styles. Borofsky may be a chameleon-like product of the modern cult of creativity (the anything-I-do-is-art syndrome, which began when Picasso scribbled on a napkin in a Montmartre café), but instead of abandoning this obsolete cult of originality, Borofsky's work picks up the subject and doggedly shakes out its absurdities. Inspiration? It's in the half-conscious doodles on a shopping list. Spontaneity? Borofsky blows up those scribbles with an opaque projector. Uniqueness?

Unless you've closely followed his installations, or unless you saw this traveling exhibition in more than one of its several variants, the show makes a point that, in the carnival atmosphere, is easy to miss. His most "spontaneous" images keep recurring on different walls, in different contexts, brought into context with new images: they're infinitely repeatable, expandable, variable, and reversible, thanks to the wonders of the projector. They're as reproducible as a Sol LeWitt follow-the-instructions wall drawing. The fleeing mob of scrawly stick figures seen a few years ago in New York on Paula Cooper's wall showed up in Philly and the other museums on the retrospective's route. Ditto the blue bird dog. Art objects can be transported, of course, but images can also be retrieved. Spontaneity can be synthe-

sized. In the age of mechanical reproduction, Borofsky's wildly liberated pictures splashed on the walls are generated images (and generations of images) that have as much to say as those of any of the appropriation artists; they're only temporarily visible but as retrievable as anything stored on a floppy disk. He doesn't *not* appropriate: he appropriates mostly from himself. Like his own recurring molecular man, he's the itinerant artist carrying a briefcase full of reproducible, enlargeable sketches—the opposite of the miniaturized replicas in Duchamp's *Box in a Valise*—from one exhibition to the next.

"I dreamed that Salvador Dali wrote me a letter: Dear Jon, there is very little difference between the commonplace and the avant-garde. Yours truly, Salvador Dali."

It's also possible to miss the connection between the endless counting and the endless stream of regenerable images. Borofsky's barrage of images, in all shapes, sizes, and mediums, questions the idea of an artist's signature style. And as for that modern concern with being unique, the idea of the artist as divine creator, Borofsky replaces the artist's signature with an "anonymous identification" number (like that of citizen, inmate, or survivor). He locates each artwork according to his own impenetrable system of counting, an inexorable inner clock that takes stock of sporadic creative impulses—to remind us that objects and images are materializations of thoughts and dreams. Does creative time exist only when he's counting, disappear when he's not? And doesn't each work of art carry an identity of its own? The numbers also tell that the artist is something more, less, and other than that rare modern bird, genus Genius. He is, as Borofsky puts it, Everyman.

In Philadelphia the stack of numbered pages went from 1 to 2784831. At the Whitney the last number was 2927515, and 2927930 was emblazoned on an awning across the street, visible through the museum's big window. And by the time the exhibition was being installed in Los Angeles, its final incarnation, his signatory number had reached 2968412, on the way to infinity.

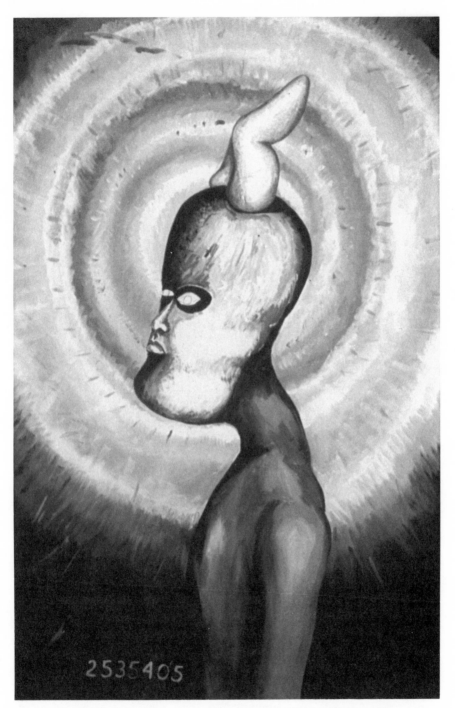

Jonathan Borofsky, *Head with a Shape on It at 2535405,* 1978.

The Times Square Show, 1980, exterior of building.

6 The Times Square Show

Postmodernism? "The new-fangled philistines of ad-
vancedness," railed Clement Greenberg in the winter of 1980. "Born
in 1978 and died in 1979," joked a cynical artist during a season of
Late Modernist last stands and neo-modern revivals, a season that
masked its fears with decoration and its despair with pretenses of
naiveté, disguising Minimalist grids as patterns or cloaking archaistic
conservativism in the old myth of spontaneity. The apotheosis of
Picasso to signature T-shirt status and the appearance of a war-weary
German savior preaching "social sculpture" marked the antipodes of
our boredom. We were ready for something else.

And just as the summer started, some of the freshest art around
came slouching in off the streets—from unlikely outposts like the
South Bronx and the Lower East Side—and installed itself defiantly
in an abandoned massage parlor in Times Square.

The Times Square Show radiated genuine energy. The work of
some one hundred artists, it was irreverent, raw, rebellious, messy,
and had the makeshift casual carefree air of an amateur endeavor, as
if nothing was at stake. The spirit of anarchy, exuberance, and cele-
bration announced itself from the street: tinny carnival music blared
from a loudspeaker into Seventh Avenue, setting a tone of fun-house
bedlam, and the second-story windows had been removed, as if to
make the exhibition accessible to the city. "Four jam-packed floors!!
More than you bargained for," proclaimed a little blue Xeroxed leaf-
let, mimicking the media and the merchants, and mocking the art
world.

Inside, every space and surface of the dilapidated four-story struc-

Arts Magazine, September 1980.

ture was utilized and transformed. There was art in the dank base-
ment and in the stairwells, in toilets and closets. It was painted onto
electrical switches and telephone wires, sprouting from urinals, hang-
ing from corridor ceilings, lurking in odd corners. Look out a window
and you might see a tiny cabin lashed to an air vent. Venture into the
depths of the cellar, to find a gauzy *Ghost* haunted by memories of
classical sculpture. Not far away, a crudely outlined human figure
sprawled across the floor and up a wall, while a pattern of white
footprints paced the gritty floor, and the whitewashed ceiling was
covered with black handprints. The figure seemed to be inscribing
itself in a circle with a stick, and its crooked legs appeared straight
when you stood in another circle marked out on the floor. Was it a
magic cave painting or a perceptual puzzle? Leonardo's measure of
man or a measured illusion of two dimensions and three? A reinven-
tion of fixed-point perspective, a comment on boundaries, or the dec-
laration of a weird new humanism?

There was so much art you could hardly tell where one piece left
off and another began. There were walls papered with patterns of
dollar bills, guns, and dinner plates like Warhol's wallpaper, with a
border of rats running around the floorboards. Graffiti-like narrative
artworks scrawled on the walls coexisted with a stairwell of genuine
subway graffiti by Samo* and a blackboard of spectator comments.
Stairways were ornamented with plastic ruffles, cheap flowered fab-
ric, and Xmas lights, as if to go straight to the source of decorative art,
and one of the messages on the wall declared "Fashion as Shield."
There were macho drawings, comic-book melodramas, and feminist
tableaux, and mirrors scattered throughout the building were embla-
zoned with the lipsticked words, "Women—take back the night."
There was a Portrait Gallery and an Open Air Fashion Lounge, and
a gift shop with cheap art and free giveaways. And if you were there
at the right time there were video works, performances, dance events.

Like Schwitters's *Merzbau,* the building was a total environment,
but it was inner-city art, an art of plastic and rags, broken glass and
garbage, celebrating squalor and urban decay. Like the opening show
at P.S. 1 a few years ago, where the art and the architectural decay of
the old schoolhouse were sometimes indistinguishable, this was art

*A couple of years later Samo the graffitist became known as the artist Jean-Michel
Basquiat.

that merged with its surroundings, melting into its sleazy Times Square context like camouflage. In retrospect the P.S. 1 art was smart. This show, subverting the gallery system, played dumb: the exhibition space was like an amusement arcade, containing art that couldn't be defaced because it embodied defacement, incorporated the debris of an overripe city, embraced TV inanity, Forty-second Street come-ons, and other assaults. It was an environment in which somehow the tree limbs studded with marbles by Willie Neal, a street artist, seemed more relevant as art than Mimi Gross's shelf of neo-Constructivist planar faces.

While artists have been talking within the art world about accessibility and context and content, about alternative spaces and temporal art, a newer generation—like an unexpected mutation—has gone further, creating a collective and semianonymous, inclusive not exclusive, social and antisocial art outside the environs of the art world. While critics were disputing the survival of art, an aggressive delinquent style emerged that has mastered the art of self-defense. It was truly accessible to the public. One day there was an exuberant streetwise youth unleashing excess energy on a punching-bag artwork. The next day a local bum asleep on an old plastic couch—across from two futuristic mannikins on a science-fiction chair—became part of the show. And the mannikins had changed position from the day before.

"It's Real! Art of the Future," proclaimed the tongue-in-cheek leaflet. But the future resembled the past: like a time warp back to the legendary messy Tenth Street days when art had nothing to do with money and money had nothing to do with art. It reminded me of Oldenburg's Store, of the freewheeling Fluxus energy, of Red Grooms's shenanigans, Artschwager's blips, and Les Levine's idea of disposable art. And it had a spirit of anarchy all its own. Punk music may be passé, sanitized and absorbed into the establishment, but Punk art is just beginning to emerge, and the New Wave is aware of the roots it is rebelling against. It may be "three-chord art anyone can play." It may draw vitality from its racial diversity, sexual equality, and citywide inclusiveness. It may incorporate street art and look like the ultimate free expression. But, organized by Colab, the people who did The Real Estate Show and The Manifesto Show, it was supported not just by fringe groups like Fashion/Moda and ABC No Rio but by the NEA and NYSCA. And in spite of its appearance of artlessness and its anti-intellectual stance, most of the work exuded knowing refer-

ences to art history and recent art. That cave painting in the basement, by Justen Ladda, had something to do with Borofsky's quirky work. The miniature cabin outside the window made me think of Charles Simonds or Joel Shapiro. And those absent windows, part of the collaborative Open Air Fashion Lounge, were an odd reminder of Michael Asher's Conceptual removals at the Clocktower.

There was a sink encrusted with sparkling rock salt by Jamie Summers, and on the stairway someone else, "who preferred to remain anonymous," had piled broken green glass in the corner of each step—as if Smithson's rubble had turned into actual demolition. There were delicate Renaissance diagrams sketched on a wall next to five black plastic garbage bags hung in a row, the work of Reese Williams, which might have been inspired by either Eva Hesse or Michelle Stuart, as well as da Vinci. And a layered narrative of words and images that cranked by hand through a peep-show box suggested a wild hybrid of Stephanie Brody Lederman and Agam.

John Ahearn's painted plaster-cast busts of grimacing city folk didn't just look as Hellenistic or Baroque as cheap religious statuary, but appeared as if Segal's casts had come garishly alive. Dick Miller's *Man Killed by an Air Conditioner* and a phone booth narrative by Matthew Geller suggested Kienholz or Thek, while a *Lead Suit for the Nuclear Age* by Tom Otterness evoked updated echoes of Beuys. There was a womblike nest with a nightmarish resemblance to Colette's silken dreams. And numerous small painted works—including some portraits with hoofs for heads signed "Mock '80"—looked as though they could have been spawned by Rafael Ferrer's crayons or Samaras's pastels.

There was a flashlight object by Kathleen Thomas, armored with spikes and chained to the wall, that sat on a post-Minimal shelf—a warped and folded square of metal—and emitted a piercing siren screech of self-defense when touched. Christy Rupp's plaster rats scuffling among real garbage around a sewer-pipe fountain, Marc Blane's whiskey bottles swallowing photos of burned-out Bronx streets like notes from a shipwreck, Sandy Semour's spike-heeled shoes on hubcap platters, Suzan Pitt's broom handle spiked with broken glass, and Mike Roddy's pornographic fans were pure Punk art, but they pointed out that Dada and Pop were the granddaddies of Punk.

Which is not to say that the work was derivative: the references

were more like a hostile residue of history, a way to show up predecessors and progenitors as insufficiently real. "Rather than one person's consciousness, it's directed toward a mass aesthetic. If you isolate it, most of the work is pretty academic," said Joe Lewis, one of the show's organizers, and he was right. It wasn't so much that the individual artworks were radically new; rather the whole was more than the sum of its parts. The context created a new sensibility, a collective statement.

The history of art in our century can be seen as an inexorable march toward abstraction and reduction, but it can also be seen as a series of efforts at incorporating the realities of modern life into art, with each new movement claiming to capture a more essential aspect of reality than the one before. Each was an effort to bridge some gap between life and art. And if we look at it this way—if The Times Square Show presents the newest realism—modern art has come full circle, for New Wave art exults not in progress but in its littered aftermath, and thus relegates the Modernist dreams of a utopian future to the past.

Perhaps the events of last season can be fitted neatly together after all: at the start of the '80s, Picasso and Modernism were admitted into public heaven, a born-again Beuys emerged from hell with Modernist visions of a future in which everyone would be an artist, and in the wake of a flood of escapist surface decoration and archaizing fantasy art, the grim realities of the present—the entropic metropolis and the aftermath of progress—have been shown to contain the most vital signs of life, absorbed into the vocabulary of the most accessible, alienated, and artless new art as if to demonstrate that everybody already is an artist. People used to look at a Picasso and say their three-year-old could do better. In The Times Square Show the handwriting is on the wall, declaring "I am not an alien," or "Atoms can be fun." It's like a Last Judgment. Or the ultimate stopgap.

Apostles of destruction or harbingers of a brave new world? And we are left to wonder whether New Wave art is protomillennial fin de siècle depravity or the second coming of early Modernism, or if the postmodern salvage art we've been anticipating is already here, unexpectedly making its debut in derelict guise, swathed, as it were, in rags.

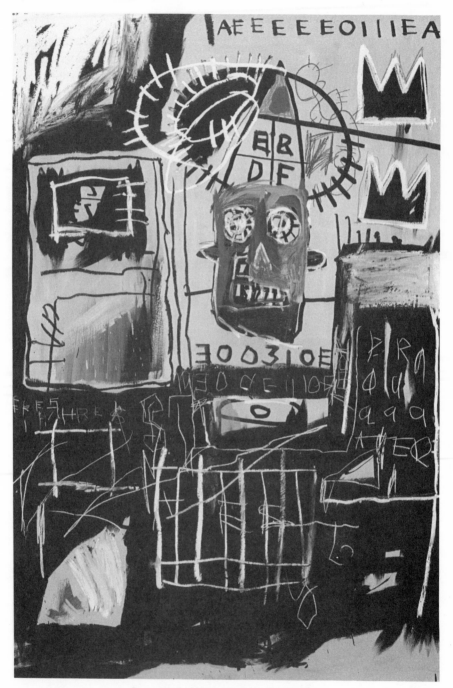

Jean Michel Basquiat, *Untitled*, 1981.

7 The Fifty-seventh Street Stop

It's a given: the clash of cultures, the sociological phenomenon, the self-satisfaction of uninformed liberals who feel they've discovered indigenous black and Hispanic art right under their own sidewalks. The heartwarming irony of Carroll Janis in the backroom with "the kids," as everyone calls them, showing them the Arps. (They liked Boccioni better.) The snide comments about how Keith Haring and Jean-Michel Basquiat are the old masters here, and yes, there actually is a fourteen-year-old in the "Post-Graffiti" show. The farcical aspects of collector Dolores Neumann (den mother to some of the graffitists and curator of this show) personally cooking fifty chickens to serve with popcorn at a disco club after the opening, which by the way was as crowded as the proverbial subway at rush hour. Of Sidney Janis saving the day at the party after the opening by doing a mean fox-trot when the rappers started squabbling and the obligatory break dancing was delayed.

What's more interesting right now is the rapid legitimization of graffiti by the art establishment—or at least the attempt to repeat the coup of twenty years ago, when Janis put its stamp of approval on Pop Art with a big group show. It's "post"-graffiti because it's not in the subway, it's not illegal, and it stays put. Let's read this exhibition as a signal that we're supposed to consider graffiti painting as art—which means on its individual merits.

The Janis catalogue contains some of the most overblown poetic statements since the days of Abstract Expressionism, and some of the most innocently pompous imitations of art jargon. "My work which I call 'Post Graffiti-Pop' is much related to the Pop artist Roy Lichten-

The Village Voice, December 20, 1983.

stein, but also has a powerful color composition that is very much extracted from my previous subway work," explains Crash. Ramm-ell-zee, the theoretician of the group, talks about his work in terms of "Ikonoklast Panzerism" ("the armamental style as opposed to the or-namental style") and "Gothic Futurism," but it's not clear whether his use of the word "Futurism" comes out of art history or science fiction, or refers to fellow graffitist Futura 2000. These quick-witted street kids, masters of slang and mimicry, are sure picking up art lingo fast. On the other hand, Marc Bracz, a folk-pop social realist in his thirties, who paints with a brush and doesn't really belong in this show, says his art derives from "The South Bronx Graffiti tradition." Don Leicht, another artist in his thirties, who works with cutout painted alumi-num, also looks out of place: the notion of artists being influenced by graffiti is a totally different matter.

As for the genuine graffiti paintings, a first reaction is that this is art history replaying itself as science fiction. Among the post-graffit-ists, there are quasi-Cubists, semi-Surrealists, Action Painters, stain painters, lyrical abstractionists. They've got their Pop artist: Crash, whose canvases really do look like free-style soft-focus variations on early Lichtenstein, right down to the black outlines, comic book blonde, and zappy words. They've got their David Salle: Daze, whose "City of Dreams" is an effective combination of disjunctive urban images. They've even got their Georgia O'Keeffe: Lady Pink, whose contribution is a painting of one very large pink rose. Basquiat looks tame, Kenny Scharf looks weak.

A-One's huge wall-size (or train-size) canvas called *Train Art* is crammed with dense jostling shapes, images, writing, and a riot of color—with all the old ambiguities of space and surface people used to marvel at in the days of Abstract Expressionism. It's layered, com-plex, and inane. Toxic, NOC, and the Arbitrator Koor share that same macho style—pure aggression and chaotic energy. Ramm-ell-zee's painting, however, for all his aggressive talk, is ethereal and sparse. His floating letters made me think of Ed Ruscha's words. These graffiti artists share the same fancy footwork, headspins, and tricky moves as break dancers: they've absorbed the visual clichés of the twentieth century.

Graffiti as art is without a past and with a questionable future, but it has a history of its own (invented in 1970 by Taki 183), which accidentally collides with recent art's own history. While artists in the

'70s were trying desperately to escape from the constraints of modern "style" and modernist stylizations, teenage graffitists in the subways were really getting into style, fighting Style Wars of their own. They were putting clouds and bubbles around their tags, 3-D'ing them, arming them with arrows. The concept of style was bankrupt for post-Conceptualists, who had become involved with linguistics and semiotics. At the same time these semiliterate artist-vandals who called themselves writers were, without knowing it, short-circuiting linguistics, using the letters of the alphabet as magical postliterate symbols of primitive power—like an alternative avant-garde down in brutal man-made caves. They were constructing meaningless scripts, almost as if they were reinventing an incoherent or indecipherable medieval calligraphy for the postindustrial Dark Ages. Contaminated by urban decay, computer technology, cartoons, laser guns, Atari games, and other space age fairy tales and fears, they seemed untouched by any preconceived aesthetic ideas. That's what piqued our interest. "We write the unreadable," Ramm-ell-zee has said.

Pop artists made art out of popular culture. These tough kids are reversing the process, making pop culture out of art. Some of their paintings have a freshness and spontaneity we may find lacking in much recent art. And because they come out of a separate hermetic tradition, their resemblances to past art can seem unexpected rather than familiar. But what we shouldn't forget is that though they're actually making real paintings, and sometimes surprisingly accomplished ones, most of these artists are still just teenage kids. As one collector at the opening remarked, "When you invest in an artist, you like to think they have a future. With these kids, who knows. Someone who's fourteen or eighteen, you can't count on them. They could get stabbed tomorrow, or they could decide to be a doctor when they grow up."

A. R. Penck, *Am Fluss (Hypothèse 3)*, 1982. Private Collection.

8 Both Sides Now: German Painting Here and There

1.

"You're sitting on top of the world but it turns over every twenty-four hours," said my fortune cookie in Chinatown on the eve of the German art invasion. Last year the artlessly mannered Italian trans-avant-gardia buoyed us with work as elegantly unstructured as an Armani suit. This year heavy, humorless Germanic brushstrokes—and roughly hacked woodcuts, linoleum cuts, and sculptural forms—bring our own Modernist exhaustions home with a thud. New Fauves, they're being called in Europe. Wild Ones. Violent Painting. Despite the strong labels, these imported wild beasties seem toothless in New York. But right now the Germans are on top, and I'm trying to figure out why.

New York dealers, it seems, have been falling all over themselves trying to capture a German ever since the 1980 Venice Biennale. And now suddenly the galleries are full of the new German painting, and most of it looks strangely familiar. It's disappointing. But the New York art world is behaving like a dog with a new bone; maybe we're the housebroken pets. Nobody dares to ask whether it's deliberately aimless or unintentionally weak, or to question if it might be just a throwback, an anachronism some twenty years too late. Its déjà vu aspect is being carefully ignored. The bone might be taken away.

New York art critics are comparing them to the old German Ex-

The Village Voice, December 16–22, 1981; titled "Rhine Whine." At the time this was written, the work of Sigmar Polke and Georg Immendorff had not yet come to New York, and the work of Anselm Kiefer was not yet familiar here. So three of the strongest "first generation" German painters were omitted from this discussion, along with a number of younger artists, such as Walter Dahn and Jiri Georg Dokoupil, whose work had not yet been seen in New York.

pressionists, arguing about whether they're neo or pseudo, disputing the fine points. They're also relating them to our own newly expressionistic art, worrying about whether the work is childlike or cynically blasé. Are we projecting our own exhaustions of intellect and longings for mindless expressiveness onto a weak alien art? Or is Europe getting even with America for decades of pushing drip and slop and Pop down their throats? I hear that American art is getting the cold shoulder these days on the Düsseldorf-Cologne-Milan axis. (Exceptions are Schnabel, whose work always manages to infuse Greek coffee shop decor with Bavarian hunting lodge ambience, and Salle, who, it is rumored, was heavily influenced by the doubled-up images of Sigmar Polke, one of the German painters not yet seen here.) Is this German craze simply an art market phenomenon—another desperate attempt to manufacture a new style? Or part of a broader trend—our Fassbinder/Stilwende fascination with How German It Is? Or has New York been displaced as the center of the art world? (If so, why are all the Germans here now?) "The scene has shifted—you've simply *got* to go to Cologne," a collector told me sotto voce the other day.

The world started turning last season as we were prepped with the requisite history: German Expressionism at the Guggenheim, German Romanticism at the Met. We've already had a glimpse of K. H. Hoedicke and some of his students, and—though no one noticed because last season belonged to the Italians—Anselm Kiefer. (We'll see Kiefer again in the spring.) And now five German artists are occupying seven galleries: Georg Baselitz at Fourcade and Brooke-Alexander, Markus Lupertz at Marian Goodman, A. R. Penck (one of several pseudonyms used by Ralf Winkler) at Sonnabend and Jacobson/Hochman, Rainer Fetting at Mary Boone, and Salome (Wolfgang Cilarz) at Annina Nosei. Schnabel's glut of garbled imagery is looking better by the minute. So the world turns.

They really are being referred to as "first generation" and "second generation" artists—I'm not kidding—in the same way Robert Irwin was called a first-generation artist in California a few years ago. Apart from Joseph Beuys (and nobody's mentioning him this year), it seems there's been no German art worth speaking of since the war. According to Cologne dealer Michael Werner, it's been strictly School of Paris in West Germany and Russian aesthetics in the East.

In the early '60s, Lupertz and Baselitz and a few others in West

Berlin fell in love with the idea of painting and began to pick up the pieces where the old German Expressionists left off—at the same time that Beuys began preaching anti-Kunst in Düsseldorf. And now here they are almost twenty years later along with their students, and we're being told it's the latest thing. No wonder it looks suspiciously reminiscent of our own post–Abstract Expressionist figurative fringes: it's coming out of a peculiar void, and out of the New Figuration that hit Europe and California—somewhat abortively—in the late '50s. Think of Dubuffet and Art Brut, Alechinsky and the Cobra group, Asger Jorn, Karel Appel—or the old Californians Elmer Bischoff and David Park. It's not all Kirchner, Jawlensky, and Marc, but it has emerged from a time warp so hopelessly late it seems early.

Baselitz tries to get rid of literary content by painting and hanging his uncomposed images—mostly crude figures stuffing their faces with food or drink—upside down. It's hard to be shocked at the upside-downness of a careless pseudo-Brut image after decades of hearing how the Abstract Expressionists used to turn their canvases upside down to make sure the space worked. It's an old academic trick that was part of the painting process, here being used as a gimmick. As far as getting rid of content, it doesn't quite work. It's easy to read into these works meanings that were never intended: the perceptual notion of eye-to-brain image flip-flop. Or the fact that eaters and drinkers have to swallow, and what goes down will come up in this ass-over-head art. So you might say it's about spilling, regurgitation, unnatural evasions. And regurgitation of the past is something all these artists share.

Lupertz takes the content out of his images by equating an overstuffed chair, a businessman, an Arab, or a pot of flowers with a bunch of heavy, jostling abstract shapes and splotchy strokes. He reduces his palette to blue, brown, and gray—artificial tones with memories of Cubism. The polychrome patina on his bronze sculpture matches the sober colors of his paintings, which work best as backdrops for his handsome rough-hewn bronzes—a foot, a hand, a head, and a body as impressively conventional as they are impassive. Lupertz says he's not responsible for the motifs he paints.

The earliest German Expressionists—the group called Die Brücke—moved from Dresden to Berlin. A. R. Penck (he borrowed the name from a nineteenth-century Ice Age geologist) followed in their footsteps a year or two ago, but he had to contend with the Berlin

Wall. He says in a poem that he's been spat out by the East and not yet devoured by the West. So he changes identity, names (another of his aliases is Ypsilon), and his pictographic images look like multiple-choice hieroglyphs, alternative systems of signals for transmitting pictures: stick figure/caveman/Greek vase silhouette/Aztec monster/totemic graffiti. He's odd man out: it's easy to get enthusiastic about his high-impact work. It looks like nothing else, except maybe Keith Haring with substance and a touch of Mircea Eliade or Paul Klee. His imagery includes coded versions of Ariadne, Theseus, and a Minotaur whose belly is an African head and a skull, and even personal myth: *Übergang* seems to feature a running figure, an armed border guard, and a West German eagle. But Penck's free-flowing symbols and signs break up before your eyes, decomposing themselves in constant transition. They cancel each other out before you can pin them down.

Baselitz and Lupertz, "personal friends but professional enemies," both disclaim any connection to German Expressionism. A. R. Penck sees himself as a conceptual artist using traditional means. "One does not wrap a grand piano in felt anymore. Instead one plays it again," he says. But the second generation is really playing the old Expressionism for all it's worth. Their work is more easily assimilated, but then, second generations always have things easier. Salome's male nudes cavorting in groups and his semiclothed figures in ayatollah drag are obviously superficial—and effective. But that's his point—and the point of his alias: it's painting in drag, covering indifferent academic drawing with bright color and flurries of brushwork—going through the motions without a touch of feeling or class.

Fetting looks good because his fakeries encompass the genuine. And if Salome prefers his figures in groups, Fetting prefers a one-to-one relationship. He's really pushing paint, and making color zing, while grafting Picasso's head onto one of his male nudes, or the pose of his early *saltimbanque* onto another so slyly you think you're imagining it. He's got the most vibrant color, the most luscious paint, the perfect drips. Like Penck and Salome, he redoes the same painting in different versions so you realize his motives are decorative: a crimson nude on one canvas has a green phallus, but there's an identical composition in which the nude is pthalo green and the phallus Schiaparelli pink. If the first generation wallows in heavy macho *Malerei,* the second generation revels in what a gay friend of mine

calls high faggotry—all style and no substance. That old saw about history repeating itself has never been more appropriate: the expressiveness of these artists is pure farce.

Individually they're not bad. Penck's black-and-white canvases (all titled *T*) are staggering. Baselitz's one big yellow painting of bicyclists with turquoise wheels suggests he may be better than he seems. Lupertz is an admirable sculptor. Fetting's painterly flourishes are crudely spectacular, and Salome's trashy fakeries have charm. But when you try to consider them as a movement, something goes all wrong. It becomes rehash—lightweight and feeble. All they have in common is a hasty image, a brushy black outline, and a technique that mixes dry pigment with glue. No oil, no turpentine, just glue to give an arid matte surface. Otto Müller did it back in the old days. They also like fast-drying latex housepaint, for the same reason.

I find it hard to believe these new Germans haven't been looking at artists like Gottlieb and Guston, and George McNeil, and haven't come in contact with newer American artists like Malcolm Morley, who've spent their obligatory year in Berlin on a grant. Less than two years after Joseph Beuys tried to take New York by storm, he's become a nonperson, and we're besieged by this massed phalanx of New German artists—without a trace of his Conceptualism, Weltschmerz, or guilt. Theirs is the romanticism of messy paint, not of changing the world.

But as far as Expressionism goes, it's a misnomer. There's not enough powder in their angst to blow their noses. Should we call it instead the New Subjectivity? Their work is too blankly impersonal for that. The New Traditionalists is more like it, to borrow a label from Devo. Or think of Kraftwerk's purely synthetic robotic sound. No feeling. No ideology. No politics. No responsibility. And no spiritual tension. The new German art may be painterly, messy, and heavy-handed, but it isn't expressive. It's evasive and blameless (after all, the first generation were just babies when Beuys was in the Luftwaffe). And it's listless. Nothing matters, nothing counts. If art could have a nervous breakdown, this might be it.

But speak of the decorative—cold-blooded simulations of the surface of an expressionistic style—they've got that down pat. They're crypto-academics. Their strength is to wrest from art history some ironic anti-Expressionist twists, and a soppy sentimentalism that denies itself. Like the new artists here and in Italy, they want to have art

both ways—figuration without content and abstraction without composition all at once, validated by spurious resemblances to past styles. But instead of being involved with ambivalent, equalized, simultaneous, unreadable images, the Germans seem stale.

Somewhere I think there's been a misunderstanding, and it may be the art world's attempt to turn them into a group—make them something other than they are. The hype may be a New York phenomenon, caused by our fascination with what's emerging from the supposedly Americanized Germany. But in this topsy-turvy world, these new German artists may tell us more about our own confusions than we already know.

2.

There's just one thing to remember if you're going to Germany, said a psychiatrist friend before I left, offering me his best professional advice: "They're either at your throat or at your feet." It's hard not to carry excess mental baggage to Germany, and we also tend to project our own baggage onto the new German art. One thing to remember about current German painting is that its resurrection of ambivalent political and social content and Expressionist style has less to do with guilty conscience than with childhood memories and a desire for acknowledgment of their own sufferings. As Joseph Beuys points out, "The enemy suffers too."

Another thing is that Expressionism means something different over there. It has nothing to do with wide-open space, unlimited freedom, personal liberty, and the pursuit of happiness. It's less a matter of freewheeling energy than of repressed energies unleashed: Germany is a place where nobody fidgets and children don't cry. And the trains run on time, as do subways, buses, and trams. If you come down to breakfast on the dot of eight, a perfectly soft-boiled egg immediately appears. If you're three minutes late, your egg is hard-boiled. It's still an orderly culture, with strict rules, no litter in the streets, and all kinds of repressed hostilities as well as repressed memories. Beneath this polite, punctual, law-abiding, and obsessively neat society—addicted to chicken broth as well as sauerkraut, sauerbraten, sour bread, and sour cream—there's an underculture of drunken louts staggering out of beer halls and pissing in the street,

and an element of medieval lustiness. In Germany a rare hamburger can be literally translated as bloody hacked flesh *(blutig Hackfleisch)*. Along the Düsseldorf-Cologne-Bonn-Frankfurt route, Germany is a combination of turreted castles on cliff tops and factories in valleys. Feudalism and industrialization coexist with an occasional Baroque curlique in between.

Nevertheless, it has the feel of an ersatz America—recreated from incomplete information and misunderstanding, like the *Star Trek* episode in which a traveler to a planet leaves behind a private-detective novel, and a gangster-era culture inspired by it springs up. Cheap '50s-style cinder-block modern buildings fill the considerable wartime gaps, looking out of place as well as unnaturally new, even though in a way it's the Bauhaus aesthetic gone fast food. It's not like California, where newness is natural, or like New York, which is always starting over. It's more surreal than any of that, more unwillingly deprived of any sense of place, period, or style. And that black American serviceman who always sulks in the background in Fassbinder's films is no artificial theatrical device. Wherever you go in Germany, he seems to be there.

In Germany Photo-Realism looks like just another kind of Pop Art, and the earliest Pop looks very much like the latest post-Punk. Even the history of recent art is slightly different there. Museums are full of Euro-Minimalists we've scarcely heard of, along with Euro-Op and Euro-Pop. Artists who have figured hardly at all in our history of influences, at least until recently, are very visible in German museums. Instead of Rauschenberg and Johns as old masters—or besides them—they've got Tinguely, Yves Klein, Spoerri, Arman, and of course Beuys. And instead of Ryman, there's a whole school of Italian Minimalists who worked with white.

I'd always heard that the best American art of the '60s went to German collections. It's true. Not just the best but the earliest Pop Art, the kind that's pretty much been forgotten about here. In the museums in Krefeld, Mönchengladbach, and Cologne, there are paintings from Lichtenstein's first show at Castelli, with all the awkwardnesses and gaucheries that soon got smoothed out, early paint-by-numbers and dance-step Warhols, paint-splattered Oldenburgs, early Rauschenbergs, early Segals, early Dines, early red wooden Judds, and what may be the one good piece of sculpture Robert Indiana ever made. There's even a pair of wrapped chairs by

Christo from 1961. Rauschenberg's *Soundings* is in Germany, as is Johns's big Buckminster Fullerish map of triangular canvases, and his 1972 triptych that's a key piece in tracing much he's done since. So is the earliest Robert Graham I'd ever seen (pure corn Pop) and the best Kienholz—the *Portable War Memorial* of 1968, with its tinny soldiers hoisting the flag and a big blackboard complete with eraser, chalk, and graffiti—along with Nancy Graves's most inventively scattered camel bones, Eva Hesse's memorable cut-tubing cube.

During World War II, European Surrealists and abstract artists emigrated to New York, causing the downfall of Paris as the capital of avant-garde art. And while we were preoccupied with Vietnam, video, earth art, and other pressing matters, Germany was assimilating McDonald's and blue jeans and buying up our best Pop Art. It's not quite a parallel situation, but to understand the new German painting, you've got to try to reconstruct an alternative history of recent art, beginning with a lost war, a foreign occupation, a period of reconstruction and Americanization. It starts with an infusion of Pop Art and goes backward from there. Most of the new German paintings have an underlay of Abstract Expressionist brushwork, an overlay of awkward imagery derived from popular culture, and an understanding of Pop that came from its earliest and crudest days. In a place where the history of art goes forward in reverse, moving from Pop to Abstract Expressionism—or its European variant, *tachisme*—and merging the two, it's appropriate that Baselitz paints his images upside down, or that Polke swirls abstract splatters onto metallic-weave fabric or pink acrylic fur. For the new German painters there was no argument between abstract brushwork and commercialized media imagery: both were gleaned from America's victorious art.

If Neo-Expressionism in Germany is closer to being an unrecognizable mutation of American styles than it is a descendant of the old German Expressionists, and Germany often looks like an unrecognizable America, America itself becomes almost unrecognizable there. On an English-language television channel, run by our armed forces, you can get *60 Minutes* and *Dallas* and all the rest. But instead of commercials there are military spots, giving pep talks about readiness, cautioning army personnel, warning about spies listening in on the telephone. And there are special cultural programs geared to soldierly concerns, such as showing how battle scenes are shot in Hollywood films. It's not quite the same America we get at home: the focus

is on power instead of consumption. Switch to a German channel and it's equally strange: California-style quiz shows about operas, with costumed performers who sing arias for the contestants. The German art invasion of 1981 was bungled: firing the latest artillery into a vacuum wasn't as effective as a bit of background explanation or a few mini-retrospectives would have been in winning us over.

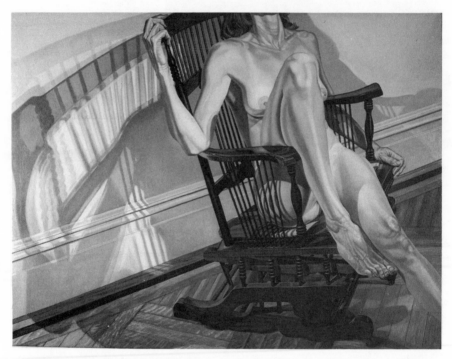

Philip Pearlstein, *Female Model on Platform Rocker,* 1977–78. The Brooklyn Museum.

9 Cultured Pearlstein

Philip Pearlstein's paintings are a magnificent example of the perversities of Late Modernism. I don't mean his so-called reconciliation of those two supposedly irreconcilable strains of art—abstractism and realism—that critics usually talk about in his work. It's far more peculiar and contradictory. During the late period of a style—or during the late styles of a period—art tends to go to extremes of severe oversimplification on one side and overelaboration on the other. It's as if the shifts within any aesthetic gradually swing wider and wider in opposite directions. Pearlstein is Modernism gone off its rocker.

He claims he rescued the figure from the torments of Expressionism, the dissections of Cubism, and from the pornographers. He says he rejected the tyranny of the Modernist roving point of view (though his uneasy space can hardly be called fixed). He said he rejected purist ideology, yet his idea of realism is as full of negations as Ad Reinhardt's idea of the abstract. "Anti-imaginative, anti-sociological, anti-symbolic, anti-expressionist, anti fun-and-games," wrote Linda Nochlin. "Anti-psychological, anti-narrative, anti-humanist, anti-erotic," Irving Sandler adds. Pearlstein renounced hot and dirty Expressionist abstraction to paint cold, clinical reality—but rejected all content to concentrate on pure form. The forms he chose happened to be naked persons in his studio, paid models, but he tried hard to make them as inert as any Pop object. If he were clumsier he would have been Alex Katz. If he were more facile—or at least sentimental—he might have been Wyeth. It took him from 1962, when he first exhibited a figure painting (the same year Warhol showed his first soup cans), until 1968

The Village Voice, August 23, 1983.

to perfect his style. By then it was as literal as any Minimalist's, as matter-of-fact as a Conceptualist's ("a documentation of a setup in my studio," he said), as sharp-focus, close-cropped, and accidentally composed as any Photo-Realist's work. Yet for all Pearlstein's suppressions of the subjective and personal, these are highly irrational personal works. What he thought of as "straightforward realism" now seems anything but.

He set out to paint a new figure from life, from intense concentration and focus on each part, fixing detail after detail, leaving—he says—no room for existential doubt. If he were more fixated he could have been Chuck Close. He's a particularizer: he wanted to show things the way they really are. But when so many things are suppressed in the name of reality, something has to give. And as his attention shifts, things that should be in the foreground slide into the background, hands or knees get grotesquely enlarged, volumes become swollen, space is compressed, color goes anemic, and all kinds of queasy slippages take place—oozing existential doubt.

Maybe we're not capable of grasping the whole anymore either: we blow things out of proportion too. But how do you deal with art whose "faults" make it interesting? Or with the discrepancies between intention and result (or between the quality of the work and the fascination it holds)? How do you reconcile mediocrity with the extraordinary when both exist together? And does it matter if you read into it things that may not be there? In other words, is it possible for an artist's oeuvre to be not only more and less than the sum of its parts but something else entirely?

Pearlstein confronts us with something that comes from the art educational system—the studio setup (an asset when he does something grand with a tired art school convention, a liability when he makes us think of student work). He strips figure painting of its past illusions, reducing the nude to studio models for whom nakedness is drudgery, hourly work. The expression on their faces—when their heads haven't been cropped—says gimme a break. His paintbrush tells too much about weary flesh, and too little. It's as if somewhere along the way he forgot that skin wasn't shiny fabric or highly polished stone. And as one viewer put it, "the upholstery of these bodies isn't very attractive." The opposite of Pygmalion, Pearlstein paints human beings as monumental pieces of statuary with bulging veins and poreless skin. Think of his work as the Michelangelo fan-

tasy. As for the "detachment" and "cold examination of perceptual phenomena," those are fantasies too.

There's something delusional, too, about pretending an eye is simply an all-seeing lens, using photographers' tricks like cropping and steeply angled viewpoints while denying photography. His argument against using photographs to paint from—a sore point with him—boils down to the fact not that he pays for live models but that the eye has a more complex lens than the camera, it's a superior piece of equipment. "I really see more than a camera does," he insists, carrying the modern love affair with technology to a competitive extreme. Cézanne said about Monet, "only an eye, but what an eye." With Pearlstein's work, the evolution of Modernism comes full circle, paradoxically back to the eyeball. His idea of the artist as an objective piece of observational equipment—and the extreme fantasy of such a position—ends a long process that began with Monet, when the external world began to go out of focus. With Pearlstein, the world is brought back into sharp focus, but there's nothing left of it except the artist's studio. His picky eye tries to put back all the particulars destroyed by abstraction—as if they're detached from any emotional sensibility or ordering brain.

Remember Warhol saying he wished he were a machine? Pearlstein, who was a classmate of Andy's at Carnegie Institute in Pittsburgh during the '40s, and his roommate on St. Mark's Place after they both came to New York, is in some quixotic way more radical than Warhol: he has spent the past twenty years doggedly trying to make his art as unemotional as a machine.

The big 1983 retrospective of his work offered both too much and too little. What was his 1952 painting of a Michelangelesque *Superman*—swirling through the agitated brushstrokes of a turbulent city sky—doing in the midst of all the flesh-colored, blue-veined rocks and cliffs that he was painting in the '50s? Of all Pearlstein's paintings, that pre-Pop work is the most puzzling (what was he thinking back then?) and it interests me most. The catalogue, which also tells more and less than you want to know, doesn't give a clue, though it does inform us that he won first prize in the 14th National Scholastic High School art contest, and, more to the point, studied with Balcomb Greene (who was famous for his glacial semiabstract nudes). Another early maverick canvas, *Death and the Maiden*, subtitled *Shower Attacking Woman*, can be tied to the information that Pearlstein's M.A. thesis

at NYU's Institute of Fine Arts was on Picabia, and the fact that while Warhol was doing shoe ads, Pearlstein was drawing plumbing fixtures for suppliers' catalogues. The assaulting faucets in that oil make you wonder if, when he later began cutting off body parts in the most awkward spots, they were being abstracted or being done violence to.

The early figure paintings are undistinguished and monochrome, like his earlier paintings of rocks. When he puts a piece of contrasting drapery under the model, the painting works better—even better when it's a colorful kilim. You could probably date his work by the recurring props, which include kimonos, Indian blankets, Peruvian cloth. An Eames chair gives way to an Adirondack rocker and most recently to bamboo porch furniture. These props function surreptitiously as autobiographical clues, souvenirs of the artist's life. They're also a sign of what might be called a Modernist flea market mentality: selection, cleaning, isolation. Pearlstein sometimes seems to allude to the history of modern art. In one painting, a rocking chair is propelled by a multiple shadow that stretches across the wall like a comment on *Nude Descending a Staircase;* in another, a nude figure in a hammock has a fetal and Futurist shadow on the floor. But the triple shadows can be explained prosaically away by the three light bulbs Pearlstein works under: no symbolism for him.

Interspersed with the awkwardly cropped studio nudes in standard poses that anyone who ever took a life drawing class will recognize (you may even recognize the models) are his portraits. One is of the artist's two stolidly brooding young daughters (he could almost be Balthus), a second of Linda Nochlin and Richard Pommer looking grumpy and bored (he could almost be Alice Neel), a third of Scott Burton—whose face is the only one that looks out alert and inquisitive, doing something other than killing time. There's also an unrevealing one of himself. But the Hitchcock-like cameo appearance he makes in one of his figure paintings reveals more: easy to miss, it's a tiny detail at the very bottom of the picture—the top of his head and the back of his canvas in a mirror that also reflects the large female nude. It's an odd, self-effacing, self-referential, passive-aggressive inversion of Modernism, existing in space in front of the picture plane.

Pearlstein occupies a curious place in the confused art history of the past decade or two, sharing incompatible prejudices on both sides of the aesthetic camp, no easy feat. In some farfetched way his work is connected to George Segal's vacated plaster bodies, or John

DeAndrea's vacant plastic ones, or even the masochistic aggressions of Body Art. You have to give him his due: he's gone on so long trying to perfect his impersonal vision—and he gets better and better at it. His work has become more severe and more elaborate at the same time as he refines his style. The flesh is more satiny and poreless, the furniture and kimonos more exquisite, the space more airless, the light harsher, and the supposedly uncomposed compositions more convoluted. You have to respect his tenacity and his conceptually bizarre—almost untenable—position. But that doesn't mean you have to like the work.

Julian Schnabel, *Stella and the Wooden Bird,* 1986. J.B. Speed Art Museum.

10 Julian Schnabel:
Zeitgeist or Poltergeist

Asked about Neo-Geo in a *Flash Art* interview in November 1986, apostle of simulation Jean Baudrillard had an unexpected reply: "Generally speaking, the play on quotations is boring for me," he said. "The infinite nesting of box within box, the play of second and third degree quotes, I think that is a pathological form of the end of art, a sentimental form. It would be more exciting for me to find something beyond the vanishing point: a hyper-simulation which would be a type of disappearance beyond disappearance."

Whatever he means by "disappearance beyond disappearance," it somehow describes Julian Schnabel's new work. No velvet, no pony-skin, no Oriental rugs, no plates, no antlers: these (with one exception) use Kabuki theater backdrops as their grounds, and add little to those already painted surfaces except a bit more paint. They hover somewhere between the absolutely banal, the apparitional, and the disappeared.

The one exception is the earliest work on view, a Coney Island freak show advertisement for a two-headed woman, which, maybe because freak shows are culturally closer to us than Kabuki, tempts us to ask whether it's an objet trouvé with graffiti-derived embellishment or a piece of classic folk Americana defaced by Schnabel's crude lettering. But it's too late in the twentieth century for moral indignation. Erasing, defacing, or dirtying up another picture is no shocking gesture; on the contrary, by now it's as traditional as a mustache on a postcard of the *Mona Lisa*. Painting on found grounds—newsprint or patchwork quilt—can be seen as classically modern. Call it an appropriated surface and it acquires the aura of the avant-courant.

The Village Voice, November 18, 1986; titled "His Next Stage."

The surfaces Schnabel usually paints on are meant for other uses or else they're tarps that have been dragged through the dirt. Who wants to start with a *tabula rasa* at this late date? But these Kabuki backgrounds aren't just material: they're readymade images, opening up a stylized theatrical landscape. They set the stage. And onto the surfaces of these preexisting vistas Schnabel's images wander like malfunctioning props. Clumsy consonants assert themselves as if dictated by a willful Ouija board. Residues of incomplete forms and images as impossible as poltergeists make their appearance for no reason.

In one, a spouting head on a barren plain gives the backdrop's hills a resemblance to brains. In another, three horned and helmeted abstract shapes dredge up memories of—what?—Max Ernst's *Capricorn*. In a third, a bird hatches and a naked child is baptized by a lumpy faucet that, like the Roman fertility goddess, is multi-titted. Or "a completely flat penis named 'Cheri,' " as the catalogue essay puts it, coexists with a flower that has a face, and a noose. In one titled *Rebirth I (The Last View of Camilliano Cien Fuegos)* two gigantic all-seeing eyes (blue ones) stare out from the green ground of an upside-down cherry-blossom backdrop, as if the picture itself were observing us. Those eyes and a few horizontal bars of paint are all that Schnabel seems to have added, and they leave you wondering whether they allude to Odilon Redon, Kilroy, Madame Butterfly, or nothing. These new paintings are about looking, not thinking; seeing, not feeling. And yet they're evocative. They indicate rather than describe. They carry remnants symbolic of grand themes—death, birth, sex, and war—but they also mean nothing at all.

But why should everything mean something? What's wrong with a taste of true meaninglessness? Schnabel's paintings are enormous (the smallest roughly twelve feet square) and operatic. His gestures, crude and at the same time precious, can suggest that he's grinding his soul the way Motherwell does (the elegiac Spanish titles suggest that connection, too). Demented but not demonic, his images and forms can be accused of being flabby, inflated, cast onto their ready-made backgrounds like beached whales. And yet they're not uninteresting. They regurgitate residues of feelings that no longer exist. They manage to be decadent and barbaric at the same time.

In terms of the current theoretical discourse, these paintings are certainly distanced and disjunctive: spectral, fragmentary forms on

unreal landscapes ransacked from the theatrical conventions of a foreign culture. They absolutely exude disassociations. And they're radically decontextualized. Taking something as bound up with convention and stylized gesture as Kabuki (which is full of ghosts), and haunting it with the ghosts of another culture, Schnabel produces a simulacrum of that obsolete quality creativity, in which nothing signifies anything. That (according to him) he chose the backdrops not deliberately but because someone offered them to him just adds, if true, yet another layer.

Schnabel's work has been lying low lately; it still has to live down the hype and rhetoric, the rumors of inflated prices, and the artist's petulant-genius stance. Careless facture, if that is what it can be called, ambition, and cross-cultural nonunderstanding aren't necessarily negative qualities. Extravagance and negligence are not mutually exclusive. It's fitting that these paintings are extraordinary and awful at the same time, lyrical and bombastic, emotive and indifferent.

This show generates a lot of questions and no answers. Are we tired so soon of neo-Minimalism, Neo-Geo, neo-Pop? Ready for another adrenaline boost of unintellectual paint? Is it possible Schnabel himself has just reemerged as a throwback like Julian the Apostate, reviving Neo-X before it's grown cold? Or has he gone beyond Baudrillard's vanishing point? How do the Kabuki pictures relate to Sigmar Polke's fabrics trouvé? And how do they relate to the work of Morris Louis now at MOMA? Maybe someone should give Schnabel a few Morris Louises to paint on. As Baudrillard said at the end of that interview, referring in passing to Daniel Buren, "Everyone seems to be saying 'I am setting up a new stage,' but in this space, in this new light, no one will ever move, there will be no play. The actors have disappeared; only the backstage and parts of the stage sets remain."

David Salle, *Landscape with Two Nudes and Three Eyes,* 1986. Private collection.

11 The Salle Question

It's not exactly that David Salle's work appeals to our worst instincts, but there's something about his art that brings out the worst in people. It certainly generates irrational responses, both rapturously pro and rabidly con.

At the Whitney Museum opening of Salle's show, a distinguished-looking white-haired gentleman in a tuxedo took it upon himself to tell a stranger that his necktie (a fat retro patterned one) looked "fecal, just like this whole show." Outside the entrance of the museum, renegade artists Cockrill and Hughes, who sued Salle a few years ago for allegedly plagiarizing their image of Lee Harvey Oswald, were handing out leaflets to remind us of that old plaint. Never mind that they quite happily settled out of court for two thousand dollars. The outrage of appropriated appropriators knows no bounds when mileage can be gotten from someone else's art. "Oswald baby kidnapped. THEY SNATCHED MY BABY GIRL!!!" screamed their mock-tabloid headline, followed by the tasteless tale of child abductor "Aunt Sally." In a frenzy of creative paranoia, they seem to have forgotten where they themselves found the Oswald image: in someone else's Pulitzer Prize photograph.

But first things first. The show looks good. The work is ambitious, it's big, it has presence and power. And it develops the way art historians tell us art is supposed to—from the relatively simple diptychs of 1979 and '80, with their split-screen overlays, to enormous complex works with inset pictures and protruding objects, which manage to juggle a dozen different things at once. The nonchronological installation—after all, it's only been seven years; Salle's only thirty-four—is

The Village Voice, February 3, 1987.

sensitive and goes for visual, not historical, effect. Before 1979 Salle, like many of John Baldessari's other ex-students, was doing Photo-Conceptualist works, but they aren't here.

Of course, Salle's stew of vacuous images and styles is coarse, crude, vulgar, and American in the worst way (but not nearly so coarse, crude, and vulgar as Cockrill and Hughes). Would we want it to be anything else? And, of course, one or two of the paintings look feeble, and a few seem overblown, but Salle continues to shed weaknesses and develop his strengths. I was quoted among Salle's detractors in Lisa Phillips's catalogue essay for having called him, in a 1985 review, "a plunderer of styles," but only a diehard Formalist would in this day and age take offense at that. I also said, "His paintings tell us that abstraction is trite, Formalism is empty, representation is futile, and figuration is obscene." In the present climate, the best of these works looks absolutely right. With more breadth than anyone else, Salle seems to address the pressing philosophical issues of our day: disjunction, disaffection, meaninglessness, vacuity, loss of authenticity and memory. When these are the issues, depth may be irrelevant.

This show invites comparison to the polished Rosenquists that inhabited the same space not too long ago and comes out ahead on our current terms: Salle's less the victim of consistent technique. His work also invites comparisons with Johns, Rauschenberg, and Warhol, and in 1987 looks less like anything resembling Neo-Expressionism than like a revision of Pop. Salle's not afraid of goofiness or inept amateurism (bad fashion sketches, dancing alligators, weakly drawn adolescent reveries). He doesn't mind degrading Modernism (lining up two Giacomettis and two modernistic lamps in tastefully colored ovoids above three semipornographic grisaille seminudes) by turning it into just another kind of schlock. He revels in putrescent color and '50s decor. It's as if he won't touch a style or image unless it's already tainted in some way.

It isn't easy to offend viewers anymore, but Salle's art raises thorny questions. Is it ironic, sarcastic, or neutral? Are his images of women misogynist, pornographic, or simply confrontational, bringing into the open a visual tradition of objectified female nudes? Is he an archmoralist or is his work really, as he has insisted ("there's no narrative, there really is none, there isn't one"), devoid of content, stripped of meaning? Does it matter whether Salle's aesthetic of violation and his repertoire of ripped-off images and styles are therapeutic

or symptomatic? Then there's the question that applies to so much art lately: is it a critique of our present culture or has it been seduced by an omnipresence of debased forms? And in any case, should we really blame the messenger for the bad news?

Rumors of tension and conflict swirled in advance of the Salle show, but no one involved will comment on them. "What does it matter anyway, it's just gossip," says David Whitney, the guest curator who installed the traveling exhibition at the Whitney. Janet Kardon, director of Philadelphia's Institute of Contemporary Art, originated the show. She told me she decided early in 1983 (after including Salle in her "Image Scavengers" group show) to put together, well, not exactly a retrospective, but "a . . . what do you call an artist in his early 30s, not really mid-career . . . an early *assessment* of his work." As the work developed and his reputation grew, and paintings went across the ocean to the collections of Saatchi, Ludwig, Bischofberger, the Tate, and the Pompidou Center, the process of organizing this show grew more complex. Nineteen works were chosen for the ICA show, but about two years ago, the Whitney entered the picture and the size of the show more than doubled.

"I hadn't understood Salle's work at all. I hadn't understood the difference between Julian [Schnabel] and David. I'm too old," says David Whitney. "I spend my time thinking about Jasper [Johns], who I really know about. But suddenly Fischl and Salle hit me and made sense to me. They seemed vastly superior to Susan Rothenberg and Elizabeth Murray, who I think are very good. I went to Mary Boone and said I want to do a show of David. Philadelphia was already doing it, so we rented the show."

Then there's the Philadelphia story. Back in October, when the show opened at the ICA in its original, smaller version, a chartered bus brought invited collectors, gallerists, and critics from New York. Afterwards, there was a dinner party. Or rather two simultaneous parties. According to Kardon, "You can never trust the buses to be where you expect them to be. There were two events planned. One was a *very* boring dull dinner and the other was a very *lively* party that I thought everybody from New York would enjoy a lot more. But I guess you just can't do that . . . and I guess people aren't as courteous as they might be."

According to one of the bused-in invitees, a few of the New York

contingent were taken to a dinner at the University of Pennsylvania President's House, while the rest were relegated to "a sophomore year beerbust in a basement. Crummy wine, fried chicken, fake Polynesian. We were ready to leave. Hilton [Kramer] decided to take the train back to New York. We got the bus driver to drive us to the house where three collectors and Mary Boone and the rich Philadelphians were still eating. We barged in and told them we were leaving. Then Janet gets on the bus and gets in a screaming fight with one of the collectors. Mary comes running out, she's panicked. David Salle wasn't even there, he was in Europe."

The trouble at the party—like the rumors of turf battles between the ICA and the Whitney—is comically appropriate: two different, simultaneous events, stylistically at odds, intrude on one another in antagonistic interchange. It could be a description of what goes on in Salle's work. Gossip can be idle, or it can serve as primary source material or metaphor. The gossip that surrounds the Salle show, different in kind from the gossip surrounding Schnabel—less personally aggrandizing, more socially reactive—may be due to something in the work, which plays on the lowest common denominators of our visual culture.

His paintings aren't polite, they're not courteous. If works of art can be said to taunt their viewers, Salle's do. Provocations abound. Ignoring, for the moment, the issue of sexism, nude figures turn their backs on us or flaunt their private parts. Sudden chair legs or a brassiere jabs out from the picture plane with barely concealed hostility. But perhaps most galling to art initiates, the appropriated images have the nerve not to reveal their sources easily. They don't allow you to feel smart.

"Oh, yeah, he rips off everyone," says David Whitney, beaming with paternal pride, as we try to recall if the rural landscape that stretches across the top of Salle's newest painting came from a Sisley or some Dutch genre scene. Called *Landscape with Two Nudes and Three Eyes*, it's a striking work, so recently painted it didn't make it into the catalogue, and I wonder, as the picture stares at us, if its free-floating eyes are a response to the pair of disembodied eyes on one of Schnabel's recent Kabuki pictures. No, says Salle, the eye motif comes from his own set for a Karole Armitage ballet not yet seen in New York, and "it has a specific historical reference which I won't go into, but the specific historical reference is not Julian Schnabel."

Salle's no-holds-barred images proclaim their prior existence in some other arena of visual life. What cartoon did that low-life duck come from? And why is a bowl of Cézanne's apples plunked onto a forehead like a Tibetan lama's third eye? Images, objects, and styles exist in his work stripped of their memories and divorced from their allegiances. These elements themselves seem amnesiac, as if they've forgotten their pasts. They induce the same feeling in the viewer. Frustration is built in, petty annoyance is called forth. Forgetting is a large part of the content: loss of knowledge, belief, meaning, significance, loss of experience and of innocence, loss of standards, loss of authenticity. "I use style like the Jesus prayer," said Salle in an interview in 1980. "I keep repeating it as if I didn't know where it came from."

As for the feminist objection to his degrading images of women, yes, it's insistent, aggressive, nasty-boy's work. There's something cold, soulless, and mean-spirited in the paintings' apparent emotional detachment, a neutrality that often infuriates viewers. Lisa Phillips, perhaps by way of apology to feminists, suggests in her essay that Salle's objectified women are really his alter egos (because an artist's works are also objects of visual scrutiny), and goes so far as to attribute them to castration anxiety. But Salle's no dummy. In a 1985 interview, he had an explanation that makes more sense. He remarked that both comedy and pornography were important to his work. "Not as a comment on the society that produces them, but in their own mechanistic ways, you know, in a detached way." Both, in other words, depend on conventions of distancing, and neither works if you're personally involved.

There may be no answers to the Salle question. I can get as mad as the next person when affronted by a sexist image. But Salle's art is so steady in its provocations, and so effective, that by now my admiration outweighs my doubt. Salle's on dangerous ground, which makes it all the more important to avoid the temptation to dissolve distinctions between the content of a work and the views of its author; those are the kinds of distinctions that censors and others often ignore. In an increasingly anesthetized, aestheticized world, Salle in his own way is the appropriate artist.

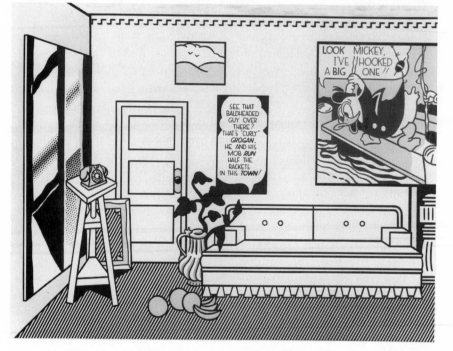

Roy Lichtenstein, *Artist's Studio—"Look Mickey,"* 1973. Walker Art Center.

12 Freeze-dried Pop: Lichtenstein and Rosenquist in the '80s

1. SECONDHAND ROY

Styles sometimes outlive themselves, to rise reanimated in the strangest ways at unexpected times. Roy Lichtenstein's stylized art looked shocking at the start of the '60s and ill at ease all through the styleless '70s. But in the '80s it no longer seems overfamiliar and slightly passé. The exhibition of his work of the '70s at the Whitney contains some of the slickest, most bloodless—and bloodthirsty—art we've seen in a while.

Take *The Artist's Studio, Look Mickey* (1973). It's an anonymous mail-order living room cataloging Lichtenstein's own art: a section of his early '60s *Look Mickey* over the sofa, an early '80s *Mirror* painting on the side wall, his *Stretcher Frame* propped up by the door (or maybe it's just the back of a canvas), and so on. There's a leggy table like one of his sculptures, a reference to his *Entablatures* in the molding near the ceiling, a not yet painted still life of a grapefruit on the floor, and a pointed reminder of his pre-Conceptualist use of words. It's all very obvious—oddly autobiographical, full of quotations—curiously blank. As a cartoon character looking through a keyhole in one of his earliest paintings declared: "I can see the whole room and there's no one in it."

In his 1978 *Self Portrait,* there's only an empty white mass-produced T-shirt with a painted blank mirror instead of a head. Again, Lichtenstein's quoting his own *Mirror* paintings from the start of the decade—dotted surfaces denying themselves, reflecting nothing, almost abstract. And he's impersonating Magritte. The absent artist was a theme that ran subliminally through the art of the '70s, but in

The Village Voice, October 7–13, 1981.

Lichtenstein's case the blank mirror suggests something more. His unyielding work gives back no reflection of his presence. It's the plight of the vampire.

"What I really want is the appearance devoid of its purpose," said Lichtenstein a few years ago. "This is something I've always been interested in, to take the meaning out." His style has always depended on referrals, needing transfusions from comics or ads or other stylized preconceptions to maintain its energy. He lives off other people's imagery. He started the '70s by painting reflections and shadows—those blank mirrors and starkly striped moldings—as if recoiling from the purity of Minimalism. And then (why not really overwork a metaphor?) he began soullessly sucking modern art dry.

His big brittle paintings of the '70s are an assault of loud, arty motifs, formal clichés, disembodied modern-master impersonations, and ordinary fakeness. They're how-to-look primers of all kinds of modern art stuff made easy. He's certainly been feeding from substantial corpses, sandwiching Léger, Matisse (stripped of all *luxe* and *volupté*), and Henry Moore together with Swiss cheese and Navajo blanket design and ersatz wood grain. Indigestible? He puts together an outrageous example of "anybody's Surrealism" and calls it *Go for Baroque*. He does a De Stijl carving job on a *Cow Going Abstract*. He even Picassoizes his own tilt-nose comic book blond heroine. Or else makes her grotesquely and ludicrously Daliesque by eliminating everything but an eye and a hank of hair. But he does it all in his own neutral coloring book style—as detached, inhuman, and schematized as some imaginary remote-control computer game called Modern Art Attack or Instant Image Invaders.

Lichtenstein's Pop style has congealed into a stunning caricature of itself. It's partly the desperation of a successful artist who has painted himself into a corner, and partly as if he's boldly turning the whole outmoded idea of modern stylization into his own brilliantly decorative semi-postmodern decor.

The flatness is what gets you first, in these roomfuls of garish Futurist, Cubist, and Purist Lichtensteins, in his dizzying Surrealist gallery, and in his brash jigsaw-puzzle German Expressionist room. It's as if the Whitney's fourth floor has been transformed into a cartoon version of the MOMA's third. And it's no longer just the Pop flatness of the printed page but an artificial flatness totally imposed— two-dimensionality insisting on its limitations all the way. So insis-

tently pressed onto the surface that it hurts to look at them, these Lichtensteins are like that episode in *Batman* where the Green Hornet is sucked into a counterfeit-stamp machine and comes out flat—a human stamp.

Add to that his flat color of the '70s—no longer bright printer's primaries but harsh, impure colors half-drained of life. Opaque reds, noxious greens, glaring yellow, bland bathroom-tile pastels, areas of dead gray. Even his benday dots have lost their original meanings— their reference to the printing process—to become gradated polka dot patterns, surface decoration along with the new coarse diagonal stripes and the wood grain. You can't say he hasn't changed.

While younger artists in the '70s were searching for ways to escape from style or put content back into art, Lichtenstein—the last of the robber barons—was grabbing hold of all kinds of familiar, debased artistic motifs to provide sustenance for his own inhuman art. He may have attained old-master or at least blue-chip status. He may have stopped making art out of cartoons and begun making cartoons out of art, but he's still taking risks.

These paintings are smart-assed, distant, literal, and ugly—really ugly. Punchy, brash, and horrible. Hideous, in fact. And, finally, quite wonderful. Full of startling, timely moves and very funny low blows at art. They stick to the surfaces but they aren't shallow. They're clever, vicious, sharp—and utterly flat. "Like the bottom of a sneaker tread," remarked one viewer at the Whitney. "Like a street radio turned up too loud," said someone else. "I don't have any idea what they mean. It doesn't make any difference what they mean," said Lichtenstein a year or two ago. "It's only that they look meaningful."

As for the sculpture—punch-drunk painted bronze that looks like wrought iron, with compressed perspective and no volume but lots of cutout see-through space—it's the best thing in the show, and I'm not yet sure why. Maybe because it doesn't really borrow anything from anyone else. Just stands on its own flatfooted, cockeyed view of the world. The glass of water, the goldfish bowl, the steaming cup of tea, the lamp casting solid rays, the mirror, and the brushstroke are improbable, indescribable, astounding.

Hilton Kramer complained that God is not in the details. But God isn't in Mondrian's details, or in Léger's either. Let's settle for the evidence of masking tape: this is hardly pious, God-fearing art. "Lichtenstein paints canvases on a rotating easel, spinning them around,

upside-down, sideways," the catalogue informs us. Think of Nosferatu climbing the walls. Lichtenstein's style is unpalatable and of questionable taste. But it sure looks as if it's alive. And it still has a nasty bite.

2. BELOW ZERO

With the rise of the cooler side of Neo-Expressionism, and the advent of a neo-Surrealism and a neo-Pop, Rosenquist was destined to be Pop artist of choice for anyone researching family trees. Among the work of major Pop artists, his always seemed the most expressively banal, the most purely Pop, as well as the most Surreal. He is a logical influence. It makes perfect sense to compare an old classic with the brand-new version. Would his retrospective prove that, like Coke, the new product is sweeter but not necessarily preferred?

Anyway, here was the Pop artist we'd thought about least over the years, on the verge of reaping his historical reward. He hadn't spawned a whole subculture the way Warhol did, or gone into art-about-art-as-consumer-icon like Lichtenstein. His work never offered itself up to sociological speculation or erudite analysis. It generated only philistine controversy over pragmatic matters such as whether or not there was bacon in outer space. But suddenly, with his juxtapositions of discordant familiar images, he could become Salle's ancestor, or Longo's, just as with his psyched-out Americanisms he could be Fischl's. Questions could be raised: how American (or European) is it? How loaded (or emptied) are the artifacts he chooses to paint? And what—unmentionable subject—is the relationship to (before and after, influence on and influence of) Photo-Realism in Rosenquist's work (or, for that matter, in Jack Goldstein's or Jeff Koons's)?

Rosenquist's technical skill might count against him, dating his production, but the pendulum is swinging back toward slick expertise. His formal complexity is more alien today, but his consumer images are not alien at all; like those of many newer artists, they're inflated and devalued. As Rosenquist has explained about the origins of his style, "Everyone was searching to get down to absolute zero, to just color and form, in their abstract pictures. So I thought I wanted to get below zero." And he did. One of the most peculiar things about being an art critic is that you never quite know until you start writing about an artist whether the work is going to fill you with ideas or leave

you speechless. This usually has little to do with the "quality" of the work and less with whether you like it or find it interesting. Rosenquist's art has the anesthetic effect of dry ice. Judith Goldman's catalogue essay, though fascinating, is mostly anecdotal and biographical, stressing Americanness. Robert Hughes in *Time* emphasized Rosenquist's European modern art antecedents. My instinct is to go for connections with recent art. These are all ways of skirting an icy core in the work that's impossible, at the moment, to touch.

"Enigmatic and sophisticated," says the Whitney of Rosenquist's art, but that's missing the point. It's the midwestern innocence—the hint of earnest, awkward blankness just under the polished surface—that saves him, and the "overtness" of all those projectiles and objects ramming into each other that lets us know there's little mystery left to the unconscious mind. Surrealism for Rosenquist, as for the Neo crowd, is simply a clever device. You might still look at some of his pictures and think watered-down, blown-up, North Dakotan Magritte, but the fact that Rosenquist's bizarre juxtapositions never manage to get into your dreams can, in today's climate, be a definite plus. After all, Freud's insights are now on the surface of everyone's waking thoughts. Razor blades and egg yolks are blatant clichés.

So if his garbled stews of big-as-a billboard fragments owe something to the Surrealists but lack their psychological depths, well, we can finally make of that a truly positive thing. And if the spectacular scale, authentic sign painter's technique (he did Times Square billboards for Artkraft Strauss), and displaced, dislocated images are exciting but rarely satisfying, that is all to the good today too. The numbing and almost amnesiac quality of some of Rosenquist's art can be considered a social statement. "He thinks of painting as acreage to cover," a semi-scornful, semi-envious artist told me. "His style is essentially the Hawaiian shirt." What could be more appropriate in 1986? Rosenquist's been capturing the mood of the times better than we ever knew.

There's an atypical early painting of a pair of flowered chairs that has a startlingly current post–East Village look, right down to the blankly mimetic tondos stuck onto its surface, but of course '50s furniture wasn't a retro item in 1963. This probably makes Rosenquist the first artist to think about reviving the look of the '50s. There's his famous mid-'60s *F-111*, wrapping around its own separate room. And the notorious *Star Thief*, the big picture ex-astronaut Frank Borman

denounced ("I have had some exposure to space flight and I can tell you without any equivocation that there's no correlation . . . between the artist's depiction and the real thing"). There are familiar Rosenquists from the early '60s, with their segments clearly compartmentalized, and unfamiliar ones of the '70s, when his style was in eclipse and his fragmentary images were melting together. The more recent cogwheels and lethal lipsticks and vacuum-packed starry skies are here, along with the latest paintings that take fashion advertising into a space warp, viciously slicing glamorous faces into sweet flowers. In terms of content, his images show as much hostility toward women as those of Salle. Formally, these slivered faces can be traced back to *Stellar Structure,* a hanging Mylar construction from 1966, and to the images of combs that appeared even earlier; they can also be related to the venetian blinds that he pictured in three large paintings of the early '80s. But then, alliteration of forms runs rampant through his work, along with the visual onomatopoeia of chance resemblances, done more for the sake of surface organization than for psychic effect. Think of the way the Firestone tire and the angel food cake, or the hair dryer, the umbrella, and the jet engine, rhyme in *F-111.*

It's hard to remember that Pop Art originated in an attempt at accessibility, an effort to popularize art by using commercial techniques and trivial images in order to escape the recherché quality of Abstract Expressionism. In retrospect, Pop Art sometimes looks like a symbolist movement. Because it was so rapidly absorbed back into the commercial world, the artists had to go further to artify their work, which gradually lost its Popness. In Rosenquist's paintings the formal devices grew more elaborate and intense. It's a long way from his billboard-derived paintings of the early '60s, like the simple tripartite image sandwich (car grille/face/canned spaghetti) of *I Love You with My Ford,* to recent paintings whose images have been cut, sliced, overlaid, meshed, manipulated spatially, and made to bear multiple imprints of a Formalist consciousness. But Formalist devices have always been his métier. In that sense, Rosenquist's work, twenty-five years of it, does look oddly dated—archaically formal. It's time to give his art credit as the major influence it is, but sometimes it's better not to study influences too closely.

James Rosenquist, *Untitled,* 1963. Private collection.

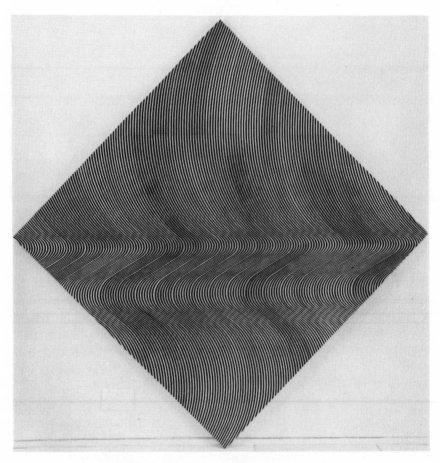

Philip Taaffe, *Brest*, 1985. Private collection.

13 Synthetically Yours

1. PHILIP TAAFFE: THE UNRESPONSIVE EYE

The text of Douglas Heubler's latest installment of *Crocodile Tears* involves a fictional artist who makes forgeries. In his current installation, Heubler's grand scheme of ongoing photographs of everyone in the world is interspersed not only with this narrative but with plaster reliefs of Napoleon and "original" oil paintings by Monet, van Gogh, Seurat, and Gauguin, all made by Heubler himself—but purportedly by his fictional forger, along with one unsightly mixed-media work of abstract art that's supposedly the original creation of another fictional artist, who keeps turning out products in his signature style. Is this an older artist's swipe at the young appropriators, or is he trying to tell us that, right now, the copy has more authenticity than the original?

Philip Taaffe might be Heubler's fictional artist if he weren't for real. "To a large extent I look upon my paintings as works of fiction," Taaffe has said. But he goes Heubler's conceit one further, rationalizing his copies of previous paintings as a "deliberate, strategic regression" and "a liberation from the search for novelty and newness," without any of Heubler's ironic sense of the preposterous or his ambition to encompass everything. Taaffe describes his work as "a surrealism that is informed by Minimalism and Conceptual art." I'd say he's another micro-Conceptualist. What is micro-Conceptualism? asks a postcard from a colleague in upstate New York. I'll answer here: micro-Conceptualism equals eensie ideas. Chalk up Taaffe as a prime exponent of the art of the eensie idea.

Taaffe's chosen field for foraging is, like Peter Schuyff's, Op Art,

The Village Voice, January 28, 1986. "Synthetically Yours" was originally the title of my review of Peter Schuyff's work (*The Village Voice*, December 24, 1985).

but he appropriates specific works of art, steps up the scale, and updates the effects. Taaffe, whose Bridget Riley appropriation was on the cover of the December 1985 *Arts Magazine* (in answer to the genuine Bridget Riley on the cover of *Artforum* the previous month), specializes in recreating Op Art paintings by means of an apparently tedious process mostly involving linoprints that are cut, pasted on canvas, and painted over. Speaking of microscopic revelations, these works look like big, seamlessly painted canvases until you peer up close.

Taaffe's eensie idea involves the appropriation of a dubious and instantly obsolete style of the mid-'60s that squeezed between Pop and Minimal art and is now being confused with the later Woodstock sensibility by a generation that was in its early adolescence then. His paintings are illustrations of an idea about perceptual art. They're representations of abstractions. As art objects they're almost irrelevant apart from their heightened commodity status. I wonder if collectors stuck with unloadable genuine Op paintings will update their investments by adding the dissimulating simulations by artists like Schuyff and Taaffe to their storage vaults. Taaffe's work, though I'm not sure he's fully aware of it, is about the farce of history repeated. From a Modernist's viewpoint, this degenerates to mere copying, but from a Postmodernist's perch, the retread is the ultimate novelty. Seeing paintings that are fictional versions of ones made twenty years ago is a surreal experience for anyone who was around at the time.

Besides the impressively undulating Bridget Rileys—whom Taaffe is best at the same way Bidlo is best at Pollock—the current show includes a "Vasarely," a "Paul Feeley," a radiating iris whose source I don't recognize, and a number of works that look like Barnet Newmans whose vertical zips are given an added twist as ropy corkscrew lines. The new Newmans are the handsomest, blandest, and least interesting of the not terribly interesting lot. However, it's not the visuals that count but the titillating idea of digging up the most despised style and playing it again. You get your kicks from quizzing yourself on the minutiae of tricky historical turnabouts. Pat yourself on the back if you notice that the title of one of his twisted Newmans in red, yellow, and blue, *We Are Not Afraid,* is appropriated from Newman's *Who's Afraid of Red, Yellow, and Blue* by way of Les Levine, Edward Albee, and Little Red Riding Hood. A gold star if you discover that his 1985 *Brest* is a mirror image of Riley's 1964 *Crest* (via

Genet's *Querelle of Brest*) but nearly twice the size, with a residue of colored haze.

The best thing about Taaffe's work is the way his neo-Op has the quease factor built in. No need, twenty years later, to depend on the viewer's ability to experience an afterimage. Just read between the dizzying stripes of his Bridget Riley paintings and you'll find the pale pastel auras painted right on. They're refinements of the ones Ross Bleckner used to play with some years ago, when he was showing curvy-stripe paintings at Mary Boone. They also materialize misconceptions that any Sunday painter would make. Long before appropriation became fashionable, I once went to a lawyer who had a mock Pollock behind his desk and a purple Stella polygon in the waiting room. He proudly informed me that his wife had painted both during the summer in their suburban garage. Perhaps she's the true progenitor of neo-Op: she'd carefully painted the pinstripes between Stella's purple bands bright orange, making permanent with pigment her memory of their retinal effect.

Is Taaffe making a stale equation between abstract and decorative? Or a slightly fresher one between the Conceptual and the perceptual? Or showing us that after Neo-Expressionism comes the neo-Ophthalmic? His work boils down the recent yearning for emotive content to its basest stock: sensory experience. Can a micro-Conceptualist appropriator transcend his or her choices? Do these choices or the ideas behind them determine the success of the work? What do you think?

Op Art, along with other recent resurrections of less recent, anomalous twentieth-century styles, does have its fascinations right now. So do other superficial manifestations of the '60s. Taaffe's show provoked me to dig up the 1965 MOMA catalogue of the original Op Art exhibition, "The Responsive Eye." The text, with its earnest comparisons between Op and Impressionism, is a farcical exercise in misguided scholarship, but the acknowledgment by curator William C. Seitz offers a timely object lesson in artwork supply and demand: *"The Responsive Eye* was announced in November, 1962. Besides showing recent works with a primarily visual emphasis, it was to have documented the development from Impressionism to what came later to be called 'optical' art. So rapid was the subsequent proliferation of painting . . . employing perceptual effects, however, that demands of the present left no time nor gallery space for a retrospective view." It

doesn't take much reading between the lines to realize that rumors of demand created the rapid proliferation: that Op was a bandwagon propelled by a curator's quest.

The catalogue for Taaffe's show at Pat Hearn Gallery, that outpost of elegance at Avenue D, is possibly as intriguing as the art. The size and texture of a coffee-shop menu, it opens with a cryptic Barnet Newman quote: "The history of modern painting has been the struggle against the catalogue," and contains four courses of elliptical rumination by Ross Bleckner. There's also a quote from Jean Anouilh that's about tragedy, though it would have been more appropriate had it been about farce.

2. ROSS BLECKNER: ARTIFICIAL RESUSCITATIONS

At the beginning of the '80s, Ross Bleckner's queasy stripe paintings, with optical aftereffects painted onto their surfaces rather than left to the viewer's retina, looked peculiarly out of step: a hallucinatory revival of Op abstraction at the height of Neo-X. They now have cult status in the Neo-Geo crowd. His subsequent pictures of unearthly chandeliers (as sentimental as the climax of Spielberg's *Close Encounters*), murky atmospheres, and puzzling votive objects were equally obscure, elliptical, and unlike anything else around. And what could have been more unfashionable than the memorial theme of his last show, death from AIDS?

Now he's working in both modes at once: large stripe paintings and smaller imagistic ones, and they're not as different as they might sound. Both are symbolic and commemorative, presenting us with the kind of spurious polarity that Gerhardt Richter once did when he alternated photographically realistic paintings of candles with equally "realistic" paintings of abstract brushwork. What unites Bleckner's two ways of working is not only the mood of remembrance and loss, but his characteristic radiant dimness, his indirect glowing light.

And not only that. These paintings refuse to abide by distinctions between what's abstract and what's representational: the same emblematic content can make its appearance in either guise. If the stripes function as repressive bars to lock us out, a keyhole or a gate as well as the dark glowing space of the imagistic pictures offers an

entrance to shadowy realms beyond. And with their funereal imagery (urn, floral arrangement, or Aladdin's lamp, each as unmodern and off-putting as a Victorian locket encasing a lock of the dead loved one's hair), they go so far as to hint at the possibility of an afterlife. A small red and gold painting features an uninscribed plaque festooned with a red ribbon and a rosette bow, while a big striped painting with scalloped edges actually turns itself mockingly into the shape of a plaque, with barely visible raised words crossing its field like a subliminal message: "Remember me." With so much art presently concerned with forgetting, Bleckner continues to go against the tide, bringing back outmoded forms of sentimentality and remembrance. Another enormous stripe painting, a multicolor one (shades of Gene Davis) called *Infatuation,* sports the red Marcal bow. Parodying a gift-wrapped present, this one preempts his critics. "It's a little self-mocking. I know if I go on with those stripe paintings what they can look like," Bleckner told me in a recent interview.

In the early paintings he took off from, and commemorated, a discredited dead style. "Op Art was such a failed image," he says. "I kind of liked the idea that it was failed, because it had such high hopes. From the '60s to the '80s things got a little weird." His early stripes shut the viewer out, but somewhere within and between those blurry bars were implications of images and states of mind you couldn't quite see. Now, expanding on those paintings, in which he took a simple formal device and imbued it with intimations of complex emotional states, he's bringing discredited feelings to the surface, linking birthday gifts with mortuary decor. He's reviving a clichéd imagery of death. One of the new ones, with black and yellow stripes, has a tiny blue fleur-de-lis stuck flat on its surface, like a decal from the moribund past of aristocratic ideals (and maybe French art). And a green one called *Cage* has ten little greenish birds fluttering against its vertical bars, as well as a number of shadowy "retinal" spots pulsing against the picture plane.

Bleckner isn't simply endowing abstraction with a human heart, or making representational art vulnerable to mortality. The end of the century is nearly upon us, people are dying early deaths, Formalism has failed: the fin-de-siècle symbolism is obvious (Bleckner mentions Odilon Redon and Gustav Moreau). But the ambition in this work is greater than that. It attempts to reconstitute the "aura" that supposedly faded from art when it was exposed to the glare of mechanical

reproduction and the modern world. This work tells us that paintings may be commodities, consumer trophies: if painting itself has become a commemorative gesture, the results are empty trophies that memorialize that act. But a canvas can also be something else: a repository of tenderness, with even an occasional twinge of remorseful originality.

3. JEFF KOONS: HIS BEST SHOT

Jeff Koons doesn't alter. He doesn't rephotograph or appropriate. And I'm not sure you could call what he does simulation. He doesn't even sign his works ("I come out of a Duchampian tradition; I would never mark on my pieces"), which are accompanied by letters of authenticity instead. He simply takes the "original" and replicates it, barely lifting a finger, which, depending on how you feel, is either the most radical readymade art act of the moment or a throwback to Super-Realist vérité.

A few years ago he encased actual wet-dry rug cleaners and other appliances in airless display cases. Last year he presented basketballs injected with gases and unnaturally submerged in immersion tanks, bronze Aqua-lungs and lifeboats, and Nike basketball-star ads. The pictures in his current installation are subway ads for seven brands of booze, including Hennessy, Frangelico, Bacardi, and Dewar's ("The Empire State of Scotch"). They're not only absolutely accurate, they're re-produced readymades. He contacted the liquor companies, was given the original plates, and had the same printers in Milwaukee that printed the originals do these. Same size, same colors. The only thing he changed was the medium: oil-based inks on cotton canvas instead of printer's ink on paper. "I'm very involved in maintaining the integrity of the original," he says.

The objects that accompany the pictures climb the social ladder: drinking paraphernalia from working-class pail to suburban ice bucket to portable travel bar (with its aspirations toward upward mobility) to the luxury of a Baccarat crystal cocktail set; from Model A pickup-truck decanter to fisherman/golfer caddy (wearing a shot-glass hat, carrying corkscrew and tongs) to a deluxe seven-car Jim Beam train on its own track. They're unaltered too—except materially. Cast from brand-new originals (no nostalgia), what was once tin,

porcelain, or crystal is now steel so highly polished it looks like chrome. "Stainless is more or less a proletarian material," says Koons. (Less is more like it, considering it costs a fortune to cast these things.) "It's also the only material that will preserve the liquor." What liquor? The gallery worries about fingerprints and says don't touch, but if you lift the engine's smokestack or the top log of the log car, you'll find the little strip of paper that, on any liquor bottle, shows the tax is paid. Each of the decanters was sent to the Jim Beam distillery to be filled with bourbon and officially sealed, becoming repositories that entomb what they were meant to pour out.

And no, the collector isn't supposed to open and drink: these are functional works of art that are not meant to be used. Says Koons: "They may learn about abstraction through intoxication, but if they use it they get art lesson number one: they ruin it as a piece of art."

These pictures that aren't really paintings and objects that aren't exactly sculpture equate rampant consumerism with alcoholic consumption. As seductive display objects and images of consumable desires, they function as a strong critique, addressing the power of social conditioning and the powerlessness of pure form. Tension is part of their intent; frustration is built in, and a perfect state of preservation is an essential element, the way unnatural equilibrium was in his basketball tanks. "I try to help the object survive."

Koons also exposes specific social messages. In the absence of any intervention by the artist, the spectator decodes not only the social positions implied by the different decanters but how the ads play on reverse stereotypes: the Gordon's girl-genius painting a seascape while an infantilized beau clutches at her shirttail, the brilliant black lawyer ("Hennessy, the civilized way to lay down the law") engrossed in his thick legal books. Frangelico, aiming highest on the social scale, goes abstract with an all-engulfing tidal wave of orange alcohol. Some artists recycle Formalism as kitsch. Others recycle mass-media kitsch as conceptually oriented art. They've crossed over to the other side of primitivism—that is, if primitivism is a belief that the acquisitions and habits of civilization are evil. Koons forces us to notice the fetishization of fermented liquids by turning the accoutrements of the alcohol cult into spiteful icons and idols.

There's more in his two- and three-dimensional replications (is that why the pictures come in editions of two and the objects in editions of three?) than exactitude, social comment, and the decon-

struction of manufactured desire. And it's not the fact that drinking, like basketball, is a national pastime that connects this show to his previous one, and to his earlier encased appliances. His subjects and objects can also be understood as biological metaphors of wet and dry, air and water, life and death. Vacuum cleaners, snorkels, and Aqua-lungs are all air-breathing machines, though a bronze Aqua-lung would drag you under. Relate that to his basketballs immersed in liquid and to the new work whose subject is alcohol (drowning your sorrows).

The implications of drinking—intoxication, distortion, loss of control—must be loaded issues for an artist whose work has been consistently concerned with precise equilibrium (in the Nike ads, being fast on your feet equals social equilibrium), balance, and keeping everything intact. At first glance Koons's art looks invulnerable, impervious, and au courant. But in the end it seems heartbreakingly cynical, almost tragic. You start to wonder if this work isn't really about an old, unfashionable issue: preservation and permanence—in other words, mortality.

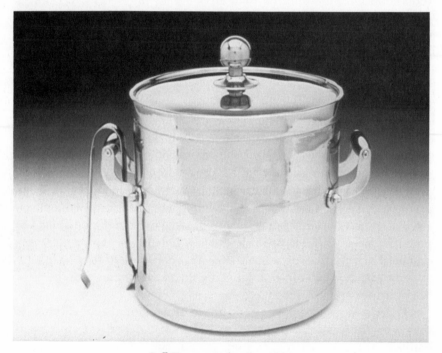

Jeff Koons, *Icebucket*, 1986.

Ross Bleckner, *One Wish,* 1986. Private collection.

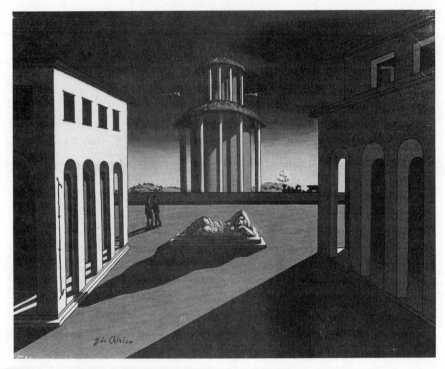

Giorgio de Chirico, *Piazza d'Italia,* 1950.

14　The Counterfeiters:
De Chirico Versus Warhol

André Breton was aghast when Giorgio de Chirico in 1924 painted the first duplicate of his 1917 *Disquieting Muses* for Paul Eluard. "By cheating on his outward appearance, he could hope to sell the same painting twice," said Breton, condemning it as a "fraud against the miracle." This crime against creativity and authenticity weighed so heavy in the minds of the Surrealists that they couldn't appreciate what was either an advanced and irrational act of innovation or an equally shocking throwback to premodern atelier practices. Only recently have the ideals of modernity worn thin enough for us to begin to admire de Chirico's perversities. Yet even now the same nagging question remains: was it an outrageous "conceptual" gesture or a cynical mercenary act? It may not be possible at this late date to distinguish between the two; possibly it was both. It makes perfect sense that Andy Warhol, who also liked to deny the artist's role as creator, would eventually decide to claim de Chirico's legacy.

Warhol didn't collaborate only with Basquiat; he also collaborated single-handedly, if such a thing is possible, with the late de Chirico. The Basquiat-Warhol works went to Europe, but the fruits of Warhol's spiritual encounters with de Chirico came to Fifty-seventh Street in 1985. Called "Warhol verso de Chirico," the show brought together Warhol's paraphrases of de Chirico and the original de Chiricos Warhol borrowed from. The master of enigma has been appropriated by the master of the banal.

To make things more complicated, most of the de Chirico originals weren't the *original* originals but the facsimiles de Chirico kept painting in his pre-1918 "metaphysical" style long after he had done

The Village Voice, May 7, 1985.

his reactionary about-face and repudiated that work. These nearly exact copies of his early paintings (MOMA curator William Rubin disparagingly called them neo–de Chiricos) mocked the Modernists who had heaped praise on his early style while ignoring his later antimodern, classico-baroque work.

De Chirico devalued the idea of a unique inimitable original. The *Disquieting Muses* in this exhibition is dated 1960, and is, if I've counted right, the seventeenth or eighteenth copy of that painting. Maybe he kept doing them because no one got the point. Maybe he needed the money. Maybe he meant it when he said his technique had improved, and traditional skills were what mattered.

As for the Warhol versions, he lays his usual off-register printlike swatches of color over silk-screened wallpaper-pattern repeats that multiply the image four or eight times. Warhol compresses a lifetime of repetitions into each piece. They're like prints of prints, flaunting their generational loss of quality. And no, Warhol wasn't jumping on the latest bandwagon: he started it rolling years before (remember his *Mona Lisa*s? for that matter, remember Duchamp's?). As for his stylized de Chiricos, which look rather sweetly old-fashioned, he did them in 1982. For both the grand old auto-appropriator and the Pop image-bank robber, mechanical reproduction is the theme. Appropriation is the name of the game, and deliberate devaluation the double-edged result.

It's easy to dismiss this as a too timely pairing of two great pretenders exposing their willful fraudulences and insincerities, but this show offers far more than that. Rarely has the disparity between quality—with a Greenbergian capital *Q*—and relevance been so obvious as it is here. This exhibition reverberates with issues that are at the heart of the current modern/postmodern wrestling match. Both artists travesty those qualities that modernists held most dear: creativity, originality, authenticity, uniqueness. Both artists deliberately degenerate form and style.

Lack of inspiration isn't always involuntary; loss of quality can be a deliberate act. Besides disowning his early "metaphysical" style and producing facsimiles, de Chirico also claimed that the pre-1918 original metaphysical paintings were themselves "fakes." It's surprising the Surrealists didn't appreciate these post-Dada gestures from someone they had hailed as the first Surrealist. No one has trouble accepting the fact that Picasso painted fifteen variations on Delacroix's

Women of Algiers—because Picasso was inventing his own imaginative variants. No one minds that Delacroix himself painted a second version of *Women of Algiers* fifteen years after the first—because he shifted the viewpoint. And we take it for granted that Warhol will use someone else's images as well as repeat himself.

De Chirico, however, repeated himself without any formal purpose except to call into question the value of invention in a work of art. He denied modern art's grandest ideals, and to top it off he depicted the muse as a dummy—part classical statue, part makeshift mannikin. Warhol willing himself to be an automaton is the latter-day exemplar of museless creativity. The kicks in his work are in the act of his deciding what to do; the execution is almost irrelevant. His rapid commercial technique simply packages ideas. De Chirico, on the other hand, was so involved in technique that the execution became almost an end in itself. I'm not sure this work by either artist would stand up so well without the other as support.

What does it mean, at a moment teeming with younger, more extreme appropriators, when one artist hailed for his denial of inspiration borrows from another who has long been reviled for the same thing? Both propose uniformity instead of uniqueness; both incorporate ideas of industrial production and economic necessity into their art. The "verso" that joined their names in the show's appropriately pretentious title may mean "toward" in Italian but it also means "reverse," and in English it's a printing term referring to the left-hand page of a book, the other side of a page, the back of a coin. In some way Warhol and de Chirico are two sides of the same coin. In the midst of mid-'80s materialism, nostalgia, and affectation (and art that flirts with the conceptual and the salable at the same time), de Chirico's appropriations from his own disowned oeuvre embody an uncanny understanding of the fatal flaw in the myth of modernity. It's not that Warhol doesn't understand the same thing, but that de Chirico understood it before its time.

This conjunction of Warhol and de Chirico somehow defines the inner and outer limits of appropriation. It brings up some fine points of the begging, borrowing, stealing sensibility of the '80s, and suggests that distinctions need to be made. There's a subtle difference between repeating and copying (how are Albers's squares different from these de Chiricos?), a less subtle one between duplication and variation. The spectrum that runs from paraphrase and parody to quotation, simula-

tion, and plagiarism is riddled with hazy bands. We may crave the inauthentic the way earlier generations craved a look of authenticity ("aura"): appropriation is a way of exorcizing the cult of originality. After nearly a century of inventiveness, art as imitation has returned with some twists. Taking without permission can be a means of revenge, citing sources isn't always the same as seeking roots, and whether or not to repeat yourself is a problem all artists confront.

As for the most metaphysical question of all: can an artist steal from himself? "Look at what happened to de Chirico," wrote Louis Aragon in disgust. Marcel Duchamp took a more detached view: "His admirers could not follow him and decided that de Chirico of the second manner had lost the flame of the first. But posterity may have a word to say."

Andy Warhol, *Italian Square with Ariadne*, 1982.

Index of Artists